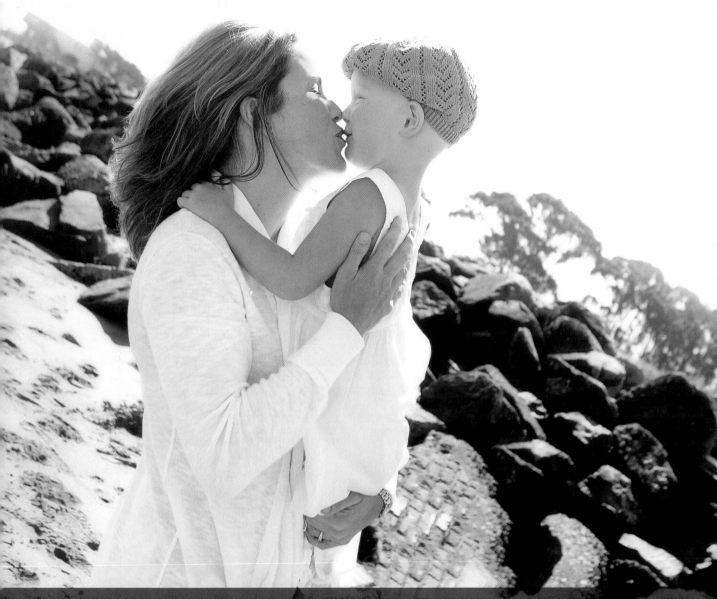

Envisioning Family

A photographer's guide to making
meaningful portraits of the modern

TAMARA LACKEY

Envisioning Family:
A Photographer's Guide to Making Meaningful Portraits of the Modern Family

Tamara Lackey

New Riders
1249 Eighth Street
Berkeley, CA 94710
510/524-2178
510/524-2221 (fax)

Find us on the Web at www.newriders.com
To report errors, please send a note to errata@peachpit.com
New Riders is an imprint of Peachpit, a division of Pearson Education

Project Editor: Susan Rimerman
Production Editor: Tracey Croom
Developmental/Copy Editor: Anne Marie Walker
Proofer: Liz Welch
Indexer: James Minkin
Interior Design and Composition: Kim Scott, Bumpy Design
Cover Design: Aren Howell

ISBN-13: 978-0-321-80357-3
ISBN-10: 0-321-80357-4

9 8 7 6 5 4 3 2 1

Printed and bound in the United States of America

I dedicate this book to my very own family.

I love the promise of you.

Acknowledgments

It would have been exceptionally difficult to write this book if it weren't for the culmination of all the portrait sessions I've photographed in the last near decade. For that privilege, I thank each and every one of my clients. I'm amazed at how much I've learned while staying focused on doing the work.

The experience of growing up as the only daughter, the middle child, in a family of five taught me much about how family shapes us. It may have taken me a while to understand it, but the connection of the pieces of my childhood to my resulting personality quirks certainly makes a great deal more sense to me now. Thank you brothers. Thank you mom. Thank you dad.

It turns out that we are consistently offered the opportunity to learn more about who we are and why we may feel alone at times, but it seems to very much be up to us to connect the dots.

What I've learned building out my own immediate family is a significant contributor to how I photograph families today, which is the cornerstone of this book. How each of us learns to care for each other—our sameness, our differences, our individual experiences inside the whole of family—is challenging, beautiful, and unending. I am so very grateful for Steve, Sophie, Caleb, and Ana Elisa. If each member of my family weren't so different, I wouldn't be able to understand such a wide variety of my subjects to the extent that I do. Living with people while making a living photographing people is like being surrounded by open textbooks at every turn.

The effort of producing this book was very certainly not mine alone. Thank you to our book designer, Kim Scott. Thank you to New Riders Press and my insightful editors, Nikki McDonald, Susan Rimerman, and Anne Marie Walker. I wrote this book while in the midst of a great deal of travel, contributing to it from at least ten different states and two different countries. My editors' abilities to keep things streamlined were extremely helpful in not just keeping me on track, but in keeping the overall structure of the book on track. Because I wrote in waves over the course of the year, this was not an easy task for anyone.

My studio manager, Sarah Coppola, was unquestionably a key player in converting text into clean formats and constantly reorganizing a multitude of photographs. In the midst of a rather intense year, I so appreciated knowing I could just hand off the words and images to her and she would take care of the rest. I also want to thank Kate Burgauer, my production associate, who offered me some excellent writing prompts one long summer morning when I remember feeling particularly stuck. Sometimes we just need a peek at what could be next to be able to start to get there.

And if it's possible to thank the act of running, I want to do that. There were more than a few occasions when I stared at a blinking cursor for far longer than I want to admit. Lacing up, zoning out to music, and moving relentlessly forward for a few miles seemed to consistently bring all the words back into my head. .

Contents

It's All About Connection

SECTION IV

The Aesthetics

Introduction

We are all moving so fast in today's day and age. More information is coming at us than we can possibly process, and it's now flying at us faster and from more directions than we've ever known. That leaves us with this constant underlying feeling of *I must catch up*. That doesn't just apply to how much we need to process information; it also pertains to just how much we need to keep up with each other emotionally—most notably, with our families.

I believe that this is where family portraiture comes in. We know how important loved ones are to us. We know how much we'd miss them if for any reason we couldn't be with them anymore. And yet it's sometimes not until we're holding a beautifully photographed image of our entire family together that we stop and see what we really have.

I liken this to a realization I experienced rather recently. I found myself inside my home for a large part of the day working—working on this book, actually. I was up against a looming deadline, and I had to shut out everything around me to be able to truly focus and write thoughtfully. I was working from home to steer clear of our busy studio. For this reason, I didn't actually end up stepping outside until late in the afternoon. When I finally did, I was struck by the extraordinary quality of the weather. It was a perfectly balmy, sunny, early autumn North Carolina day with a light breeze passing through 75-degree weather. I stopped for a second, looked up at the cloudless blue sky, and thought to myself, "I missed *this* all day

long?" What I had missed out on was something strikingly beautiful. The truth was that because I had missed out on it didn't mean that it hadn't been there all along. It had been. I had just been so busy with how much I had to do that I hadn't appreciated what was right in front of me—literally, right outside my front door.

I believe this is what we do for our clients when we present them with a meaningful portrait of their family. We give them the opportunity to look at themselves all together. A bona fide, true look at who they are and how they belong to each other to say, *I have been so busy, so preoccupied with the details of, but, look! Look at what's been here all along! Look how we've grown, at what we've overcome, at how much we still have to look forward to as a family.*

What You'll Find in This Book

When you read through this book, you'll find that it starts out a bit differently than how it continues and ends. The reason is that the first two chapters are more focused on family than photography. Specifically, the first chapter is centered on the history of what we consider family and the intriguing dynamics between family members—what family means to us and how it shapes who we become. The second chapter veers even further away from photography. It has to do with how family can be shaped, what it means to not have family, and how powerful photographs of family can be, especially after you've lost the people or the photographs.

This second chapter is the most personal section of a book I've ever written because much of it relates to how we built our family, which was in large part through adoption. Please don't mistake this for a vanity chapter, because I found that the way I photographed families was greatly changed by the experiences of how we made up our family. I simply looked at the concept of family differently than I ever had before, and I knew better what to see when I was looking at families who had formed, no matter how they came to be who they were to each other today.

There are few things that improved my portrait photography more than the experiences I share in Chapter 2. It's my sincere hope that you can look to

experiences in your own life as catalysts for furthering the depth of your own work as well. There's little else that guides us to better seeing what is significant to us than life-changing occurrences that force us to stop and reevaluate everything we thought we once knew.

If, however, that sounds like a bunch of soft gooeyness and you prefer to jump straight to the photography sections, by all means start with Chapter 3. (There's plenty of detailed information throughout this book, and you'll have more than enough to digest either way.) Chapter 3 kicks off the gear and technical section, which includes an overview of what's in a portrait photographer's bag, how to set up a working studio (Chapter 4), and considerations to ponder beyond the basics. Chapter 5 wraps up this section with a breakdown of many of the technical specifics you need to know to be able to better showcase your own artistic style.

Chapter 6 is a thoughtful yet detailed look at how to interact with your subjects, recognizing that empathy is one of the best tools we have when it comes to producing great portraits. Chapters 7, 8, and 9 continue with connection and specifics, and include precise overviews of how to photograph families in their home, in the studio, and in a variety of locations.

Closing with "The Aesthetics," I speak to the specific rules behind traditional posing and framing in Chapter 10, and how they can greatly impact the quality of the more expressive contemporary portrait. And ending with Chapter 11, "Lighting the Frame," includes diagrams, image reviews, and a general look at how to light your portraits well anywhere.

A Personal Account of the Importance of Family Portraits

After spending a *considerable* amount of time with this book, it struck me that it might be interesting to ask a client of mine why it's important for her to seek out professional portraits of her family. So I asked a wife, mother, and now friend whose family I have photographed repeatedly over the last seven years to select one photograph of her family and tell me why it matters to her. What does she

see when she looks at it? And why are family portraits so significant to her that, in the midst of such a rich and busy life, she prioritizes them again and again?

These are her words and the reason I put so much effort into personalizing each portrait for my clients:

> My family. It is the most important thing in my life. Enjoying my marriage and watching my children grow are the greatest gifts ever given to me. Because it all happens so fast, I treasure these photographs as glimpses of my life along this journey. I see joy and hope when I look at this particular family portrait (opposite).
>
> My children live out their days full of joy, as only children can. On the face of my oldest son I see the joy of confidence of being loved and the belief that he can do anything and be good at it. On my daughter's face I see the joy of comfort of being held by the man she cherishes most in her life, her daddy. On the face of my youngest, I see the joy of energy, wanting to take on the world and always moving swiftly from one thing to the next. On the faces of myself and my husband I see the contentment that joy brings when we live life together as a family. We each married our best friend, and we still find joy in that all these years later. All that I see may change by our next family portrait. Life experiences and time have a way of stripping unbridled joy from our hearts. But at this moment, we know what it feels like to have it. And it will serve as a reminder to all of us that it is possible.
>
> I will always choose to capture my family's moments through photography because these portraits are indelible reminders of a life lived well. They each tell a story about who we were and where we were headed, and that we were just having a great time living life.

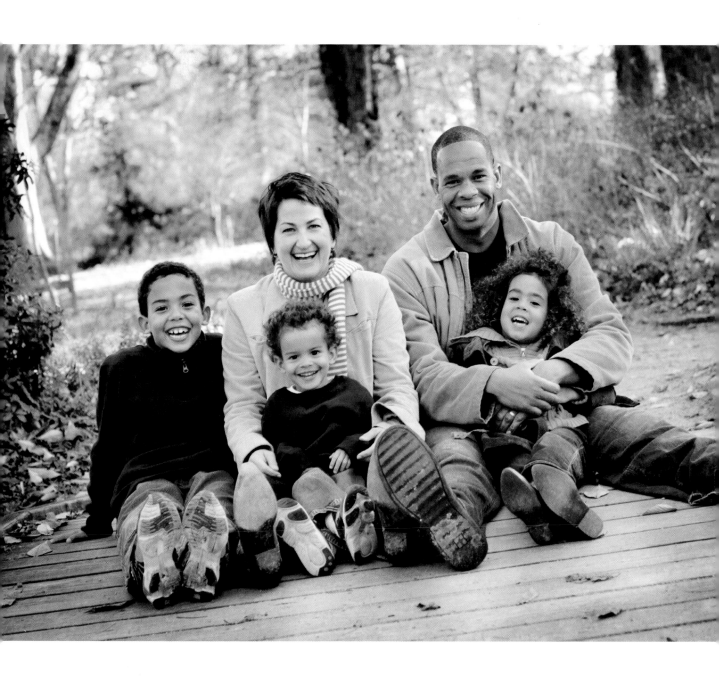

The Meaning of Family…Photography

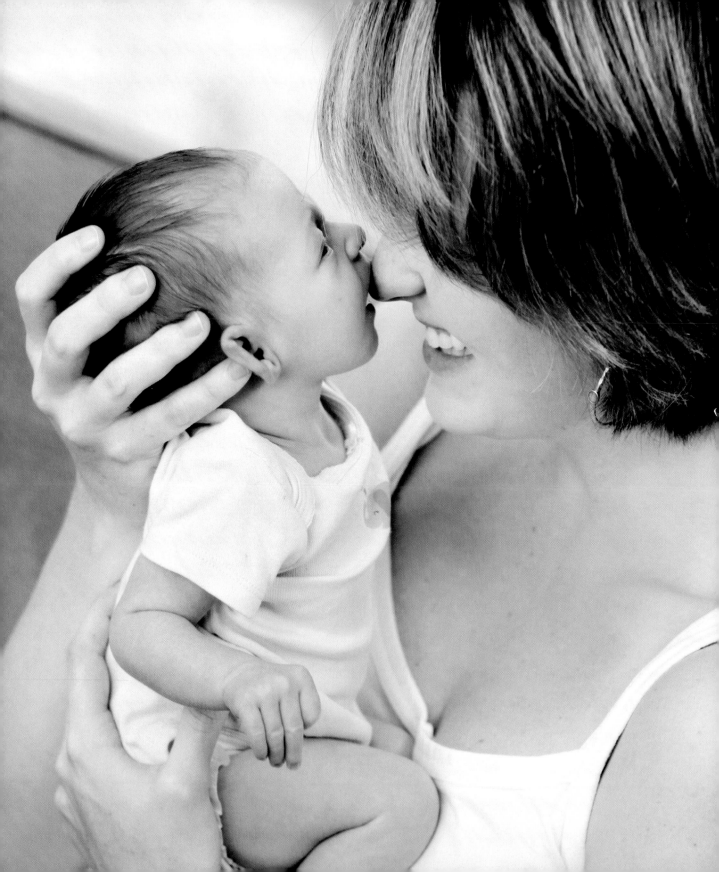

Exploring Family

*Other things may change us, but
we start and end with family.*
—Anthony Brandt

FAMILY. THE WORD CONJURES UP more emotions than any other six letters could otherwise. For some, the earliest thoughts of family revolve around home, of hazy memories draped in nostalgia, and of knowing what it meant to belong. Needs were simpler, and as time shut doors, eras were lost.

For others, the earliest memories of family might evoke a complex array of emotions—of patterns to break and of dynamics to escape. The actual experience of what family was may have provided some incredible incentives to change the meaning of the word.

We grow and change. We create new families, new senses of the dynamics we used to know—mom, dad, brother, sister—and we look idyllically at what these relationships can mean now. Perhaps it is a recapturing of what was or an optimistic adaptation. Perhaps it is a new start. As much as family can mean different things to different people, one truth remains: The very definition of what family means changes more every day. And at a rate faster than we've ever known before.

Pick up a decades-old family photograph and try to think of what you knew at the moment the image was captured. If you can't remember the exact moment, think about what experiences may have surrounded that split second, or preceded it, or came shortly afterward. If you really try to place that very specific time, you'll most likely see a short film come to life, courtesy of a long-dormant memory. One solitary instant captured in years past can take you back to cities once lived in, paths once traveled, relationships once experienced… and love once felt. That is the beauty of a still image: It can be a catalyst for an entire motion picture of living.

As photographers, we are able to more richly capture these significant moments when we better understand more of what this long-standing social structure means to our subjects and how it shapes them.

The Intriguing History of Family

To better understand family, the complex dynamics of relationships within families, and how to more usefully relate to our subjects' perceptions of how they fit into their families and often the world, we need to start at the beginning.

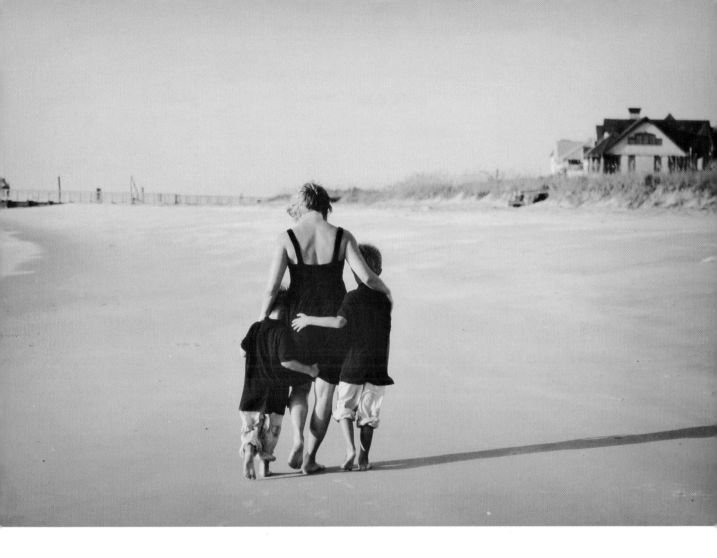

Ancient Legends

The first origins of the structure of family vary by geography and historical documentation. According to ancient Chinese legend, families were first identified as separate social structures when Emperor Fu Xi standardized a naming system in 2852 B.C. to ease the burden of census taking, which also led to better defining matrimonial relationships. By taking family names, the structure of individual families became more distinct. Families became very important and more technically were attributed as consisting of parents, grandparents, aunts, uncles, cousins, and of course children. It was widely accepted that ancestors who had passed on were still active members of family, too—perhaps not seen but still worshipped and considered decision influencers.

Legend has also credited Fu Xi with inventing the first 100 Chinese family names, which usually represented animals and totem worship. The popular last name Long, for instance, means dragon. Names became increasingly significant over time—and even exclusive. In the Western Han Dynasty (2063 B.C.–A.D. 23), those who dared to have the same name as the emperor could face the penalty of death. During the reign of Emperor Liu Bang, if you even had the syllable "bang" in your last name, you were forced to change it.

In addition, members of a family with one name couldn't marry members of a family with the same name. This led to all kinds of changes, and biologists will tell you that this was beneficial for society in general.

The Creationist First Family

Marrying outside of your immediate family wasn't a luxury for the biblical first family. If you read Genesis, the creation story, you read that the very first family to walk the earth was a family of four: Adam, Eve, Cain, and Abel. Many historians, including Sir Isaac Newton, calculate the origins of this first family as having occurred around 4000 B.C. Where was their family home, The Garden of Eden? Some say it was in Iran or the Tigris and Euphrates Valley. Others say it was in Missouri; even Ohio has had its hat thrown into this first-family-home ring. It is almost certain that by the publish date of this book, the location of The Garden of Eden will probably still not be absolutely confirmed.

What is known is a bit of how this first family developed. As stated in scripture, Cain was the first born—as in the first human being ever born on the planet. Perhaps that set up family dynamics for generations to come, because Cain seemed to have had some issues with the second-born child, Abel. In fact, according to Genesis 4:1–8, "Cain attacked his brother Abel and killed him."

The impetus for this grave act was jealousy. But exactly why Cain was jealous is up for interpretation. The more accepted understanding is that Cain was jealous of the attention Abel received from God, who preferred Abel's offering over Cain's. But the Midrashic interpretation of this event is different: Yes, jealousy was still the motive, but not jealousy over God's favors. Apparently, Cain and Abel each had twin sisters, which also meant they had future wives queued up and ready for them. Despite the fact that they were twins, Abel's betrothed wife was considered the better-looking one, and because there were literally no other fish in the biblical sea, Cain was pretty fired up about this injustice. When Abel

suggested they let God decide by means of a sacrifice, Cain was even more upset when God rejected his offering and proceeded to attack Abel in a fit of rage.

Whichever way this act went down, the ending remains the same, and the initial outlook for the original family seemed bleak. However, if you read Genesis 5, you'll discover that three sons were born. The third, oft-overlooked son was named Seth. In addition to those three children, you'll see the phrase, "other sons and daughters." According to the Book of Jubilees, the family continued to expand when Seth married his sister, Azura. This was well before the Fu Xi decree, or any other man-made decrees for that matter. All things being equal, everything turned out pretty well for Seth and Azura. They had a couple of kids, and Seth lived until he was 912 years old—not too shabby at all.

But we can go back even further.

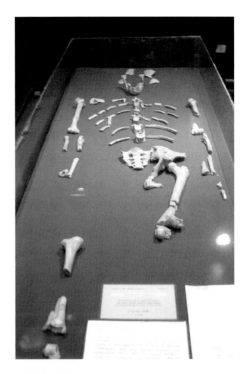

The Evolutionist First Family

The other set of beliefs about first families comes via archaeology, less creationist and more evolutionist. This belief takes you back much earlier than 4000 B.C.—much, much earlier. Scientists will tell you that one of the first families on earth may not have been written about, but its members were all found together. Estimated to have been living together between 3.9 and 3 million years ago, and found in Hadar, Ethiopia, "the first family" consisted of 13 individuals: Nine adults and four children, males and females, were all entombed together. Most likely it was an "extended family" of the same species. Many anthropologists, led by collaborators Donald Johanson and Tim White, believe that this "first family" was a mainstay in the story of human evolution. These earliest of ancestors were at the top of a tree that would branch out for millions of years all the way to modern times and to modern families.

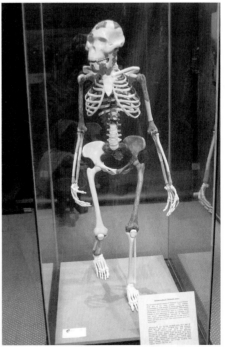

The Making of a Family

After looking at three different parts of the world and three very different stages of life on this planet, what do we know about the origins of family?

There was a need to band together for survival and support. There were directives from authority that led to structure around unions and tribes. There was creativity in naming distinct groupings meaningfully. There was proof of togetherness and affection. There was evidence of lifelong love, dramatic uncouplings, a plethora of progeny, and violent upheaval. There was a whole lot of drama.

There was proof of togetherness and affection. There was evidence of lifelong love, dramatic uncouplings, a plethora of progeny, and violent upheaval. There was a whole lot of drama.

How Family Shapes You

The concept of family has changed, adapted, and shifted throughout the ineffable number of years people evolved on this planet. Written history provides you with more specific views into what family creates, not just new members of a family but the impact family has on its members and how family relates to shaping personalities.

It's not unusual to see behaviors between family members emerge again and again. As a photographer, so much of what you do is connect with your subjects, putting sincere effort into determining what they respond to and what makes them uncomfortable. The amount of nonverbal communication going on so very often within families is like a secret language you can tune into and use to your advantage if your goal is to set your subjects at ease. Let's see if we can't decipher a bit of it.

A considerable amount of thought has gone into the study of birth order. Your inclusion in your family in a particular sequence fashions your personality. Your relationships to siblings—or your lack of ever having siblings—is an indelible ingredient of how your character is shaped. What does it mean to be referred to as "a typical middle child" or an "only child"-type personality?

In general, the much-researched theory is more easily based on three children in the family, but it can easily be modified for two children, four children, or more.

Birth Order Comparisons

When delving into birth order, we find that the eldest child typically receives the most focused attention from the parent or parents, simply because there is no competition. This often leads to the eldest child becoming the most advanced in many areas and in charge of more responsibilities. Hence, the eldest child often feels the most pressure to succeed and feels the most responsible to others and to certain duties. The first born may resent or nurture whoever comes next but is rarely unaffected by the next addition to the family. This child is to "set the example" for future siblings. As such, firstborn children are less apt to challenge authority or limits and are more likely to tow the line.

The next eldest child tends to still receive attention but not as much as was solely given to the eldest. Whether it's true or not, second children may not be considered the smartest or the most responsible, which can have a lifelong effect on how they perceive themselves and thus on how others tend to perceive them. Accordingly, they tend to feel driven to prove their accomplishments, to act out, to stand out. If they are the middle child of a three-child family, they tend to take on the role of children who need to garner the most attention, because they are not seen as the most responsible or as the baby. Middle children has been referred to as "the lost children," not old enough for certain privileges but too old for babying, which sometimes sets them up for a lifetime of needing to be noticed.

The youngest child is often granted the most lenient of childhoods, after parents have seen that the first and then second child survive all the fears they'd had. Whereas a dropped bottle might have been boiled and sanitized for the first child, it is barely wiped off for the youngest. This child is either the most protected or the most spoiled—sometimes, the most left alone. This can often lead to a relaxed temperament in the youngest child, who can either act as the peacekeeper of the family or the affable class clown.

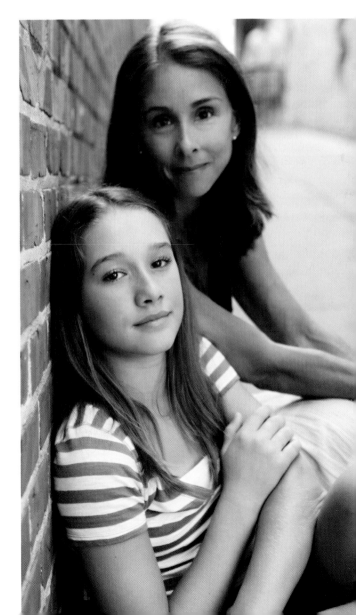

Only Children

And then there is the "only child"—one who grows up with either lots of attention or possibly hardly any at all. The "only child" is a relatively rare occurrence in the long-view history of the world. Families choosing to raise just one child became less of a rarity in the middle of the twentieth century. And, of course, a one-child-only rule has been in effect in Mainland China since 1979. Following the research on birth order, it would stand to reason that the "only child" is more similar to either the first born or the youngest child in the amount of attention the child receives. The cultural myth about only children is that they can be spoiled or maladjusted, but scientific studies show those myths to be generally

false. In fact, research shows that many only children tend to mature faster, and although they may report bouts of loneliness in their childhood, those times are often coupled with a general sense of feeling extremely important and special to their parents.

Birth Order Effects on Personality

The ramifications of birth order, or even the sequence of when adopted children join a family, play out in all kinds of intriguing ways when children reach adulthood. The responsible, more advanced firstborns tend to be leaders. The middle children, having found the role of rule follower already taken, tend to feel more comfortable shaking things up and are more likely to be innovators. The last-born children can often move into careers that support a relaxing environment. Or, less concerned with towing the line, they follow a more creative path.

Compellingly, ongoing research seems to heavily support these generalities. Vistage, an international organization of CEOs, reports that 43 percent of the people who occupy the big chair in boardrooms are firstborns, 33 percent are middle borns, and 23 percent are last borns.

And those later-born and last-born CEOs even tended to lead differently than the majority of firstborn CEOs, according to research by Ben Dattner, a professor of industrial and organizational psychology at NYU. His research uncovered that later-born children tend to make riskier choices, reinvent businesses, and pursue more innovative opportunities. The firstborn CEOs tend to lead in a more steadfast manner, making incremental improvements and ensuring that everything runs correctly.

Richard Zweigenhaft, a professor of psychology at Guilford College in Greensboro, North Carolina, revealed an overrepresentation of firstborns in the U.S. Congress. Later, he went on to conduct another birth-order study of individuals who were protesting at labor demonstrations. When individuals were arrested, he interviewed them and found a significant pattern: The majority of those who were shaking things up were later or last borns. On the occasions that the events grew unruly enough to lead to arrests, he would interview the people the police rounded up. Again and again, Zweigenhaft found that the majority were later or last borns and "a disproportionate number of them were choosing to be arrested."

Breaking from the Mold

With all the typecasting going on, how does one break out of entrenched molds and figure out who he really is before all the conditioning started? How can removing oneself from the conditioning affect a relationship with parents and siblings over time?

And, an even more relevant question: How can you, as a photographer—arguably, the most removed by far—see where your subjects are coming from and better cater to their needs?

Family conflicts occur for many reasons, but a source of much angst has to do with how different family members are from each other based on their individual experiences of being members of that family. If you better understand some of the subtle negotiations happening between family members all the time, you better know how to bring them together in a way that portrays them more fully. Because although you are trying to photograph a group of siblings, for instance, the youngest child may be cracking up and making silly faces, whereas the older one might be steaming because this wasn't how the shoot was supposed to go. Neither is "wrong"; both are just experiencing the session from a very different perspective. When you are tuned into the dynamics, you can better control the entire flow of the session.

As a child, you can experience a reality that is not at all the same as what your sister or brother is experiencing. And this can continue into adulthood, especially when it comes to looking back on a childhood and sharing memories of it. In fact, says Terri Apter, who conducted in-depth interviews with 96 sibling pairs and trios for her book, *The Sister Knot*, most sibling conflicts stem from a basic disagreement about what really happened.

Feeling misunderstood, like no one gets you, can often lead to frustration and conflict.

She states, "I discovered that there was no consensus among sisters about their shared family history." Feeling misunderstood, like no one gets you, can often lead to frustration and conflict.

Yet multiple accounts of one experience can be quite legitimate. The effect of a child's age, birth order, and personality can be so significant that it's almost like each child experiences a different childhood and a different set of parents. Throw in how parents view their children based on their own personalities and empathies they probably have regarding birth order, and relationships really get complex.

It's not uncommon to hear of the most accomplished people in the world, those who have achieved fame, fortune, and glory (or whatever else they thought would bring happiness), returning to their childhood home and once again

DID YOU KNOW?

An Average "Middle Ages" Family

Family life in the Middle Ages was quite different than it is today. Many attribute the kick-off of the Middle Ages to coincide with the fall of the Roman Empire. So, although slavery was dying out, there were still many family dwelling areas that included those who worked for the family and the family trade.

Although the general concept of children living with their mother and father was the original living arrangement in medieval European families, many suddenly "defunct" family lines forced new families to be created. Children often ended up living with other relatives, neighbors, or sometimes just an older brother or sister, simply because one or both parents died before the children reached adulthood. In addition, it was rare for children to know their grandparents, who had often passed before they were born. The average life expectancy of a common citizen during this time was approximately

30 years old due to a variety of reasons: poor sanitation, lack of medication, poor diet, rampant disease, and the sheer danger of everyday living during this time period.

Schooling wasn't a common option. Children worked in the fields or cared for the home or members of the family. In wealthier families, children might become educated through opportunities to live in monasteries or abbeys.

The normal age to start working outside of the home was around 12 or 13 years of age, and it would usually mean working for a neighbor or as an apprentice. Becoming apprenticed to learn a skill, such as blacksmithing or craftsmanship, was a standard route to being able to afford the privilege of having a family someday.

Source: Linda E. Mitchell, *Family Life in The Middle Ages (Family Life through History)* (Greenwood, 2007).

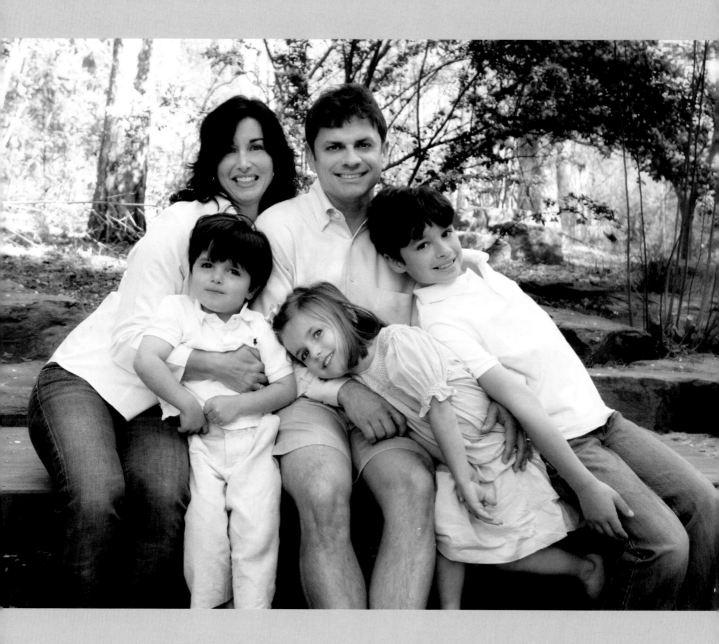

feeling familiar insecurities, fears, and frustrations. Suddenly, none of their accomplishments matter: They are 12 years old again and still the controlling/checked-out/annoying one. It's as if they are suddenly no more or no less than they always were perceived, as if their entire adult life had just been an attempt to escape the inescapable.

Family dynamics are a strange force. Understanding them and consciously bringing that empathy into each of your shooting sessions will improve each photograph you capture from that experience.

What Makes a Family Today?

Currently, the "nuclear family" model is in the minority. We've seen tremendous shifts in family structure just in the last 50 years. The modern family—or the postmodern family—exists in great variability today. Common structures that always existed but are now more prevalent and more accepted include single-parent families, same-sex parent families, divorced and remarried couples and half and step siblings, unmarried parents, child-free couples who may choose to only raise pets, and grandparents raising grandchildren with or without parents in the household. International adoption has also become significantly more visible with many families raising children from several different countries in one family unit.

The role of marriage in society has changed considerably. If, according to the National Center for Health Statistics, there are about 2,077,000 marriages in the United States each year, the marriage rate is 6.8 per

1,000 people. But the divorce rate is 3.4 per 1,000 population, which is keeping pace with about a 50 percent divorce rate in this country.

Divorce has had an effect on how people view marriage. When individuals do choose to marry, they are doing it at a later age than ever before, often citing as a reason the higher divorce rate for those marrying at a younger age. In addition, more individuals are choosing to not marry at all and no longer see being unmarried as a barrier to "having a family."

Current information from the U.S. Census Bureau shows that the "traditional nuclear family" model only exists in 24 percent of American households. Although 70 percent of children in the United States, for example, live in two-parent families, 66 percent of those live with parents who are married and 60 percent live with their biological parents. Roughly two-thirds of all children in the United States will spend at least some of their lives in a single-parent household.

The bottom line is, as much as the idea of family is adjusting rapidly, much of what is true doesn't change: The meaning and significance of family is core to how everyone defines themselves. Most people trace the roots of their personal identity back, in large part, to their experience of being part of a family or their lack of experience of ever being able to have one. Get that—really get that—and you hold the key to unlocking a real connection with the families you photograph.

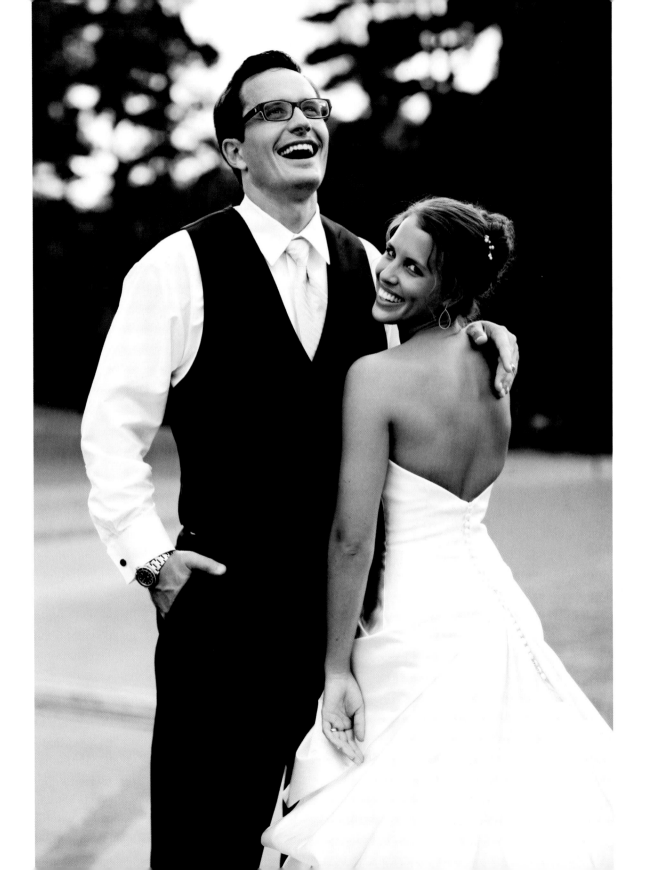

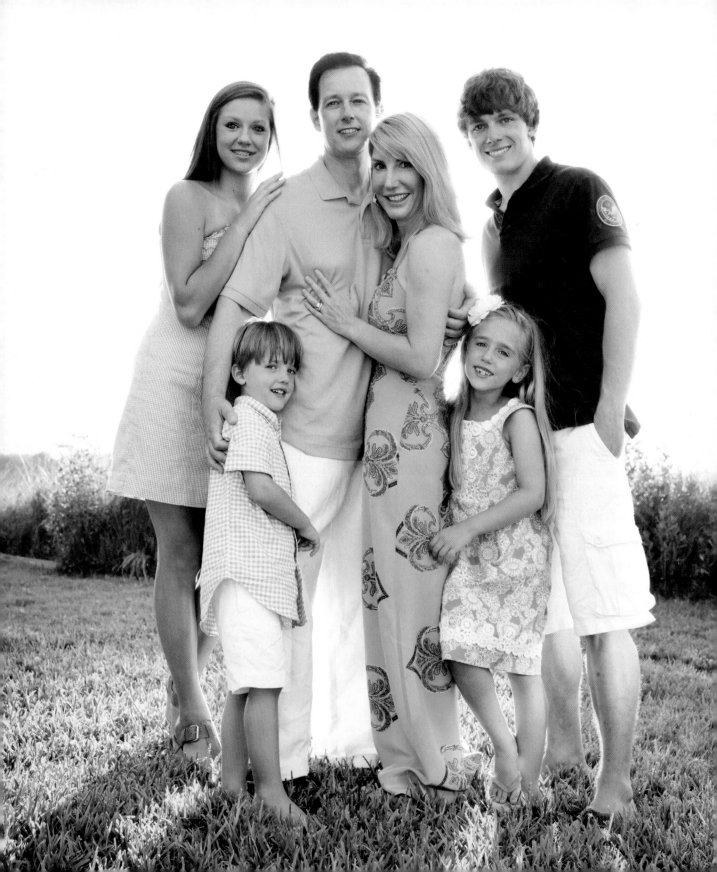

Waiting on a Family

Call it a clan, call it a network,
call it a tribe, call it a family:
Whatever you call it, whoever
you are, you need one.
—Jane Howard

TO PUT THE CONCEPT AND MEANING of family into perspective, it's valuable to recognize what you, the photographer, are most looking to capture when photographing families. I wasn't quite sure what this was for the first several years I was shooting besides knowing I wanted to capture a strong likeness of everybody together in a natural way. It was by experiencing the lives of those who do not have a family—who learn family as a theory first before hopefully understanding it in practice later—that I was able to better appreciate the underlying connection between individuals in a family. There are few concepts as intangible and yet compelling as the sheer significance of what it means to someone to feel like they belong somewhere, and especially to *someone* somewhere. Between the time I spent in orphanages and the act of building my own family, I was surprised to learn a dramatic lesson: Looking for and photographing the belonging in a family is one of the most important things you can do when creating a truly moving photograph of who they are, together.

The Baby Room

After a 28-hour flight to Ethiopia, we were a bit disoriented but still needed to wait for luggage, go through customs, and become accustomed to the sounds, smells, and sights of Africa. Whisked straight to the orphanage, we were one of three sets of couples who all had joined the flight on a layover through Washington, D.C. We'd never met each other before, but each of us were about to meet our new children. It was about 10 P.M. local time when we walked through the doors of the sparsely furnished but airy home in Addis Ababa. Thirty children were staying there at the time—often many more, but rarely less. They were all staying in different rooms, usually about four to six per room. The baby room, however, stood apart. As our driver led us into a room with cribs upon cribs, he flipped the light switch and a harsh fluorescent light filled the room. Where they'd been silent before, several little bundles started to cry in shocked protest.

I happened to be in the front of this little parade of tentative Americans. Our driver smiled at me—a beautiful, confident, loving smile—and then said, "Yes, this one!" He leaned forward, picked up one of the crying bundles, and handed it to me. "Yours!"

Yes, this one! Yours!

Preparing for Our Son

Back home in Chapel Hill, North Carolina, our daughter Sophie was waiting for news. When she'd turned 2 1/2 years old, we thought it'd be a great idea to adopt our second child and then go back to the biological route for our third child. My husband had been adopted, as had his sister. Adopting a child was just always something we knew we wanted to do. As we moved further through the process, Sophie fell in love with the idea of adoption and was as involved as we were in choosing a country.

We'd selected Ethiopia because we'd traveled through Africa before, we knew of the unfathomable number of orphans who waited for families, and we were simply drawn to the culture.

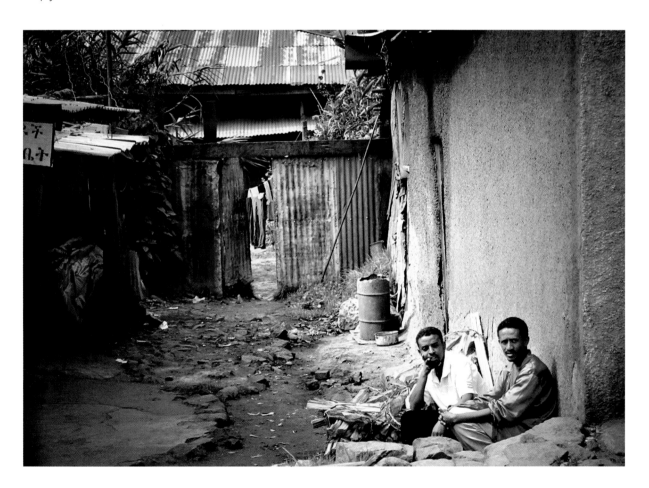

On August 1, 2003, we'd filled out the initial request for information and marched down to the mailbox, lifting the flag with delight so that our letter would be collected. Exactly five months later, on January 1, 2004, we stepped off the plane in North Carolina with our son in hand.

Ah, but I've skipped ahead.

Although we hadn't discussed protocol, how exactly we would meet our nine-month-old baby when we arrived at the orphanage, I believe I must have expected something a bit more ceremonious. We'd received his photographs, we'd read everything the orphanage could share with us, and we'd chosen his name. I'd dreamed of him repeatedly. In my dream he was looking up at me with his almond-shaped brown eyes and softly cooing, the same eyes that were peeking out from behind the bottle in the photograph that was sent to us.

Waiting for the Attachment to Kick In

In reality, while holding my son for the first 45 minutes, he didn't look up at me at all. And instead of cooing, he was totally, piercingly screaming. My thoughts as I held my son were a constant rotation of four questions.

Are they sure this is him?

The baby I held seemed to be rather haphazardly plucked from his crib. I was the person closest to the plucker, and I couldn't remember telling the driver my name. Also, no name tags appeared on the cribs.

Is this even a him?

As for the gender question, I would later find out that it wasn't uncommon to dress the children in whatever clothes came out of the dryer, which helped to explain why my son was wearing a red and yellow dress when he was handed to me.

Are we bonding yet?

I didn't feel like he'd always been mine; it didn't feel like he'd been waiting for me. There was no burst of profound "in-loveness" happening. As my husband peeked in to look at him and then crept back so I could have my time with my son, or what on earth, daughter? I waited for the feeling of attachment to go ahead and kick in.

And then we saw his face light up with a smile for the first time. It was transformative, that smile.

How do I get him to stop crying?

(I really wanted him to stop crying.)

After what seemed like an eternity, one of the caretakers stepped up and handed me a bottle of milk. I popped it into his wide-open mouth, and he immediately started drinking. I too wanted a drink, but I was thinking of something stronger than milk. The silence fell all around me, and it all suddenly—very suddenly—felt wonderful. For the first time, I could focus on looking at him. My husband and I sat on the floor, backs to the baby room wall, and watched his face as he drained the bottle; we also watched his expression change considerably. He looked content, sleepy. I recognized him from his photographs, and yes, I admit, I double-checked the underparts: Not only was he a boy, but he was our son, our Caleb. I spoke to him softly and tickled his side a bit. And then we saw his face light up with a smile for the first time. It was transformative, that smile. It changed his whole expression, it drew us in, and it turned us from parents of an only child into a mommy and daddy of two.

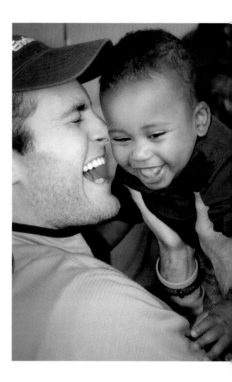

Breaking Down the Need

Some of the statistics in Ethiopia seem unbearable to process. As I looked out at the room of cribs, the despairing thought washed over me, "all these motherless babies." They hadn't always been motherless, of course. But, whatever the reason, they most certainly were now.

We'd read all the statistics before going to Ethiopia. As one of the four poorest countries in the world, the annual per capita income was less than $160, nearly half the population lived below the poverty line, and about 85 percent of the country's population lived in rural areas, working in agriculture. Regardless of specific experience, one of out every ten children in the country die before their first birthday; one in six before their fifth birthday. Malnutrition was and still is the underlying cause of more than half of those deaths. The situation isn't much better for mothers—25 percent of mothers die in childbirth or from a pregnancy-related illness.

And if extreme poverty, famine, conflict, and risky childbirth aren't enough to contend with, there's HIV/AIDS. More than 60 percent of all people in the world with HIV live in Sub-Saharan Africa, and there's an estimated one million AIDS orphans in Ethiopia today. Factor back in all those other risks, and according to UNICEF, with an estimated 83 million people living in Ethiopia—a country the size of Texas—4.6 million of them are orphaned children.

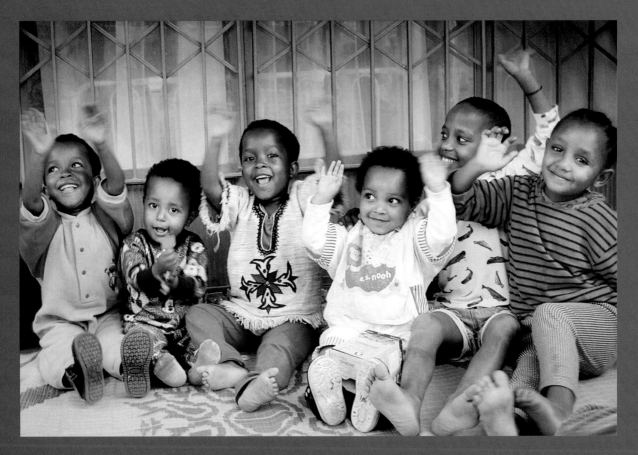

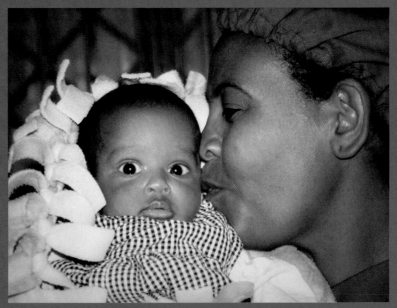

Reading statistics is one thing, but looking into eyes that crinkle with delight at the warmth of snuggling up with you is quite another. The very act of experiencing individuals in other cultures is what often transforms a person from an empathetic spectator to an active participant. It's no longer a matter of being moved by the needs of others; you feel your own needs being met by these new relationships. Any thought of adopting to do a "good deed" goes out the window. You realize that this is also a selfish act because it fulfills a need you always had: to find connection in this world and to find, surprisingly, that it doesn't need to be anywhere near your part of the world. Nor does it have to have anything to do with your genetics.

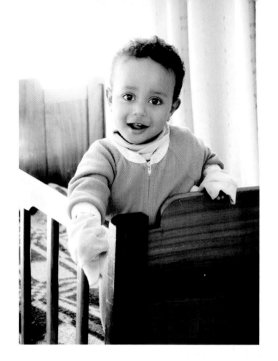

After a week in the orphanage, we knew that we'd likely be adopting again. It was truly heartbreaking to pull our son away from everything he'd ever known, but we were looking forward to being together as a family in our home—a sensation that is by no means limited to those who have a family and a home.

Seeing the Belonging

When we returned to the United States, we realized we were now part of something greater—increasingly more accepted groupings and new networks: They included families who'd adopted, families whose core members were of various races, and interracial couples who knew what it felt like to look different from those you loved, even though you felt the same. As part of this growing community of diverse families, I started recognizing something different in my family portraits, too.

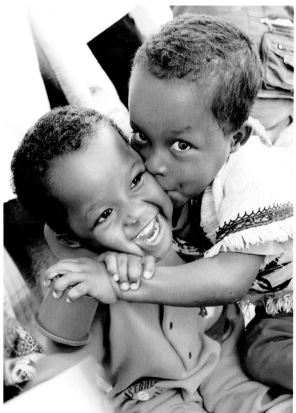

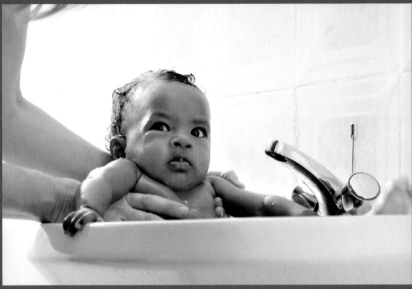

I was looking at faces, expressions, and relationships, and I was looking for the belonging.

Yes, I was still looking to capture the family as a whole while showcasing individual personalities, but I was also seeking something new in my work. I was looking for—and finding—the invisible glue that I hadn't known to seek out before: the sense of how various members of a family belong to each other.

I was looking at faces, expressions, and relationships, and I was looking for the belonging. And although belonging may sometimes be laced with frustration, confusion, and all those other messy family dynamics, I still found it every time: You're mine, I'm yours, you have my back, I have yours; this may not be all I am, but you're in the core of me now and always will be.

Adopting in Ecuador

In October 2008, we again boarded a plane with the intention of adopting a second time. But this time, the four of us were traveling together—my husband, my seven-year-old daughter Sophie, and my five-year-old son Caleb. It was a shorter trip to Cuenca, Ecuador by way of Miami, Florida, and Guayaquil, Ecuador. We were on our way to meet "our" 3 1/2 year-old little girl who had been brought into the orphanage at the ripe old age of five days old by a woman who said

that she'd been handed to her by the grandmother. She would offer no further information than that.

Why did we choose Ecuador? I can easily say now that we went to Ecuador because that's where our daughter was. But before we'd met her, we couldn't say that yet, could we? There were a few jumbled, vague reasons. But partially, it was because we knew there was a great deal of need in that country. And partially, it was because we'd learned that Ecuador was one of the hardest countries in the world to adopt from due to the difficulty of the process.

Working Through the Adoption Process

We learned that we could not adopt a child under the age of three years old. As a mandate, the country must exhaust all efforts to find a biological tie to the child before the child can become eligible for adoption, which takes a minimum of three years. We'd been told that we'd have to live in-country for at least six weeks to ensure that the adoption was completed. And we would come to understand that part of why we were experiencing a long, drawn-out acceptance process was because all of the adoption committee members had to decide on which coffee shop to meet at that month. Sometimes they'd skip a few months until they agreed.

Combine all the obstacles, and it's easy to see why most people don't adopt children from Ecuador. But we knew we were open to an "older" child; we knew we could manage to work remotely throughout the course of the adoption process. And I could personally attest to how important coffee could be in a person's life.

In the end, we moved forward in our adoption from Ecuador with a clearer idea of why we could handle it versus an explicit purpose as to why we had selected it. Sometimes we can't always explain why we're drawn to what we are. We just feel the pull.

Adopting Ana Elisa introduced us to a very unique process. The entire adoption took 19 months, not the five months it had taken with our son. Adopting a 3 1/2 year old who speaks a language you do not—and who does not know the language you speak—is an experience unto itself. And when your brand-new daughter doesn't sleep through the night for weeks and won't let go of you that entire time, or let anyone else touch you, or won't go to anyone else, it can be an exhausting experience. I often summarize our time in Ecuador as beautiful, yes, but also quite challenging.

Introducing Ana Elisa

The day after we finally received the last official acceptance and had our visa in hand to travel back to the United States, nearly seven weeks after we'd arrived in Ecuador, I wrote an announcement about the formal adoption. Here is a modified version of that post:

I am so unbelievably proud to announce the formal completion of our adoption of Ana Elisa Anita Maria (Vasquez Sarmiento) Lackey.

You know that feeling after you finish an event of some great physical endurance, which to some might mean surviving a holiday with extended family, competing in a 5K race, crossing the finish line of a marathon, or crossing the expanse of the Sahara Desert? Immediately afterwards, you know you'll be having that whole flood of realization; of accomplishment; of specific, separate feelings. But at that moment, right at the you-are-done finish, you are simply tired and just a bit overcome.

Receiving Ana Elisa's exit visa as it was slipped under the bullet-proof window at the U.S. Embassy, wow. I double-checked the pertinent details; I so did not want a problem getting back home via Miami. As I held the visa and passport with one hand, and my officially new-daughter's hand with my other, I was flooded with such an immensely powerful rush of emotion. All was correct. All was complete.

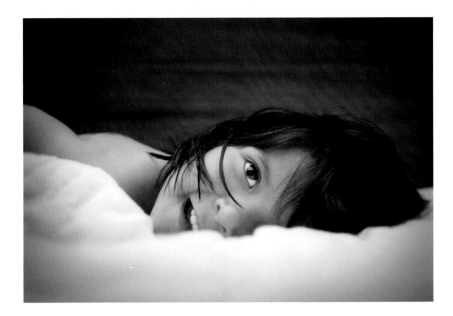

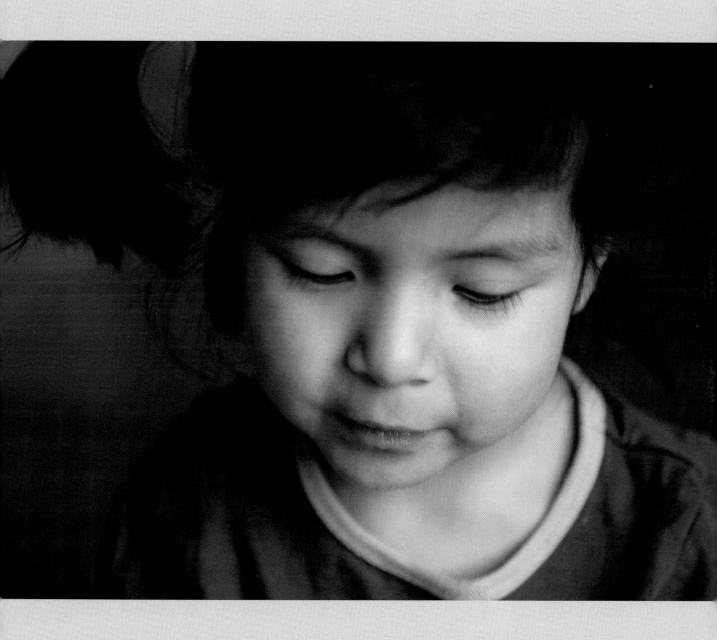

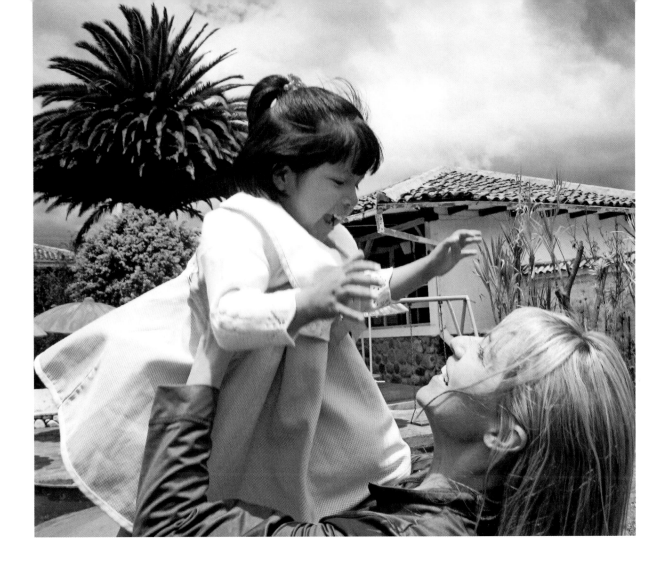

Realizing that everything was done, I immediately swooped her up and just held her to me tightly, feeling the sting of my eyes filling up with those sharp tears of relief.

We gathered everyone together and walked out past the security checkpoints, past the graffitied walls, and past the curious looks into the bright sunlight, sticky heat, and dirty smog. I didn't care who thought what. Once we got out, I just buried my face into her little neck and squeezed her to me snugly.

I was so proud, so thrilled, so in love, so relieved, and so all-the-way-to-the-bottom-of-my-heart happy to introduce our new daughter, Ana Elisa.

If she looks different in many images, you've gotten a great look at our daughter. Depending on the angle, her clothing, her mood, or her hair, she can look very different. She is often a beautiful surprise.

About the Orphanage

We've been asked about the orphanage many times. What struck me first, more than anything, was that it was an exceptionally caring place. Not a great deal of luxury. Definitely not. But certainly you could see a great deal of affection and love.

So many wonderful people work at the orphanage: the sweet-smiling nuns who run it, all the individuals who care for so many children day in and day out—a huge job—and the volunteers! Lots of volunteers give their time—and so much of their hearts—staying in Ecuador for short stints or moving there for months or even years. Visiting the orphanage almost every day, they do what they can to make the lives of the children better.

Because of the sheer amount of work of caring for so many children, the children are kept on a strict schedule. As it was explained to us, they had one hour of free play, and Ana Elisa spent about 13 hours a day in her crib. All other times they were confined to their rooms and these small outside areas, which were located just off the bedrooms they shared, fenced in to ensure that they would not wander off and get hurt.

How these children need homes, families, and their very own Mami.

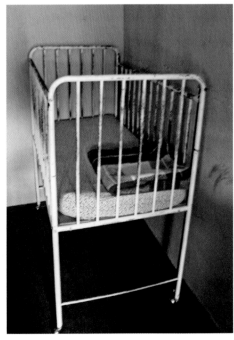

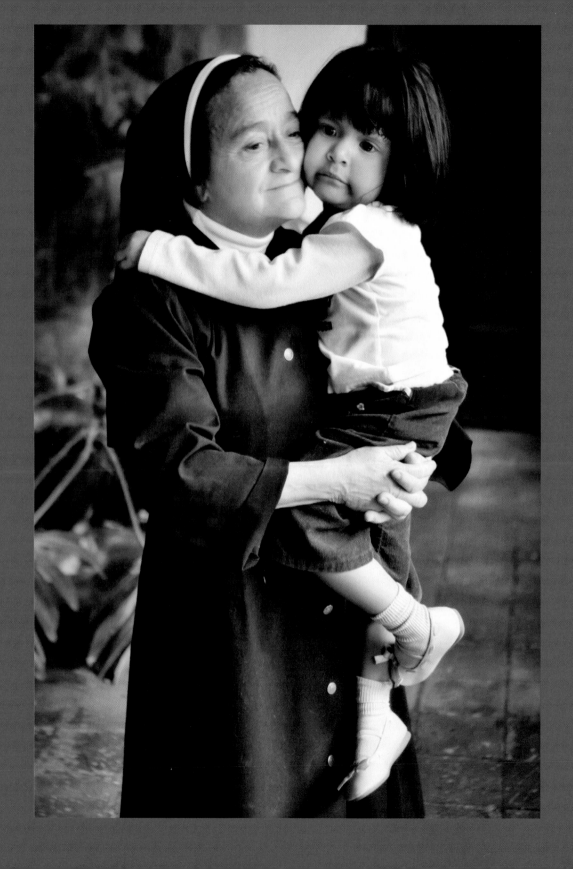

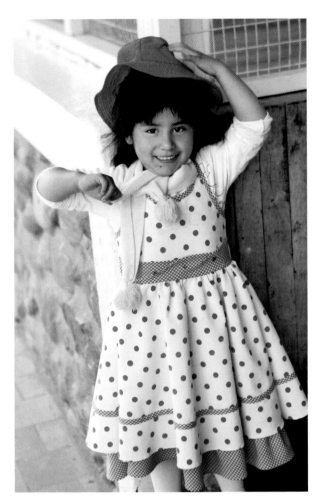

Beautiful, beautiful children live in this one orphanage (one of so many around the world, as I mentioned earlier, about 150 million orphans worldwide). Children who are alive, yes. Children who learn and grow, and find a way to find their way, but who mostly just wait.

When Ana Elisa walked past the pens with me, children cried out and she guarded me fiercely, "Mi Mami, Mi Mami!" I looked at all of them as we walked past. How these children need homes, families, and their very own Mami. It is not difficult to feel yourself buckling at that. The need.

We were lucky enough to take Ana Elisa back to the home in which were staying the day after we met her, an exceptionally fast release from the orphanage. The orphanage called us a couple of days later, asking us to bring her in to say goodbye to the other children and the Mother Superior of the orphanage. It was a heart-wrenching experience for everyone.

DID YOU KNOW?

The Number of Adoptions Have Fluctuated Quite a Lot Over Time

For a variety of societal and economic reasons, there have been dramatic fluctuations in the annual number of adoptions in the United States. They skyrocketed from a low of 50,000 in 1944 to a high of 175,000 in 1970. In 1992, there were almost 127,000 annual adoptions in the United States. The trend has continued to shift, with the incidence of adoptions steadily rising for years and then falling again with recent Hague Treaty–related delays in the United States and abroad.

Sources: Maza, Penny. Adoption Trends: 1944–1975, at Table 1, Child Welfare Research Notes, No. 9 (Aug 1994) and Flango, Victor, and Carol Flango. How Many Children Were Adopted in 1992, pg. 1022, Child Welfare, Vol. LXXIV, No. 5 (Sept–Oct 1995).

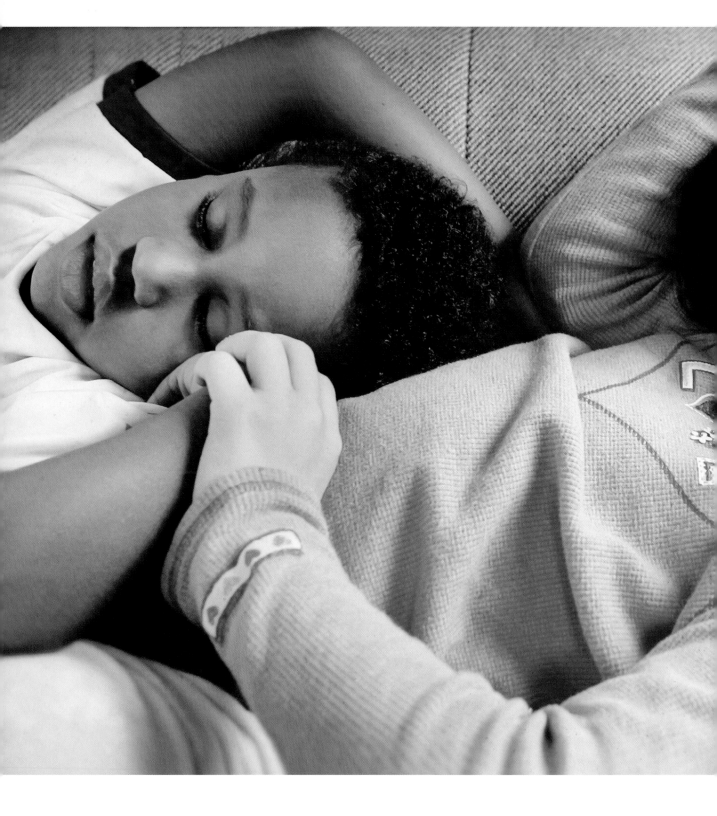

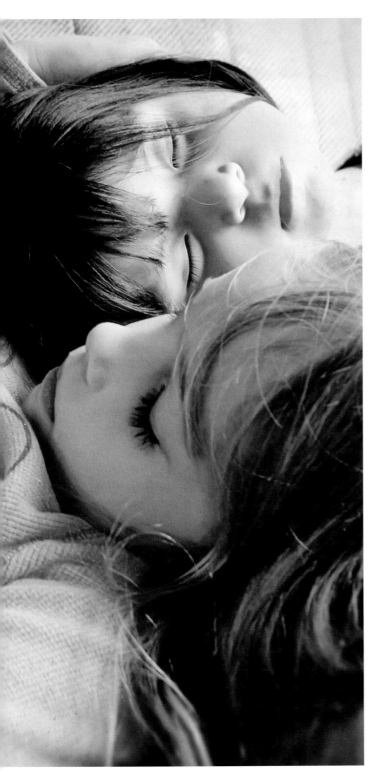

So, the end of a journey. And, of course, a new beginning. I've never had an answer to this oft-asked question before, but, finally, I do. My absolute favorite photograph of all time shows the power of what family can be.

To Have and To Have Lost

We know that photographs freeze time for us. Everything as it is right now will forever be immortalized because we created a photograph of it. And, like bona fide antiques, photographs only grow in value as time moves us all forward, and away. No matter what we do, we cannot make everything as it is currently remain as it is right now, yet having that one image at least allows us something similar. But losing treasured photos is akin to having it all taken away—every last bit.

On May 22, 2011, a tornado hit Joplin, Missouri. Not just a regular twister but a devastating multiple-vortex tornado that was actually categorized as an EF5, which is the worst kind of tornado on record. Wind speeds hit an unfathomable 250 miles per hour. Even worse, the width of this racing deadly force was confirmed to be in excess of one mile across.

It was the deadliest tornado to hit the United States in over 60 years, and it caused more than three billion dollars in damage. Even more difficult to truly process is that the Joplin Tornado took the lives of 158 people with its catastrophic force, leaving another 1,300 listed as simply "missing." It would take a significant amount of manpower, money, and caring to find the missing, to heal the hurt, and to even fathom how to begin to rebuild.

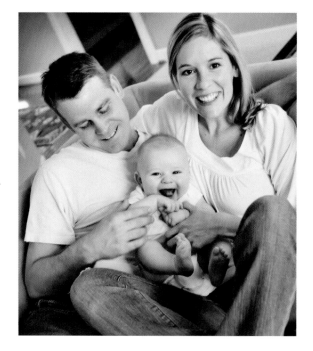

But, as the *Los Angeles Times* reported on May 27, 2011:

For the storm survivors who have lost everything, insurance and federal aid money will soon pour in to help replace their smashed vehicles and the piles of tinder and brick that used to be their homes. But there's no safety net to replace the photos and souvenirs that fill up a life—the personal memorabilia that say what someone's done, where someone's been, who someone is...

Found, a wrinkled black-and-white, stolen by the wind and dropped into a stranger's yard: a young woman in a dress relaxing in the grass, silhouetted gently against the light, sitting close to a smiling baby boy on some sunny day that must have passed more than half a century ago.

Even though many of the victims of the Joplin tornado were relieved to have lost photographs returned, they knew they were receiving back photographs of families they would no longer ever be. Some family members were gone; others gravely injured. Many family homes had all but disappeared. Certainly, their hometown, as they'd always known it, had been altered radically. Sections of Joplin, Missouri, had been completely decimated.

The effort to return found photographs stemmed from a desire to help, to do something, to assist in piecing back together lives that were indelibly changed. It was understood that photographs of times, people, and places that have passed are simply irreplaceable.

Why Family Photography Matters: A Case for Redefining the Genre

After spending time in orphanages and better recognizing the pain of loss, I saw major change in the focus of my work. My interest in family photography increased significantly. Whereas before I had been primarily focused on children's photography, I felt a shift, an opening, in looking at these larger groups and finding a new beauty in their togetherness. That may sound odd to those who think the genre is simply "children and family portraiture," but in my experience, most photographers don't feel the same excitement for "family photography" as they do for children's photography. It's as if they will go ahead and do family photography because it comes part and parcel of the job. When it comes to photographing children, though, that is the work they hone in on. There's a passion around capturing great portraits of kids, couples, individuals, and even one parent with one child, or siblings together. But hauling everyone in the family together is another job entirely. As a workshop participant once said to me, "I love to photograph the kids. If I absolutely have to, I'll photograph the adults that come with them."

I must admit that I too used to think of the family photograph as something I "knocked out" so I could focus on the good stuff, the stand-alone children's portraits. However, all of that changed as I started to really think about what family means and what family photography could convey, especially when done well.

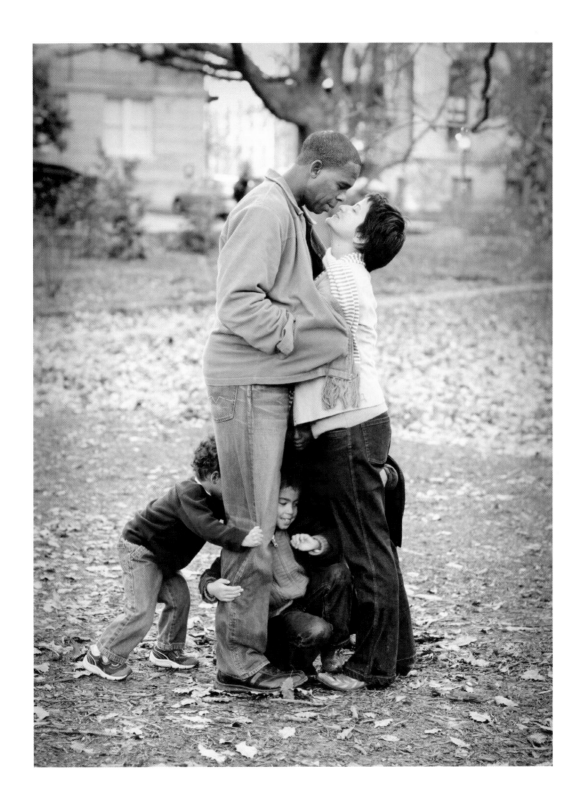

Gearing Up

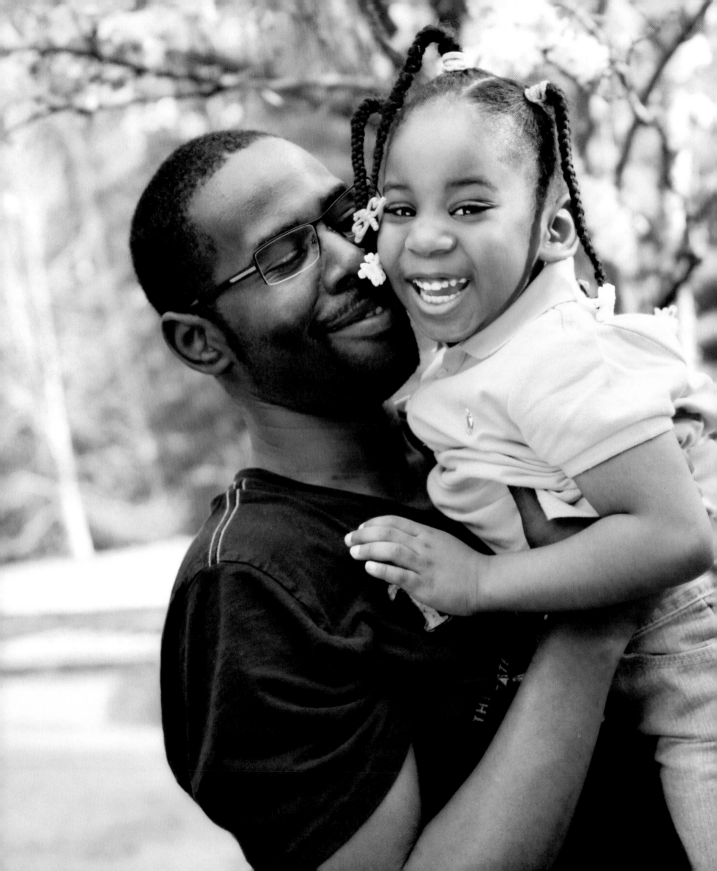

The Overall Kit: What's in the Bag

Never forget that all the great photographs in history were made with more primitive camera equipment than you currently own.
—Brooks Jensen

Which lenses you need is based on the kinds of photos you are shooting, the subject matter, and the location at which you choose to do the session.

ALTHOUGH IT IS QUITE TRUE that the best photographs you capture will be a result of your unique vision, how you see the world, and how you interact with your subjects, it's still critical to ensure that you actually have equipment you need when it comes time to photograph your *next* most phenomenal shot of all time. In this chapter, I'll walk you through all the options at your disposal and suggest some proven ways to keep everything organized. One of the chief methods for ensuring that gear becomes less of an everyday thought—and more of a mechanism for capturing what you envision—is to know your equipment well.

Preparing for the Shoot

Few things in photography feel worse than when you thought you had everything you needed, believed you were prepared, showed up for the shoot, and then found out you were missing something crucial. It might have been a battery or a memory card. Hopefully, it wasn't a camera. What is more likely, however, is that you leave behind a lens, a light, or a reflector, something that would improve the look and feel of your photographs. Of course, improvisation is a great skill, but being truly prepared is a much better way to enjoy your work and to ensure you showcase your talents as well as possible.

It's important to make the process of getting ready for a shoot into good habits that include checking lists you create but to also have a flow of how you prepare that works for you. You want to walk out the door and into your shoot with a bag either on your shoulder or rolling behind you, and actually *feel* as confident as you want to be perceived.

Packing Your Bag

Everyone organizes their gear differently according to how their own brain works. But the important aspect is that you organize your equipment. Your cameras, lenses, and memory cards will be safest if they have their own sections in your camera bags. You don't want to waste time—and the opportunity to grab some great shots—because you are searching around for what you need. Decide how you want to set up your gear in your bag and keep the same routine until you determine that you want or need to change it. As much as it's wonderful to be creative and spontaneous, having some sort of system for storage can save you more time than you know.

When you're actually getting all your gear together, pack the big items first, especially the essential big items. Start with camera bodies and lenses. Then pack the accessories, such as flashes, batteries, lens cloths, and filters. Ensure that your batteries are charged and that the memory cards you need are clean, safely cleared of earlier data, and formatted for new photographs.

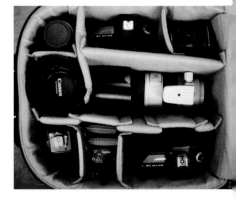

Choosing Lenses

Which lenses you need is based on the kinds of photos you are shooting, the subject matter, and the location at which you choose to do the session. It's incredibly helpful to bring more than one lens, just in case you decide to change the angle or play with a different look.

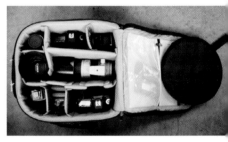

Wide-angle lens

When photographing families, a wide-angle lens can be quite useful, especially if you don't have a lot of room to shoot a large group. Because more of what you see is included in the frame, you are often better able to showcase a more panoramic angle when shooting with a wide-angle lens. If you choose to shoot with an extended field of sharpness, the subject and the background all become active parts of the image, which can lead to some very interesting photographs.

Wide-angle lenses are typically defined (on a full-frame 35mm camera) as any lens that is less than or equal to the 35mm focal length—most commonly, the 35mm and the 24mm. Under 24mm, you start dipping into the ultra-wide-angle lenses, all the way down to a 10mm lens. One well-known ultra-wide-angle lens is referred to as the *fisheye* lens, which produces more distorted views.

A cautionary note about photographing with wide-angle lenses: Keep the distortion tendencies of the lens in mind when considering how attractively you want to photograph your subjects. If you move in too closely with a wide-angle lens, you can create significant distortion—noses look larger, ears appear to be teeny tiny, and hands look out of proportion to the bodies they are attached to, especially when those hands are shown as close to the lens. When photographing a large group, pay close attention to who is in the middle and those on the edges of your grouping. Those in the middle of the image will look "normal," and those on the edges of the frame can look "wider." Widerville is not a place many people want to find themselves when they're looking at the photograph later.

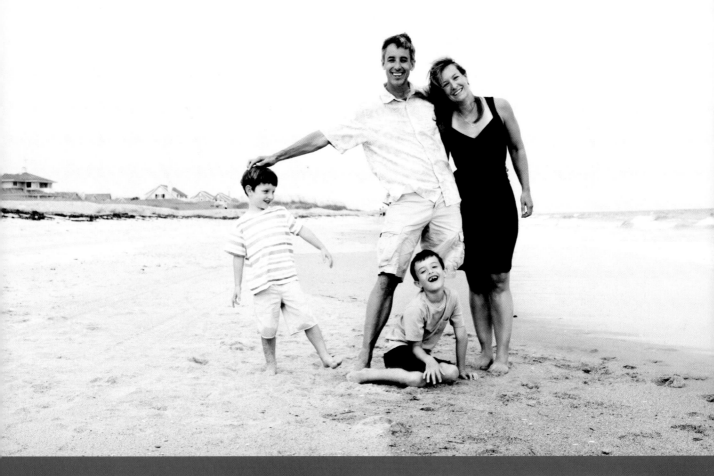
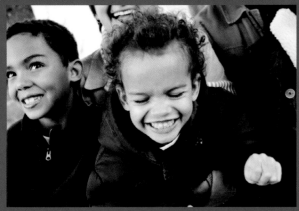
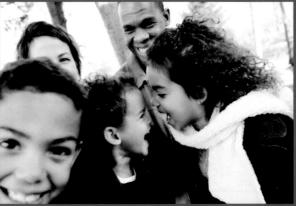

Standard lens

A standard, or normal, lens has the most "natural" view, the most undistorted angle of the subject matter, because it is pretty much the same angle of view as the human eye. What you see is what you get with the standard lens, which some may find reassuring and others may find disappointing. I find the standard lens a more challenging one to use when my focus is on creating artistic, compelling, creative images. When it comes to photographing portraits with a standard lens, I really need to step back and think about determining what kind of distance I need from my subjects; how to create a wide depth of field that doesn't interfere with a sharp, high-contrast image; and how to bring forth a unique look. It doesn't come easily to me. That said, I know plenty of amazing photographers who absolutely love their 50mm lens, which is a pretty standard focal length for the standard lens. Any lens between 40mm and 58mm is considered to be within the "normal" lens range.

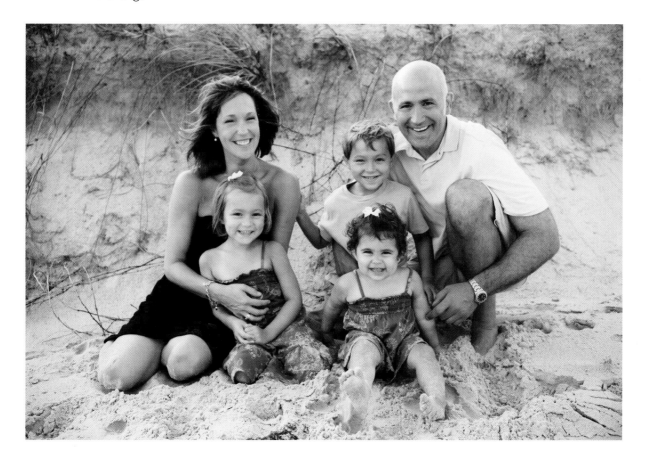

Portrait lens

A portrait lens, especially when utilized at a distance from your subjects, is ideal for spotlighting individuals or smaller groupings. It's interesting what is considered a portrait lens today, because times—and shooting styles—have changed. A portrait lens used to be in the 100mm range, but now it is acceptable to refer to a portrait lens as one just over the 50mm range and up to 200mm or more. I consider my 85mm 1.2 lens my portrait lens. One of the most significant attributes of a strong portrait lens is that you are able to isolate your subjects from the background utilizing a shallow depth of field and a wide aperture. And a good rule of thumb to consider when photographing an undistorted portrait is to stand at least 12–15 feet away from your subject to achieve realistic proportions of their facial features. The distance of the lens to the subject matters because of the factor of perspective compression: The closer you are to your subjects, the more distorted their facial features can be (those bigger noses and smaller ears); the farther you are from your subjects, the more their features "flatten" and become less realistic in proportion to the other parts of their faces (e.g., those highly unflattering photographs of celebrities shot from a near-mile away).

Telephoto lens

A telephoto lens used with considerable distance from your subject delivers the strongest emphasis on perspective compression, as well as the opportunity to capture a very shallow depth of field and a noticeably strong separation of subject from background. The job of the telephoto lens is to visually compress distant objects so they don't appear too far away, which is the reason you get a more impactful image of a full moon when shot with a telephoto lens versus a standard lens, for instance. Although telephoto lenses are quite commonly used in sports and wildlife photography, they can offer a striking artistic advantage when used well for photographing portraits. The upside is that you can really maximize the lovely look of bokeh and enhance the dreamy quality of a family portrait through this distinct narrow angle of view (which means you can be quite selective about what you choose to include in the frame); the downside is that you have to shoot from quite far away, and you may want to consider whether or not you want to draw that far back from interacting with your subjects. Shooting from a distance isn't always a bad thing. If you want to shoot with a very narrow aperture and keep your subjects close to a background, you can bypass the bokeh but still have the advantage of shooting from quite a distance,

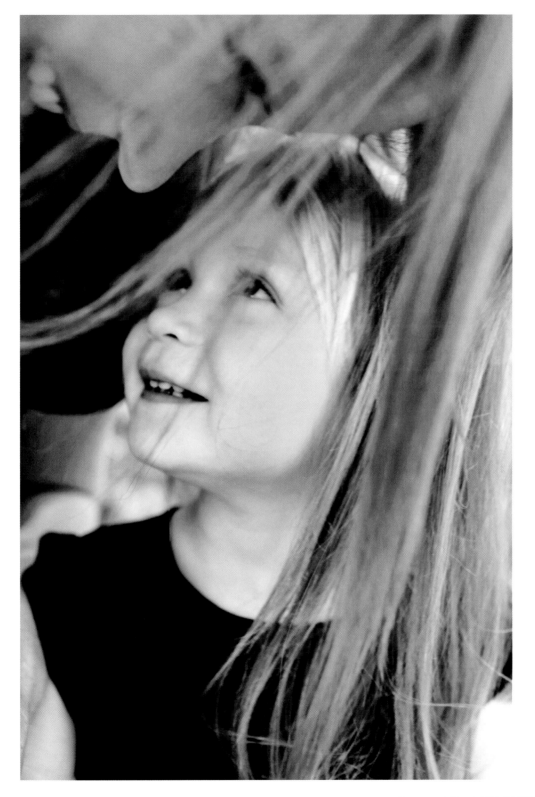

such as across a pond or from a bridge, which often allows you great flexibility in terms of vantage point. Most telephoto lenses are between 200mm and 600mm.

Whew. That's a lot of information about lenses. But, wait! We're not finished! There is even more lens information coming your way soon. But I can defend the onslaught of information by stating, quite unequivocally, that it's rather crucial to know how lenses work, what they can produce, the best way to select between them based on the look and feel you're going for, and the options you have overall.

What's in My (Camera) Bag and Why

So what, exactly, do I carry in my bag when I head out for a family portrait session?

Cameras

I start packing my cameras first. Currently, I shoot with two 5D Mark IIs, and I keep my 1D Mark II close by as a backup when needed. Because I go out to shoots with two cameras, I ensure that they are both set up with matching custom settings. This can be key when it comes to pulling all my images together later. If the images are shot with different color profiles, levels of sharpening or contrast, or any other of the many ways you can customize your shooting style, it makes for a heck of a time trying to match the images when you get to postprocessing.

I like to shoot with two cameras for two reasons: for additional security (I've had cameras just fail on me, or lock up, or not allow me to change my aperture) and the ease with which I can switch back and forth between two lenses mounted to two separate cameras that are both on me and easy to move between. When it comes to photographing families and the fast-moving humans who tend to populate them, I need to be able to shave off any seconds I can while securing the camera and lens in place, positioning myself correctly, and setting the proper exposure for the shot I'm about to take, which is happening *at that moment*. If the best lens for what's immediately in front of me is in my camera bag, or

even my lens bag, and I need to take a full 30 seconds to change lenses, I'll most likely have missed the moment.

The cameras you pack should be accompanied by fully charged batteries and fully charged backup batteries. If I'm going on a long shoot and know that the battery life of the batteries I have with me is sufficient, I will *still* bring a battery charger and leave it in the car along with the third camera. I've seen supposedly full batteries drain rapidly with no explanation. So I bring backup batteries and a charger, just in case.

Knowing your camera

Each photographer has a favorite camera, but what is most important is that you know how to use all of those customizable functions I referred to earlier—the ones that help you modify the camera to shoot closely to the

Courtney Ortiz

DID YOU KNOW?

Camera Manufacturer Names

Camera manufacturers got their names from somewhere. Here are how a few camera names came about:

- **Nikon.** The original name for Nikon was Nippon Kogaku, meaning "Japanese Optical." The company was formed in 1917, and its name was later changed to Nikon.

- **Canon.** The original name for Canon cameras was "Kwanon," the Buddhist god of mercy. The first Kwanon camera was built in a small Tokyo workshop in 1934, a prototype for Japan's first-ever 35mm camera with a focal plane shutter. The name was later changed to Canon in 1935, rumored in part to avoid offending religious groups.

- **Fuji.** The name of Fuji is simply taken from the name of the highest mountain in Japan, Mount Fuji.

- **Leica.** Ernst Leitz started making lenses for microscopes and telescopes in 1849, and it wasn't until 1911 when Oskar Barnack joined the Leitz firm that it made its first camera. It was going to be called LECA until someone suggested that LEICA (LEItz CAmera) sounded better. The name stuck.

- **Mamiya.** The name was taken directly from the surname of the inventor of the camera, Seiichi Mamiya.

Sources: Nikon, Canon, Fuji, Leica, Mamiya

> *Get to know your camera's functions and modify them to your preferences.*

look you have defined as your style. More than a few photographers will just unpack a brand-new camera and start shooting without even recognizing that it is still set to generic factory settings. Consider whether you want the camera to boost sharpening on your images, or whether you'd prefer to do this afterwards in postprocessing, or whether you'd rather not do this at all. Explore whether you prefer a certain standard picture style to be a preference via the menu options. Do you like to lock in your focus? Focus and recompose? Click only from the shutter or from the back of the camera as well? Get to know your camera's functions and modify them to your preferences. You should be able to follow along with your camera manual quite easily to determine what each function does in the ever-more-complicated menu settings of your camera.

Lenses in the Bag

When I am populating my bag with lenses, I typically start in a certain order with specific lenses. Let me explain why, specifically.

Canon 24–70 2.8 lens

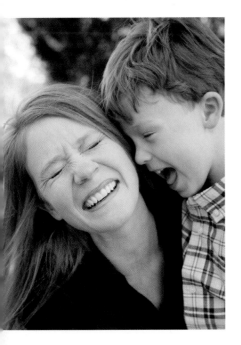

I consistently bring the Canon 24–70 2.8 lens to my shoots. Many photographers consider this their workhorse lens, because it works in so many different situations. If I don't know exactly what I'll be walking into at a shoot, I start with this lens on my camera body. The advantage of using this lens is that it allows you to immediately shift from an up-close, wide-angle view to a from-a-distance portrait view or a remain-where-you-are standard view, all with relatively little effort. The disadvantage is that it does not produce nearly as crisp and clean of a shot as I achieve with my prime lenses. I've also noticed that it tends to drift toward back-focusing over time. As a general rule, I ship my lenses and camera bodies to the manufacturer factory for a tune-up at least once a year. With my 24–70 2.8 lens, I've had to ship it more often than that. I've become very good at looking for this drifting problem when it starts to emerge again. But if I didn't know to look for it, I could easily end up thinking that I was losing my ability to photograph well. In addition, I find distortion in my images at the wide ranges of the 24–70mm 2.8 lens, and not the type of distortion that I am seeking from a creative perspective. With so many issues, you wouldn't think that the 24–70 2.8 lens is the first lens I would pack. But the truth is that I just don't know of any other lens on the market that I can use in nearly every situation, and until I do, I'll continue to keep this lens with me for every portrait session I shoot.

Canon 85mm 1.2 lens

My other go-to lens is the 85mm 1.2 lens. This is rather similar to my 85mm 1.8 lens, but it costs about five times more. That's not an exaggeration; it really is that much more expensive. In addition, I find that my much cheaper 85mm 1.8 lens focuses faster in lower light, and it's the one I grab first if the light is dropping fast. So why did I buy the 85mm 1.2? After all is said and done, it's really an extraordinary lens. The capture is so consistently strong that you can see the difference in shot after shot when compared to any image shot with a different lens. Considering how often I shoot portraits, the expense was worth it to me

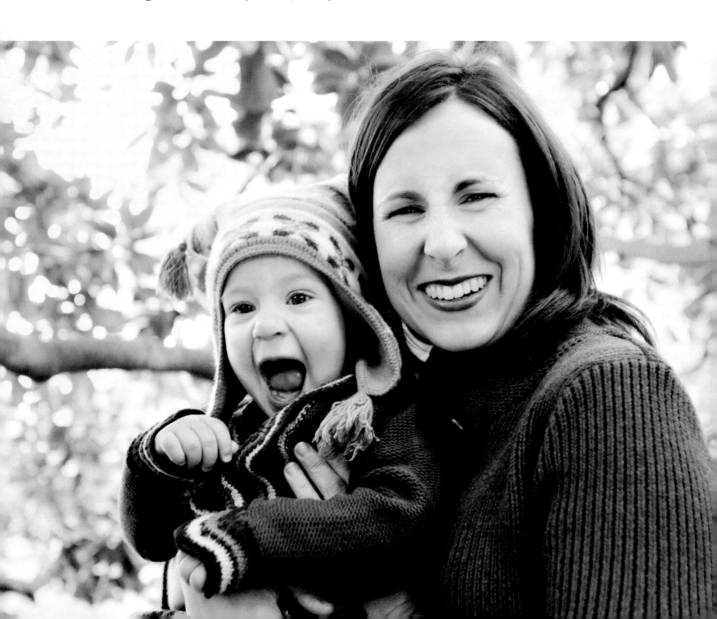

because I really do use it on almost every shoot. Overall, there are three issues to be cautious of when it comes to this lens:

- The sheer expense of it (I covered that already, but my goodness it bears repeating).

- It can be slow to autofocus, especially with fast-moving subjects (which is ironic because it's referred to as fast glass).

- It must be utilized carefully. By that I mean you need to get a feel for this lens and understand that the downright literal heaviness of the lens requires additional support.

If you're shooting with the 85mm 1.2 lens and don't brace yourself well off tripod, it is easy to create unintentional blur in your frames, and you don't always notice it when you are out shooting. It's often not until the shoot is over when you are downloading your images and there's no chance of repeating a family session you just finished that you start to notice a lot of blur in your images. Remember to respect the weight of the 85mm 1.2.

Canon 35mm 1.4 lens

The third lens that makes its way into the bag is my treasured 35mm 1.4 lens. This prime is a thing of beauty, and it works for me very well because my shooting style is often up close and personal with my subjects.

Earlier, I referred to the 24–70mm lens, which offers me all kinds of focal length options. But if that's the case, why would I bother purchasing another lens with a set focal length that I can certainly achieve with a lens that I already own? Because well-made prime lenses invariably outperform zoom lenses in terms of image clarity and stability. I've shot with the 24mm 1.2 lens before, and even though it's a strong-performing lens, it just wasn't the right look for my style.

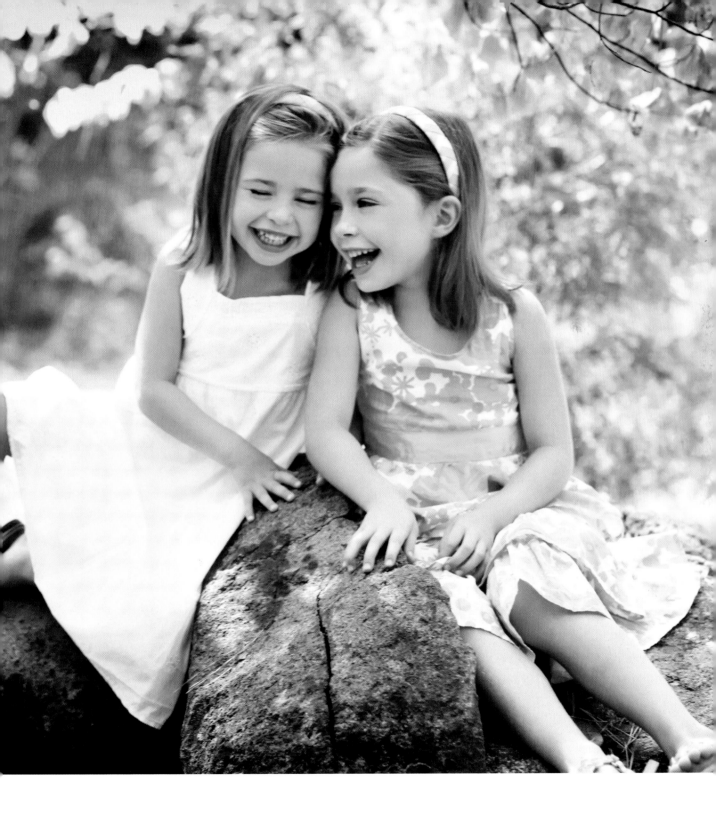

The 50mm 1.2 lens is my least favorite because of the standard view, although I must admit that it receives rave reviews from some phenomenal pros. So, considering all these other lenses, the 35mm 1.4 seemed like it'd be just right for how I like to shoot and the look I want to achieve—and it *really* is. I love the crispness of the images it delivers and that it stays dependably sharp on the edges, which is not a feature you find with every lens.

Canon 50mm 1.2 lens

The last lens I pack is the 50mm 1.2 lens. It's a well-built lens that performs reliably, shoots briskly, and delivers clean images. It just doesn't seem to suit the way I prefer to shoot, so I don't use it often. That said, I find that it can be helpful in certain situations where I am restricted in terms of distance to subject, and I prefer a prime over a zoom lens. But I'm quite sure that it will continue to sell just fine regardless of my take on it.

Other useful lenses

After I pack the four lenses just mentioned, I have a variety of other lenses that I use for a range of shoots that may call for different equipment.

Canon 70–200mm lens. The Canon 70–200mm lens, or "the white lens," is a stand-out performer for a zoom lens. I rarely use it at the 70mm focal length, simply because it's a heavy lens and can still capture blur by responding to small movements, even though it has image stabilization. I'll sometimes use this lens in portrait sessions, but more primarily with individuals as opposed to family groupings. When I tapered out of photographing weddings (I shot close to 200 of them over the course of nearly nine years before choosing to focus solely on portraits), I brought the 70–200mm lens to each one of them and was glad I did. What I admire in this lens is the lovely way it isolates subjects and the ease with which you can produce beautiful bokeh. Keep in mind that determining what your background will be is your choice. Sometimes your subjects can make for a dreamy background to give a more interesting feel to a lifestyle, not just your subjects.

Sigma 50mm 1.4 macro lens. The Sigma 50mm 1.4 macro lens is an excellent, inexpensive lens to use for a variety of purposes. Certainly, the macro capabilities of the lens are quite strong. I enjoy capturing small details and really emphasizing the look of them with this lens. For weddings, I would use it all the time for photographing rings, flowers, or any other small, important details.

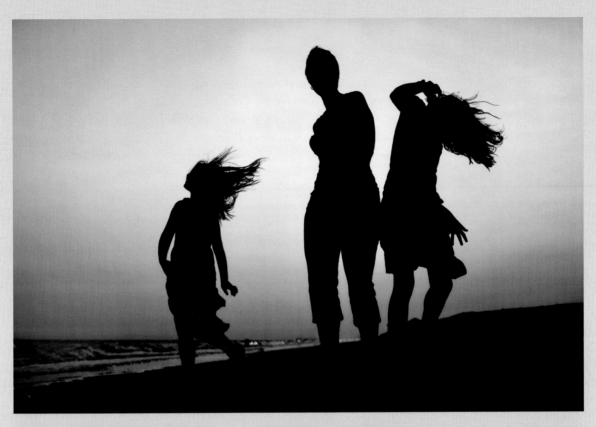

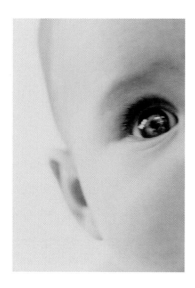

With portraits, I find it incredibly handy when I want to photograph all the little perfect parts of newborns, for instance, or the exact way a child will hold tight to her mother. However, note that this lens is slow. If you want to use the macro function for any sort of moving object, you may have problems. In addition, it does seem to "clog up" after too much use. Again, there's always the option to service your lens for a fee and receive it back like new. But the less you have to worry about parts breaking down, the more you can focus on what you are connecting to and what you are shooting.

Canon 16–35mm 2.8 lens. I purchased the Canon 16–35mm 2.8 lens with the intent of using it often to capture atmospheric shots and to shoot landscape images. In addition, I thought it made a great deal of sense to purchase a top-rated wide-angle zoom lens, because I like to shoot close to my subjects. It turns out, however, that I don't use this lens very often at all. For my tastes, I find it rather limiting. I tend to shoot very wide with it or not at all. That said, I have captured some lovely landscapes using the 16–35mm lens. I do enjoy snapping wide, atmospheric shots here and there, and every once in a while I go super wide, close, distort—and like it. But, overall, it wasn't the best use of funds, which I could have put elsewhere to either better my cash flow or reinvest in my business. I suggest that if you are trying to determine which lenses you'd like to purchase that you take the time to try one out on an actual shoot or, even better, a variety of shoots. A number of places rent lenses and let you try them out for a few days. It might cost you $100 to do so, but you may end up saving up to $2,000 by finding out that the lens you thought would be perfect for you really wasn't after all.

Canon 85mm 1.8 lens. I mentioned the 85mm 1.8 lens in relation to the 85mm 1.2 lens. If I'm shooting an event in the evening or a very low-light session (in a home with little natural light, for instance), I would choose this lens over the 85mm 1.2 lens. It simply autofocuses much faster, and although the quality is not quite the same, it's not terribly far off and it shoots quite sharply. It's also available at a terrific price.

Flashes

Once you've packed your lenses, you want to start thinking about lighting. I use one flash primarily but have two additional flashes as backups. My primary flash, whenever I do choose to add flash, is the Metz 58 Af-1 flash. It is a rather powerful light source, which I like, and offers a more neutral light to my images versus my Canon 580ex ii, which is a reliable flash but is also a bit warmer in terms of

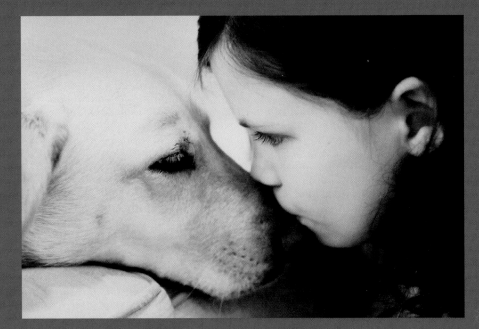

the color of the light. I use the Metz 54-3 flash as a backup to my main flash, because it's not uncommon to have issues with your flash locking up or delaying between recycle times. In my experience, if I just switch out the flash and let the other one "rest" for a while (when shooting in a dark reception hall, for instance, you can absolutely overuse your flash), I can return to the 58 Af-1 after a short break and find it's firing consistently again.

Powering the Light

If I know I'll be shooting with off-camera flash, I'll also bring along my Pocket Wizards in the event that I want to mount a flash in a static location and trigger it remotely from my camera. Pocket Wizards are excellent tools to use when you're trying to incorporate this type of lighting in your session.

You also need to consider how you will power your flashes. You can always use throwaway, or even better and greener, rechargeable batteries. I do both. I utilize rechargeable batteries primarily, but I keep throwaway batteries on hand everywhere, because you never know when you might need them.

The other way to power your flashes is to use a remote battery power pack of sorts. All kinds of options are on the market, but I own the Quantum Turbo 2x2 battery. I can plug this directly into my flash when it's mounted on my camera and shoot forever—or at least for three to four times longer than I'd be able to shoot with regular batteries. An external battery will really speed up the recycle time on your camera as well, which may be a factor to consider if you tend to use flash often.

Beware, however, of a very real concern when using external battery packs: the illusion of invincibility. When I throw a power pack on my flash, it really does feel like I have unlimited power and that the flash will go and go and go until, well, it explodes. Literally, until it explodes. This has happened twice. I've basically overpowered my flash by just shooting away and not paying attention to how much juice I was giving my flash, until it just couldn't take it anymore. The first time the light on my flash exploded, I was photographing a bride and groom, and I was sorry to not have had enough light to capture the shocked expressions on their faces when my flash just started smoking after a very loud pop. The second time my flash exploded, I just happened to be doing the exact same thing. I didn't get that photograph either. A word to the wise: With great power comes great responsibility. Don't blow up your equipment in front of your subjects. It's just not great for instilling confidence in your clients.

With great power comes great responsibility. Don't blow up your equipment in front of your subjects.

Video Lights

What happens if you lose power with all three flashes? It's highly unlikely, but let's go there anyway. I like to ensure that I have options for more creative shooting, as well as know that I have one more backup on hand, by packing a few video lights with me. My main video light is the Lowell id-Light (with portable battery pack). This video light has a dimmer switch and barn doors on the front, and can really light up a lot of real estate; you can hold it in one hand and shoot with the other.

Another easy option is the Sunpak video lights. These little lights are incredibly handy, very transportable, and can provide just the right pinch of light when you

need it. They're very inexpensive and easy to throw in your bag. However, they don't stay powered up for very long; max usage is maybe 20 minutes. That's why I have a couple of them and use them sparingly or just when needed.

Reflectors

In addition to artificial light, I bring a reflector with me to every shoot. This form of fill light is almost a requirement when it comes to shooting backlit subjects, creating catch lights, or just filling in the shadows of whatever is lighting my subject. I love, love, love working with reflectors. Although I only bring one on a shoot, I probably have ten of them at my studio.

To me, reflectors are similar to my shoes in that I have them in different shapes, sizes, and colors. None with heels, though. The shape that I prefer is the stand-alone, large reflector—the 42 inch size (also called a "board" reflector). I especially prefer the larger size when I want to redirect light back to a few subjects, as in the case of family photography. My favorite colors are the unbleached muslin, which offers a soft, warm reflection of light; and the silver, which allows me the most powerful bounce of light. The simple white is a close third, and it provides a rather neutral bounce of light.

The most convenient aspect of these reflectors is their sheer, lightweight portability; they are usually collapsible and featherweight. You can easily pack seven reflectors in one zipped bag meant to hold them all, and tuck that into an outside pocket of your camera bag, providing multiple options from which to choose when you're on the actual shoot.

Memory Cards

Last but surely not least, I pack a combination of memory cards. With the cameras I use, I shoot with Compact Flash cards. My two favorite brands in terms of reliability and speed (which varies per model of card) are Lexar and Sandisk. Because I shoot video as well, I have eight 32 GB cards and four 16 GB cards. That's more than enough storage for a number of portrait sessions, but I still own 12 4 GB cards. As often as possible, I like to pull out a 4 GB card, fill it up, and then go to one more if needed. The reason is that I can isolate any issues that might occur if the Compact Flash cards become corrupt and minimize the number of shoots that might have been affected. I don't, of course, bring all that memory out with me to a shoot, but I like having enough memory to be able to

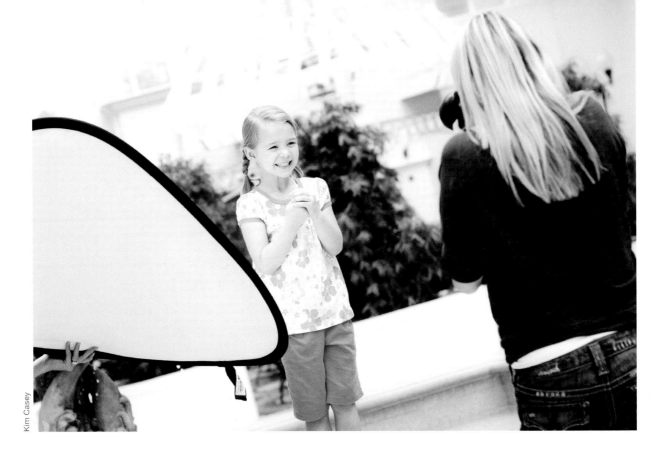
Kim Casey

leave shoots on my card for as long as possible before needing to clear them—just one more insurance policy against losing any data.

I'm a big believer in storing your memory cards safely. So I have a wide variety of Gepe Card Safe Extreme Compact Flash card cases and keep them clean and clicked shut whenever I'm not using the cards inside.

Accessories

In addition to the aforementioned vital pieces of equipment, other odds and ends I pack include any lens hoods that I may not have on the lenses, some cash that I want to keep on hand (bribing is a fantastic accessory), sunblock (protect your skin), lip balm (protect your lips), water (protect your throat), and any storyboard ideas I may have sketched ahead of time (protect your imagination).

I also pack an optical cleaner and a few microfiber lens clothes, which are tucked here, there, and everywhere. There's one in my regular camera bag, one in my car, one next to my computer, one in my lens bag, and a stack of several in my studio. I like a clean lens, and it really matters that you keep your lenses as clean as possible.

I store much of this equipment in a rolling camera bag. When I'm out on the shoot, however, the exact equipment I need for that particular shoot will be packed inside a backpack camera bag that I can easily hitch across my shoulder or tuck inside a lens bag that is even easier to keep close.

There's a fair amount of gear I need to own and take with me on shoots. But surely that should be all I need as a photographer, right? Right, except when I want to take my photography to the next level. That's when a well-equipped studio space becomes essential.

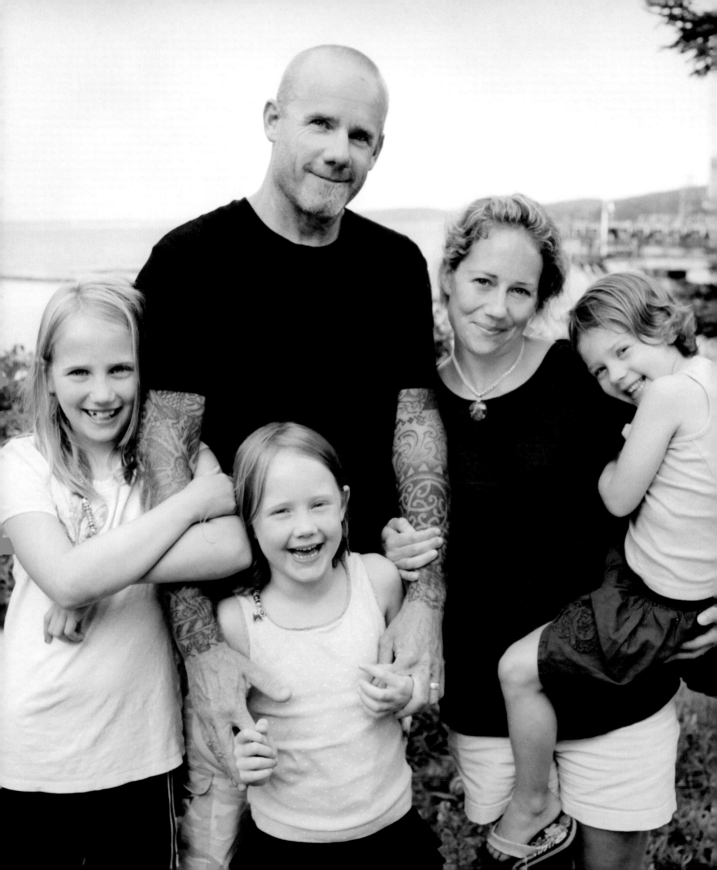

Setting Up a Working Studio

The beginning is the most important part of the work.
—Plato

A WORKING PHOTOGRAPHY STUDIO has a lot of camera gear, props, backdrops, media, supplies, stationery, computers, and storage options. It also typically has furniture—desks, chairs, and file cabinets—and of course a mechanism to show images from the shoot and an abundance of photographs! There are also lighting kits, reflectors, c-stands and stools, chairs, and benches. But a working studio is far more than just all the gear and accessories within it. It's a hotbed of creativity, a gallery of your work, a production studio, a meeting place, a sales center, and an office to manage your business. Studios can foster a creative environment, offer a welcoming ambience, and provide areas for people to relax when not on-camera or, even better, when viewing their photographs.

It doesn't matter if a studio is a designated space within your home, a stand-alone structure, or an area located within a commercial retail center. But there are several considerations to keep in mind when setting up a working studio.

Shooting Spaces

Not all photography studios include a place to shoot sessions. Many photographers prefer to shoot on location as much as possible, so they don't include a shooting space in their studio. But they may still want a central location to meet with clients, do their editing, and manage day-to-day operations. Those who do want to include a shooting space should look at two significant factors when it comes to selecting and building out a shooting area: what type of light to maximize and what type of extraneous light to eliminate. If you are utilizing natural light in your studio, it's helpful to consider which direction the windows in your studio are facing. Determine if you will have to contend with a sharp morning sun or whether you can expect fairly even lighting throughout the day. You'll want to be able to manage the fluctuating light as it shifts during the day. In addition, you'll need to consider color balance issues if you are adding natural light to artificial light, because the color of light will also naturally shift as the sun shifts. It is cooler in the morning and grows much warmer near sunset.

If you are interested in eliminating natural light, you can either create a boxed-in room, where you control all light artificially, or you can invest in natural light diffusers, which can be as simple as black-out shades that are used when necessary. The upside of controlling all of your light is that you always know what to expect. The downside of controlling all of your light is that you may have to work harder to keep shaking things up from a creative perspective.

Lighting Kits

Lighting kits will vary immensely, but most photographers choose to shoot primarily with either a strobe lighting setup or a continuous lighting setup. With a strobe lighting setup, photographers can trigger their lights to flash through a remote system, such as pocket wizards—or some other remote trigger source. When I first started shooting about ten years ago, I was still using a long cord that connected from my camera to my lighting system. I can tell you from experience, after many trips and falls, that it was quite a relief for me to move to a wireless system.

With a continuous lighting setup, what you see is what you get. You are able to light your subject, see with your naked eye how it looks, and then shoot it accordingly. You may lose a bit of power moving away from strobes, but you may be trading that in for the option to light more broadly and consistently.

Rachel Garrison

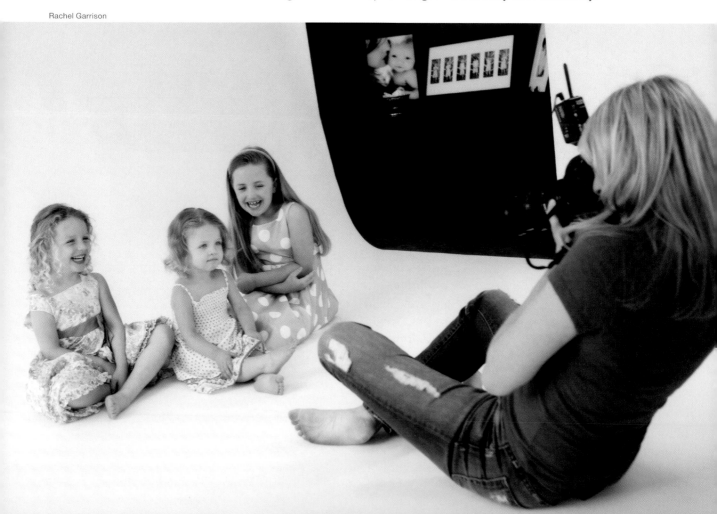

Down Low or Up Top

Regardless of which types of lights you choose to use, you will need to determine where to place them. Lighting can take up a lot of space, especially if you have a multiple-light system, and most photographers will own at least three separate lights—a main light, a fill light, and a hair light. I'll talk more about that in Chapter 11, "Lighting the Frame."

If you use floor-based lights, you'll need light stands and possibly additional light modifiers, which take up room and can be easily knocked over. Every time you move a light, you may need to move sandbags as well—or whatever weighting system you use to secure your lights.

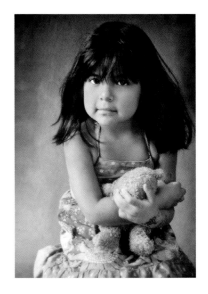

If you use ceiling-mounted lights, you'll have some flexibility in positioning them in an easier manner via a rail or scissor system. They also take up virtually no room in your studio, which allows for more open space to shoot and create. Although it sounds like a ceiling-mounted lighting kit is the way to go, you need to factor in cost, commitment, and restriction: Plan to spend more to set up and secure your lighting, and you may want to stay in your studio space for a while after spending that time, money, and effort. In addition, if you choose to use the same lights in a different location, for instance, it isn't as simple as grabbing your light and heading out the door.

Backdrops and Options

A background for your shooting space is also vital. You may decide to use a certain wall or a combination of fabrics, muslin, drop cloths, or some such product. A seamless paper background can prove to be the most convenient option. Rolls of paper come in various sizes. The standard is 9 feet wide, but I tend to go with the 12-foot wide rolls so I can offer my subjects more breathing room when I'm shooting them in the studio. It's awfully difficult to photograph a large group comfortably on a 9-foot-wide background. Although the standard colors in seamless paper are white and black, modern colors have come a long way from the original powder blue or school-picture green, and new options are as stylish looking as they are ear-catching—with selections like plum, thistle, spice, and thunder.

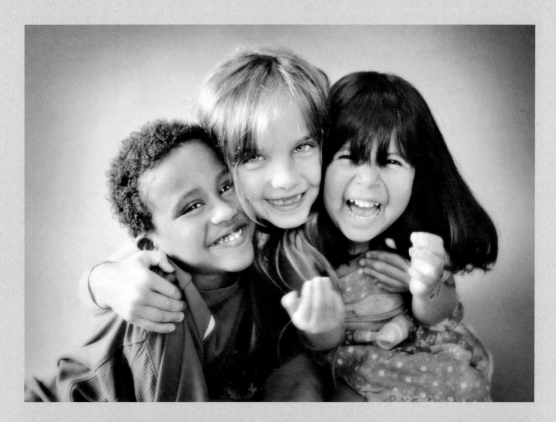

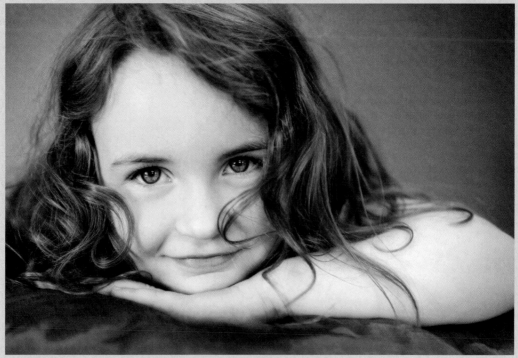

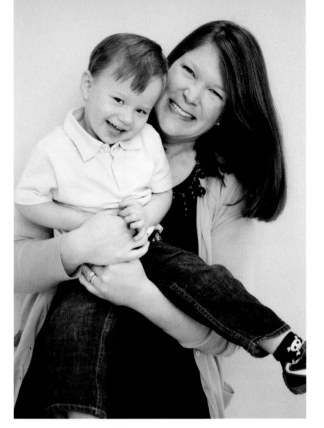

You can mount the backdrops on the backdrop mount system of your choice. When I first started photographing portraits, I used a portable $200 backdrop crossbar on a backdrop polls set. When my shooting schedule became steadier, I upgraded to a wall-mounted backdrop support system that cost a few hundred dollars more and utilized a chain pulley to roll my backdrops up and down. As business really became brisk—and I brought on associate photographers—I finally moved to a several thousand dollar ceiling-mount five-roller backdrop system with a remote switch box, which allowed me to adjust backdrops with the push of a bottom. There are plenty of ways to get started and many options to explore when time becomes more valuable than money.

DID YOU KNOW?

One of the World's First Photography Studios

Gaspard-Felix-Tournachon, otherwise known by his pseudonym, Nadar, is credited as creating and managing one of the first photography studios in history. Born in 1820 in Paris, Nadar was a caricaturist, writer, portrait and aerial photographer, and as the builder of a huge balloon named Le Geant, the inspiration for Jules Verne's *Five Weeks in a Balloon*.

Nadar opened one of the world's first portrait studios in Paris in 1854. Four stories high, he opened up his space to various artists and well-known figures of the time, the "Paris Intelligentsia." He also housed a variety of exhibitions. Nadar practiced photography for only six years, but in that time focused on the psychological elements of portraiture. More interested in revealing the personalities of his subjects than simply capturing their likenesses, Nadar stated, "What is taught even less, is the immediate understanding of your subject—it's this immediate contact which can put you in sympathy with the sitter, helps you to sum them up, follow their normal attitudes, their ideas, according to their personality, and enables you to make not just a chancy, dreary cardboard copy typical of the merest hack in the darkroom, but a likeness of the most intimate and happy kind...."

Source: The J. Paul Getty Trust, The International Committee of the Fourth International (ICFI).

The Look and Feel

Like a person's home, a studio can contain as much or as little as you choose to acquire and utilize.

The interior look of a studio can vary widely and should coincide with the branding of your photography services. If you are not exactly sure what that message is—the communication of who you are, what you offer, and how you do things—I suggest you start by creating a more neutral space with simple wall colorings, simple flooring, and simple décor. Then get more specific from there as you continue to better define your brand. It's infinitely easier to build on to a space in terms of design and offerings than to take away, peel back, and reconstruct a decidedly styled studio that doesn't really represent who you are or what you do.

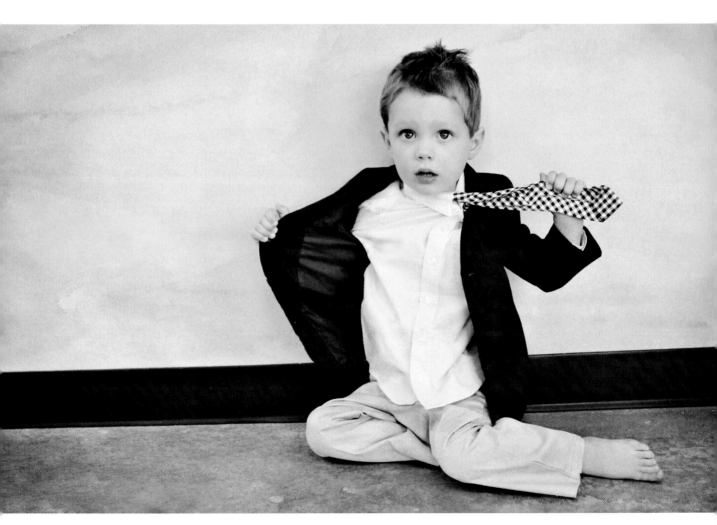

Like a person's home, a studio can contain as much or as little as you choose to acquire and utilize. And, also like a person's home, it's not difficult to find that you have overstocked your studio, which results in a cluttered place that can frustrate you and stifle your creative energy. It is your decision as to how you prefer to stock the contents of your own working studio. In addition to what I've already mentioned, the next section provides some suggestions for the bare minimum necessities that can make the art of photography a more seamless practice.

Additional Considerations

As you build your very specific space, the sky is the limit in terms of what it can contain. Here are just some of the many provisions you may want to consider.

A Studio Sign

Being able to hang a shingle has been a source of pride for business owners, shopkeepers, and tradespeople for thousands of years. Having a clear sign that shows off your business enables you to better position your studio, drive more traffic to your location, and more quickly become a well-known brand to those who see it. Of course, you'll have to check on any zoning ordinances that may not allow for to post a sign, but if you are in a retail or commercially zoned space, be sure to take advantage of this marketing goodness.

Backup Gear

When listing all the gear that goes into the camera bag, I didn't mention all the backup gear that lives in the studio. Strongly consider a little home for any extras you may need, not just backup cameras, lenses, and flashes, but also backup batteries, battery chargers, lighting gear, additional bulbs, lens caps, and so on. I've learned that everything tends to fail at some point. Like the best of people, even the highest-quality products can have issues at some point—and they do (the gear and the people). Get into the practice of stocking up on some backup supplies, and you'll be glad you did.

Back Up the Backup

It may sound redundant, but backing up the backup is precisely the point. Ensure that you have a great system in place for backing up your images. Your backup system should consist of multiple levels of storing your photographs, including DVDs, external hard drives, and cloud-based storage options. These are just some of the many ways you can secure your work, making sure it is safe and sound.

*Get into the practice
of stocking up
on some backup
supplies, and you'll
be glad you did.*

Tripod

Even if you do not choose to shoot with a tripod regularly, it can be critical to have one available to you when you need it. Even if you tend to rarely use one, you will be glad you have access to one the next time you are commissioned to photograph an extremely large family that prefers the photograph be taken indoors, for instance. This, of course, is extremely common when it comes to photographing family portraits at weddings. In that case, you will absolutely need to minimize any chance of camera shake.

Or you might want to try some creative shooting with light painting, for instance, when you use an extremely long shutter and light your subject in patterns to capture a different, unique, or interesting look.

Or you may want to take some steps toward offering video services to your clients, either as a separate service or as part of a fusion of still photographs and video clips. When shooting video, it can be significantly easier to mount your camera on a tripod. There are all kinds of reasons you might want to have quick access to a tripod, even if you don't use one regularly.

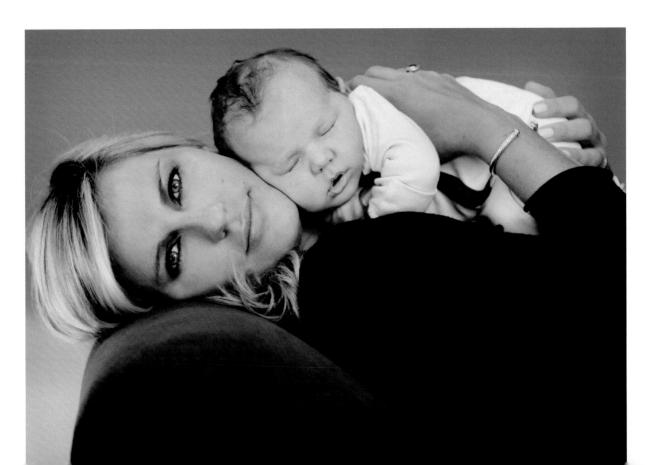

Client Literature

In this only-becoming-more digital age, we tend to rely on technology to store, transfer, and showcase much if not all of our information. This is a wonderful thing when it comes to backing up our work, sharing our images, and creating galleries on websites. But when prospective clients walk through your door and ask about your services, it is remarkably refreshing to be able to hand them some sort of clear overview of what your studio is all about, what your pricing is like, what others are saying about working with you, and what type of work they can expect to receive when they book with you. Whether this is a detailed brochure, a cleanly formatted promotional card, or a tablet-driven presentation that you print out and give to them when you are finished is up to you and how you choose to present yourself. If you can also show them work that you've already displayed on your walls, albums to flip through, and a brief overview of your studio and how you like to shoot, you are much more likely to book them for a shoot than if you had told them to please just go to your website.

Production Area

You will want a clean and ample space to work with your physical prints. Whether you are just unpacking prints from a lab or laying them out for packaging purposes, it's advantageous to have a designated workspace. You should also decide if you will offer framing services, and if so, if you will do them in-house or outsource your framing. There's a whole separate set of products and tools you will need at your disposal if you decide to offer framing as a studio-based service.

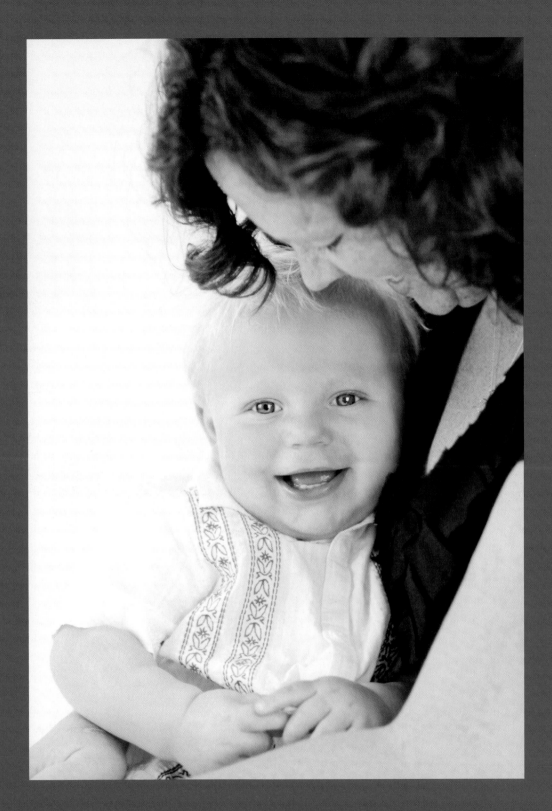

Samples, Samples, Samples

The old adage "show it to sell it" does apply—to buy it, they need to see it first. The more you show your clients the physical products they have the opportunity to purchase from a shoot, the more likely they are to buy. This includes whatever you want to sell: canvas pieces, art boards, framed prints, collages, cards, albums. It bears repeating: Show them so you can sell them.

Props can come in handy as well. I don't actually shoot with a lot of props, but it may prove beneficial to at least have a few simple posing stools, chairs, background options, and toys to distract (or actually pose with) on hand. The sky is the limit here. I've seen studios stocked with whole rooms of props that include everything from clothing and hats to toys, stuffed animals, blankets, masks, branded little sets of products they've created, and so much more.

Additional Supplies

Any working office needs some basic supplies in place for communicating with clients. Even if you strive to go paperless—an excellent green option that helps protect against clutter as well—you may still need a scanner, printer, and copier (hopefully all in one), and the rest of the core needs to simply be able to do business. The more every office supply has its place, the less likely it is to be overlooked when your stock is low.

The Bottom Line

I could go on and on when it comes to considering everything a photographer might have in a studio. The bottom line is that you need to secure a working space that works for you and allows you to focus more on shooting and relating to your clients and less on having to manage one more cluttered environment.

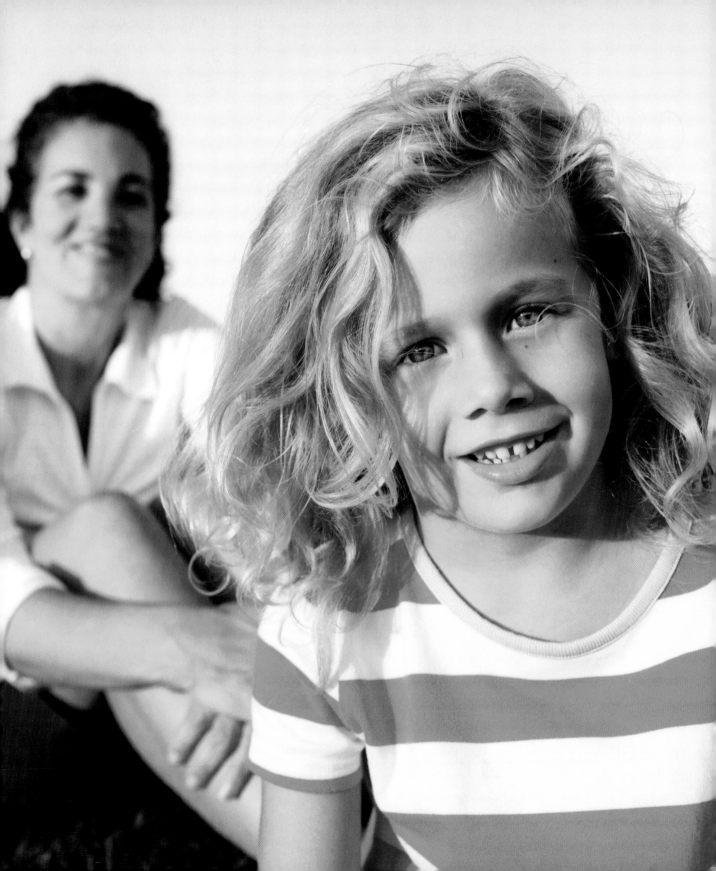

Technically Speaking

*The work will teach you
how to do it.*
—Estonian proverb

There is no camera or lens on the market that can match the dynamic range of your eye—at least not yet.

IF YOU CHOOSE TO SELECT an auto mode on your DSLR camera, you relinquish your creative control over how you will photograph your subjects. By selecting an auto mode, you grant all technical decisions of how to use aperture, shutter speed, and ISO to your camera. Many photographers are fine with making that decision, but if you want to step up your game and better control the overall look, feel, and impact of your imagery, you need to understand how to operate your camera in manual mode.

Let's start with how cameras work, because there are numerous settings, custom functions, options, and modes. Yes, your camera comes with a lot of power, but do you own it? Do you know what everything does and why—all the features and limitations? Can you make your camera do what the shoot requires and capture a frame just as you see it in your head? There is no camera or lens on the market that can match the dynamic range of your eye—at least not yet. In fact, it's estimated that the human eye can see about 14 or 15 stops of light, whereas most sensors today have a range of around 7–9 stops. The trick to closing that gap as best as you can is to understand how your camera works to really appreciate all the power you have at your fingertips—and then successfully utilize it.

Know Your Camera Settings and Features

Each camera may have different features, but they all have the same basic settings to help you control exposure, blur, noise, and color. The way you make these basics work for you will help you create your own unique style. I reference noise versus film grain because the vast majority of photographers shoot with digital cameras today. Even many of those who shoot with film cameras own and operate a digital camera as well. And that's important to note, because digital cameras differ greatly from film cameras in that they are now basically mini-computers that record images electronically. Each image is composed of a certain number of megapixels (millions of pixels) that form an image. The other way that digital cameras are different from film cameras is that they don't require additional chemicals. They also rely on a digital chip as an image sensor.

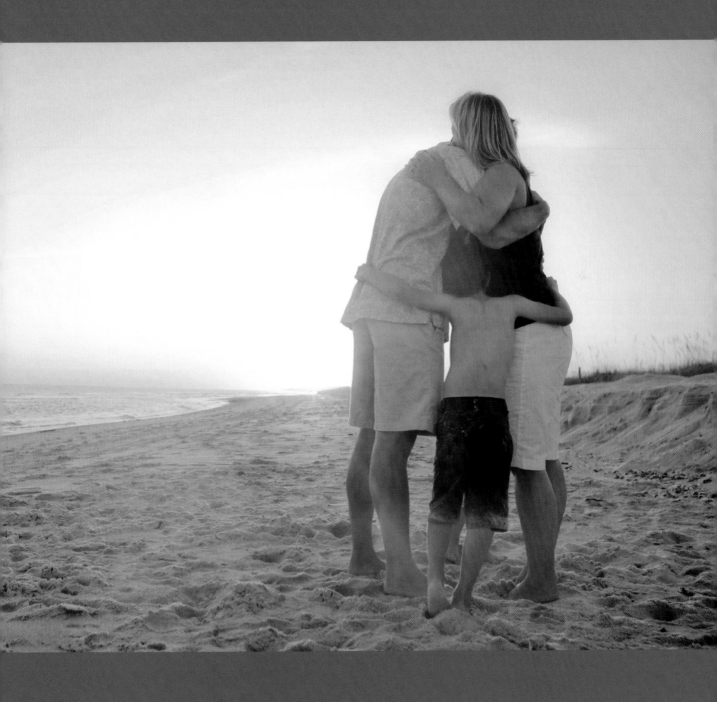

Custom Functions and Settings

When you open the box containing your new digital camera, you are unleashing a world of powerful technology. You are also unpacking a product that is set to factory default settings, which are not necessarily the settings that you want to use when creating photographs that fit your personal style. Fortunately, DSLRs come with custom functions and settings, special programs that allow you to personalize the camera's wide array of features to your precise preferences. You gain access to custom functions and settings through the main menu of your camera.

With so many custom functions and so much variety between various cameras, how do you know which to customize and which to leave as is? First and foremost, I'd be remiss if I didn't remind you to read your camera manual. That puppy is chock-full of amazingly detailed information that helps you use an expensive product to the best of your capabilities, and it's extremely customized to the product you have. However, statistics bear out that something like 90 percent of new camera owners will not, in fact, read their camera manual. They will instead play with it a bit on their own, get it to a "good enough" place, and then just start shooting, often in an auto or program mode. That's similar to buying a souped-up Maserati, driving it off the lot, and never leaving the main gear or taking it over 45 miles per hour.

At the very least, let's step through a few of the custom functions you should review when tailoring your DSLR to fit your shooting style.

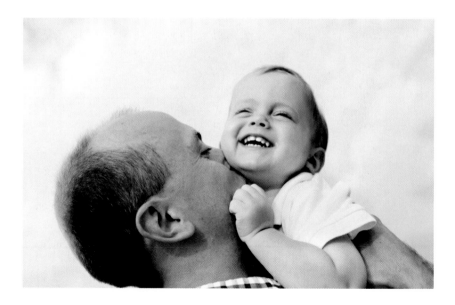

Picture Style or Picture Control

Picture Style or Picture Control is a key custom function that brings together some of the core settings for image processing parameters to completely change the look and feel of how you capture every image you shoot with your preferred settings. Detailed settings include levels of sharpness, contrast, saturation, and color tone. The major decision you must make when determining which set of parameters you want to go with—no sharpening, high saturation, major contrast, or whatever your preferences—has much to do with whether or not you plan to do postproduction work on your images after you shoot them. If you want to boost sharpness in postproduction, for instance, you may not want to also boost sharpness in-camera as well.

Although there are a variety of preset options in Picture Style or Picture Control custom functions, you can also tweak each of the options (boost saturation a hint, drop contrast a bit, etc.) as much as you desire. The goal of specifying your own tailored set of parameters is to give you optimum control over exactly how you want to capture your images.

I tend to do most image-boosting work in postproduction, because there is a great deal more power and control in Photoshop or Lightroom than I would have with the camera's more limited engine. So I tend to keep my style or control at a more neutral level when I'm shooting, which is literally called the Neutral Picture Style mode on a Canon camera.

AutoFocus Point Selection

If your shooting style includes selecting your autofocus points manually, this is quite a valuable custom function to utilize, because it allows you to select your desired autofocus points even while in the midst of shooting. Depending on your camera model, many DSLRs offer a "joystick"-like control that allows you to move the autofocus point or zone. In more recent models, the ability to adjust autofocus on the fly has become even simpler and faster.

In my experience, I find that most photographers utilize autofocus points based on how they prefer to shoot, so favorite selections vary widely. Personally, I am so interested in the connection I have with my subjects that regardless of all the options available to me, I still shoot with one center-focused autofocus point and simply focus and recompose as needed. I just don't tend to enjoy all those red autofocus points coming between me and my subject, even if it's just through my viewfinder.

> *The goal of specifying your own tailored set of parameters is to give you optimum control over exactly how you want to capture your images.*

Highlight Tone Priority or Active D Lighting

The Canon camera manual's description of the Highlight Tone Priority or Active D Lighting feature states that enabling this feature ensures that "The dynamic range is expanded from the standard 18 percent gray to bright highlights. The gradation between the grays and

highlights becomes smoother." Basically, this means it becomes more difficult to blow out the highlights in your image. Especially when shooting very bright subjects—for instance, photographing a family wearing predominantly white while out on the beach in the early morning sun—it is important to capture as much detail in the highlights as possible. Enabling this feature allows your camera to include a few more tonal steps from the midtones of the images to the brightest parts of the highlights. The good news is that the feature works well. The downside is that this function can also create more visible noise in the shadows of your image, so it's not a custom function you will want enabled in all situations.

Auto Lighting Optimizer or Adaptive D-Lighting

The Auto Lighting Optimizer or Adaptive D-Lighting function does some curve tone adjusting for you before you get to Photoshop or your postprocessing software. It can give you a better starting point if you choose to not spend much time in postproduction. This setting analyzes the photograph you're taking and individually assesses each image to determine if the contrast is flat, and if so, goes ahead and kicks up the contrast for you. This also means that when it sees you have underexposed shadows, it will boost your shadow detail. One factor to be aware of is that it works very specifically with each image, and it will vary its effect based on each image it shoots and each reading it gets. Because each of your images will be affected differently based on how each scene is being read by your camera, you can end up with quite a variety of looks, feels, and captures. This setting can be a great bonus to use at the end of a long shoot when you feel like you've pretty much captured most of it but are interested in a bit more variety toward the end.

Date/Time sync

As mentioned in an earlier chapter, I usually shoot with two camera bodies and sometimes three. Especially in a situation where you are shooting for long periods of time, capturing a great number of images and pulling in imagery from a second shooter as well, it is vital that you sync up your Date/Time capture programs so you can better match up images with capture times after the fact. I can tell you from experience just how painful it can be to re-create timelines of a wedding or a certain event where various things were happening simultaneously and being captured by multiple cameras. I check Date/Time sync before any long shoot I do, because some camera models also tend to "drift away" from staying synced up with each other, although I can offer no technical reason as to why.

Back Button Focus

Activating the Back Button Focus feature allows photographers to customize the way they use their camera so that they can focus on their subjects by pressing a rear button on the camera, typically with their thumb. This is used in tandem with the shutter button, which is still fully depressed, to release the shutter. The purpose of the Back Button Focus is to separate autofocus activation from shutter release with the goal of limiting interference of anything that may enter your frame and throw off focus while you're in the midst of shooting. Think of those times you've had your shutter button halfway depressed to focus on a scene, and just as you're about to depress the shutter button fully to capture the image, a distracting element enters the scene—such as a random person walking into the frame: The focus plane immediately changes to the wrong point, and you miss the shot. I know I've certainly experienced situations like this—for example, when I finally had a large group positioned in a hard-won natural fashion and I only had a microsecond to get them all positioned "just so." By the time the distracting element was out of the scene, the moment was also lost. I could continue capturing their likenesses as a group, but I had missed out on that "decisive moment" when I had seen all their personalities come to life at the same time—not an easy thing to re-create.

Image Review Time

The Image Review Time function will display the image you just shot for a specific amount of time. You can adjust the review time to be longer, shorter, or to just not see the image automatically at all. Some shooters cannot imagine

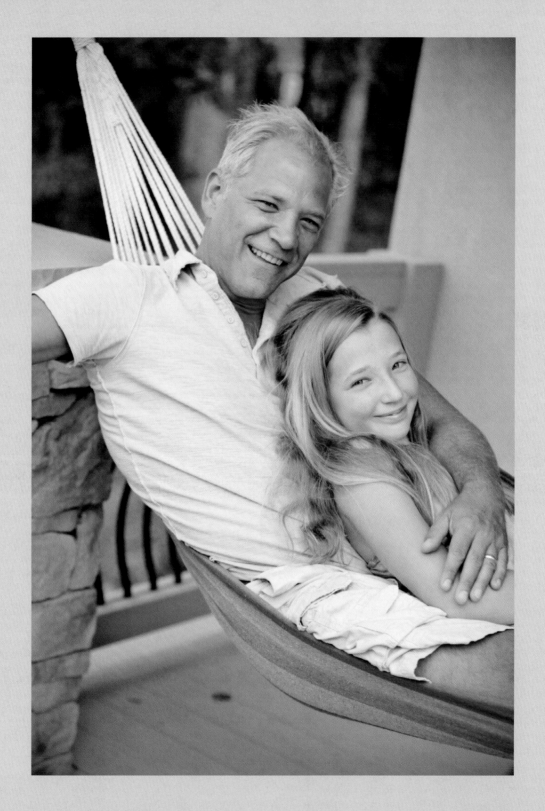

photographing without the ability to view their capture immediately. Others find it highly distracting that an image pops up automatically. Perhaps the biggest decision point is how much you prefer to conserve your camera battery; longer image review times can eat up precious power. I prefer to keep my image review on most of the time but only for a two-second review.

Keep your image sensor clean

Many new DSLRs feature a sensor-cleaning mode that occurs automatically at a time specified by you in your settings when you turn on the camera, when you turn off the camera, or sometimes both. I prefer to set the sensor-cleaning mode to occur when I'm shutting off the camera, because I don't want to risk capturing a moment I may be grabbing my camera for and find that it's busy cleaning the sensor while I'm missing the shot.

Hopefully, all of the preceding information gives you a good overview of some of the more powerful and user-friendly custom functions and settings in your camera. If you've found this additional detail helpful, I strongly suggest you keep going on your own and even further customize your camera. Create the most perfect image-capture machine you can for your particular style.

> *Create the most perfect image-capture machine you can for your particular style.*

DID YOU KNOW?

The Beginnings of Photography

The camera obscura, an optical device that projects an image on a screen, was one of the very first inventions that led to photography. Initially, a camera obscura was simply a box with a hole in the side. Light would pass through the hole and hit a surface inside the box, where it would be reproduced and then projected, albeit upside down. Over time, the box was upgraded with mirrors, and the projected image could then be viewed right side up. More finessing of the box proved that making the hole smaller would result in the reproduction of a sharper image.

The first forms of a camera obscura were documented as being around in one form or another as early as 300 B.C., when Greek philosopher Aristotle utilized a similar methodology to safely view a solar eclipse. He noted that "Sunlight travelling through small openings between the leaves of a tree, the holes of a sieve, the openings of wickerwork, and even interlaced fingers will create circular patches of light on the ground."

Reference: The Camera Obscura and The Origin of Art, Matt Gatton
Film and Cinema Spectatorship: melodrama and mimesis, Jan Campbell, 2005

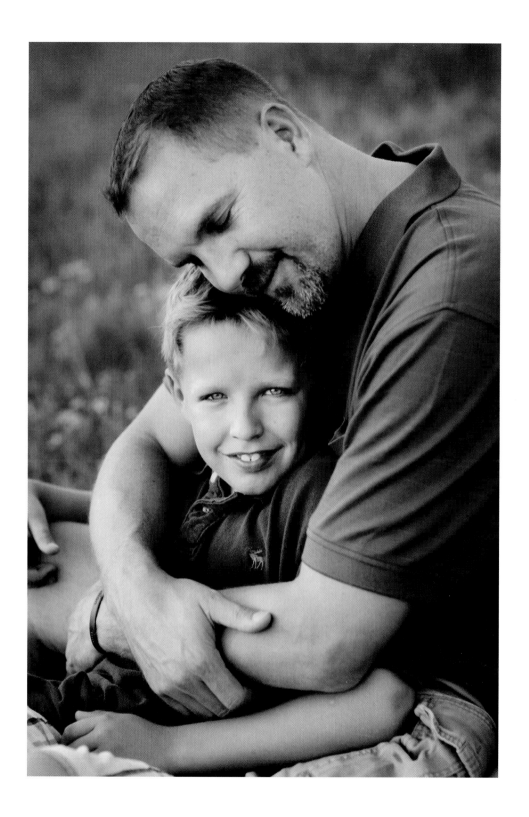

Setting Aperture, Shutter Speed, ISO, and White Balance

Once you have your camera set up, you'll want to use aperture, shutter speed, ISO, and white balance to their full effect to further shape your captures.

Aperture

Accurate exposures are rather critical when you're photographing subjects professionally, and setting your aperture correctly is a remarkably significant component of nailing your exposure. Aperture is a term that comes from the original Latin word *apertura*, which means an opening. It refers to the adjustable opening in the camera that limits the quantity of light that can enter the camera; aperture is measured in f-stops. Each f-stop has half the light-entering area of the previous f-stop, and the actual aperture will depend on the focal length of the lens. The larger the f-stop that is selected, the smaller the opening will be. The smaller the f-stop that is selected, the larger the opening will be.

In addition, the size of the aperture controls the depth of field in the image, which is the zone of the sharpest focus in front of, behind, and around the designated focal point of the image. Although depth of field typically refers to everything surrounding the subject, most of the out-of-focus effect is concentrated behind the subject.

Shooting with a large aperture produces a shallow depth of field, referring to the zone of the sharpest focus being a smaller part of the image and much of the remaining elements in the image being out of focus. The opposite of a shallow depth of field is an extended field of sharpness, where much of the image is in focus.

Thus, a larger f-stop number, like f/16, actually lets in less light and produces a darker image with an extended field of sharpness. A smaller f-stop number, like f/1.2, actually lets in the most light and produces the brightest image with a more shallow depth of field. In addition, utilizing a lens with a greater focal length or standing closer or farther from your subject will also affect the magnification of the subject, which can also increase or decrease the depth of field. This means that if you are shooting a family of six people at f/4.0 with an ultra-wide lens at

an extremely close range, there's a good possibility that some of the individuals in the family will be out of focus. But photographing the same family of six individuals at f/4.0 with a portrait lens and a distance of 15 feet will typically ensure that all subjects will be in focus, all things being equal.

You should also consider the focal plane of your subjects in relation to each other. If you are shooting at a shallow depth of field and some of your subjects are closer to the lens than others, you are likely to be focusing on either one set of subjects or the other. Note how both **Figures A** and **B** are shot with the same specifications, same equipment, and same distance from the subject, but in **Figure A** the two objects of focus are on different focal planes, so one is in focus and one is not. In **Figure B**, both objects of focus are on the same focal plane, so they are both in focus. And in **Figure C**, we have a much smaller aperture of f/16, so nearly everything in the frame is in focus.

Shutter Speed

Shutter speed refers to the length of time the camera's shutter remains open, which is measured in fractions of seconds. The larger the number on your digital camera's screen, the larger the fraction, which actually refers to a speedier amount of time. For example, 1/1600 is much faster than 1/60. The smaller the number on your digital camera's screen, the smaller the fraction, which actually refers to a slower amount of time. A shutter speed of 1/60 is slower than 1/1600.

A slow shutter speed will bring more light into your sensor but can also result in more unintentional blur. A fast shutter speed will bring in less light and capture a more precise, sharper image. Determining which shutter speed you need is often a combination of determining how much additional light you need and what kind of subject

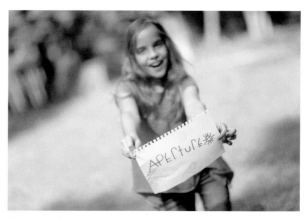

Figure A This image was shot at 1/1600 sec, f/1.2, ISO 100.

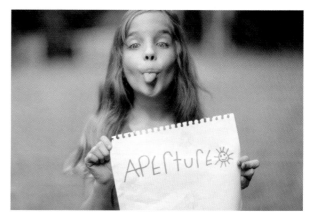

Figure B This image was shot at 1/1600 sec, f/1.2, ISO 100.

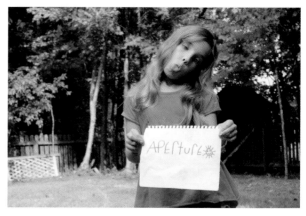

Figure C This image was shot at 1/32 sec, f/16, ISO 320.

movement you may be managing. Freezing a moving subject so that it looks still requires a higher, or faster, shutter speed, which is a greater fraction. Letting the object intentionally blur, giving it a sense of movement, requires a lower, or slower, shutter speed, which is a smaller fraction.

The focal length of your lens also affects the shutter speed you will select. Using portrait lenses or telephoto lenses, for instance, will increase the opportunity for camera shake, particularly when shooting at slower shutter speeds. Choosing lenses with image stabilization will help to manage unintentional blur, as will using a tripod or better securing your lens while shooting.

If you're not using a tripod, the general rule of thumb is to shoot with a shutter speed with a denominator that is at least the same, if not larger, than the focal length of your lens. So, for instance, if you are utilizing an 85mm lens, you'll want to keep your shutter speed above 1/80 sec. as a way to control camera shake.

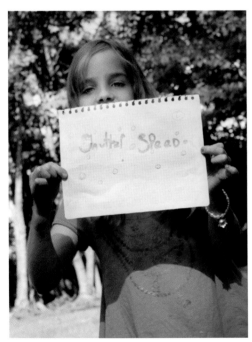

This image was shot using a shutter speed of 1/125 sec., f/11, ISO 125.

This image was shot using a shutter speed of 1/20 sec., f/16, ISO 125.

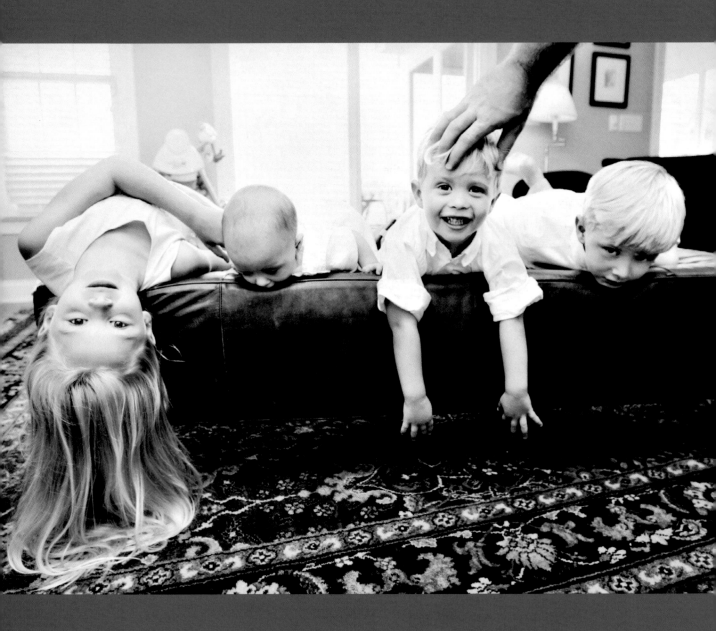

ISO

The International Organization for Standardization, or ISO, was a different consideration in the age of film. It measured the sensitivity of film to light, and film came in a certain ISO speed. You used to have to select the ISO for a roll of film and just stick with it. Now you can change your ISO on the fly when you need it for whatever you're photographing. That advantage alone is the reason many photographers switched to digital cameras when they initially became available. Currently, ISO refers to the sensitivity of the image sensor, and in general, the higher the ISO, the more reactive the camera is to light. Higher ISOs, like 3200, also have a grainier or (with digital) noisier look. The higher you go up in ISO, the less color saturation and image detail you retain. Higher ISOs are utilized in darker situations to boost the available light. Because manufacturers are now producing cameras with better and better ISO-sensitivity, photographers are able to use natural light more than ever before.

White Balance

There's quite a lot to the concept of white balance. Basically, the point of shooting white balance correctly is so that you can capture the color in an image as accurately as possible. That said, it is not uncommon to manipulate white balance as a means of artistic expression by purposely warming up or cooling off a scene. But if you choose to balance the color of light, there can be some complexity involved. Not only do different light sources have different color temperatures, but the same light sources can even have different color temperatures based on multiple factors.

The color of light is measured on the Kelvin scale. There are lots of measurements in photography, don't you think? Kelvin works as follows: The lower the number, the cooler, bluer, or purpler the light. The higher the Kelvin number, the warmer the light, or the more yellow or orange. The color of light sources can change, too. The earliest rays of the sun, for instance, start out as a cool light and then quickly advance to a brighter yellow as they warm up during the day. The rays peak in warmth around sunset and then drop to a cooler light in the evening.

Correctly setting your white balance helps to render your subject and the surrounding environment closer to what your eye sees (back to the human eye being quite superior!). Our eyes will adjust white balance automatically. We have to help our cameras to do the same. White balance is actually about color. You can

Correctly setting your white balance helps to render your subject and the surrounding environment closer to what your eye sees.

utilize a gray card as a reference when shooting and apply your white balance corrections based on that, but in my experience, just truthfully capturing white balances will serve you well. DSLRs come with a wide variety of white balance settings. You can really see the range of these settings by simply shooting the same subject in the same light with the same settings and just dialing through all the options. Here are the white balance modes your camera might include:

- **Auto White Balance** mode is the camera's default setting. The camera selects a white balance based on an algorithm of what it calculates is most correct for the shot. This is generally a good setting but certainly not perfect in all situations.

- **Daylight** mode takes an average of the color of light and determines a white balance accordingly.

- **Shade** mode assumes the light is cooler, so it will add a good amount of warmth to the image.

- **Cloudy** mode assumes some of the warmth of the light has been dimmed, so it adds a hint of warmth to the images.

- **Tungsten** mode assumes that incandescent lighting, or light from a bulb, is being used, and it generally adds some strong coolness to the tone of the images.

- **Fluorescent** mode assumes it must correct for indoor fluorescent lighting. But because this type of indoor lighting is not as warm as tungsten lighting, it does not offer as much coolness as the Tungsten white balance mode.

- **Flash** mode manages the cooler light that is emitted from a flash, so it adds warmth—somewhere between the amount given to Cloudy mode and Shady mode.

- **Custom** mode allows you to photograph a gray card under similar lighting and then set that as your white balance for the rest of the shoot.

- **Kelvin** mode gives you the option to set the white balance over a broad range of values.

In summary, don't ignore the significance of achieving consistent white balance on a shoot. Current editing software allows for a lot of changes to be made for color correction, but you can spend less time editing if you get it right in-camera—and achieve much more accurate results.

Auto White Balance

Daylight

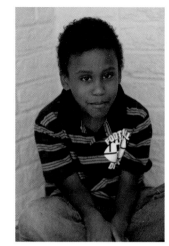

Shade

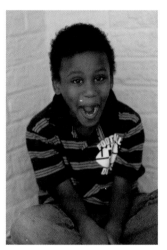

Cloudy

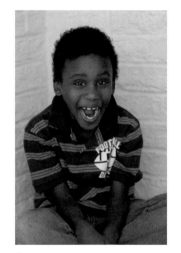

Tungsten

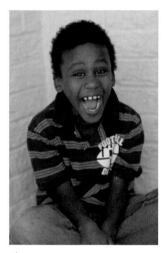

Fluorescent

Flash

Custom

Kelvin

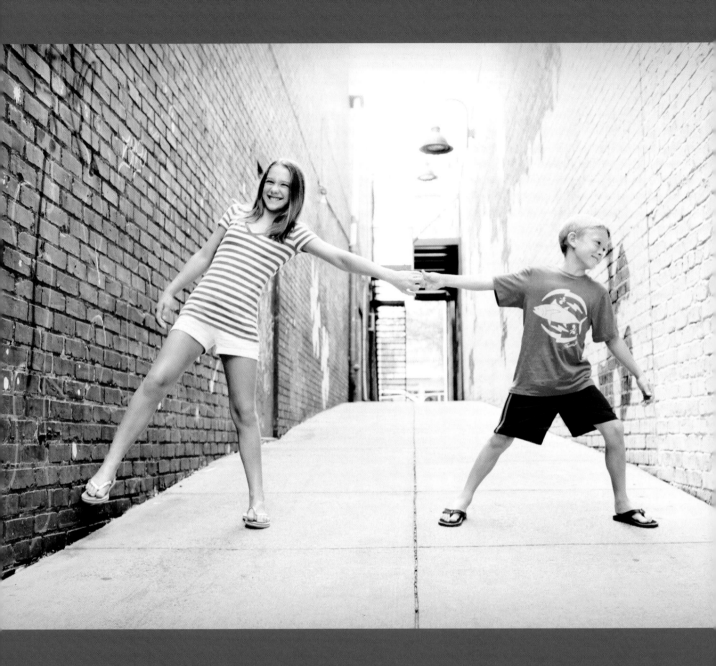

Mastering the Technical to Achieve Your Vision

Writing this chapter was perhaps as arduous for me as reading this chapter may have been for you. Of all the aspects of photography that I've studied, the technical details to achieve great photography have been the least appealing to me. On the other hand, I remember exactly how frustrated I felt when I was trying to capture images I could see in my head and being unable to do so without knowing the technical settings behind how I could achieve such captures. Learning, practicing, and then mastering these specifics changed the entire game of photography for me and allowed me significant freedom to express my precise vision when it came to photographing families. I hope it does the same for you.

It's All About Connection

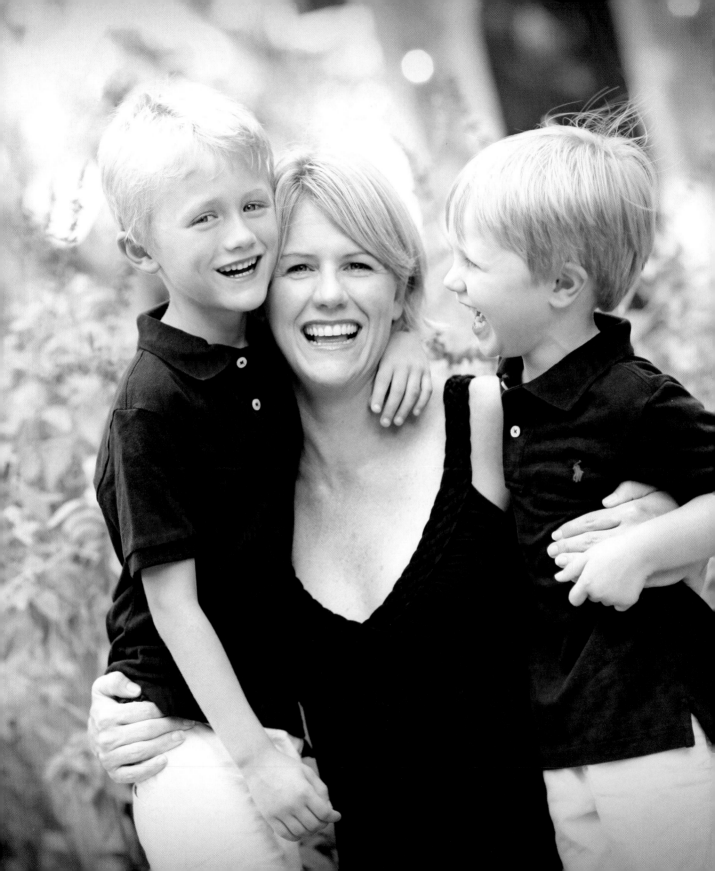

Interacting with Your Subjects

*We don't see things as they are,
we see them as we are.*
—Anais Nin

SO WHAT DOES IT MEAN to interact with your subjects? Does it mean merely sharing a great topic of conversation? Exchanging contact information? Asking someone about all of her favorite things? Sharing vulnerabilities? Establishing a decent rapport? Endlessly asking a wide variety of questions, such as these? I certainly hope not. That sounds exhausting.

I would suggest that meaningfully interacting with others—whether you're photographing them or not!—often comes down to simply getting past the superficial bubble we all place around ourselves and finding a meeting place where you can connect in an honest and engaged manner.

Quickly getting past small talk is one of the most direct ways to combat any unease you may feel in an unusual situation (and if you haven't already recognized this, it's unusual to spend the afternoon having photographs taken of your family; the sooner you acknowledge that, the sooner you can consciously move past it). One shortcut? Discover something in each other that moves each of you past what you can do for each other and mercifully transports you to a place where you simply accept and appreciate each other.

At its core, significant portrait photography consists of reaching a place with your subjects where they are no longer aware that there is a lens being stuck in their faces and together simply exchanging communications in a meaningful and authentic way.

Going into Battle

If you can zero in on getting to a mutually satisfying point with everyone you photograph, you will have already won much of the battle, and I don't use the word "battle" lightly. Fortunately, a great deal of the experience of a portrait session can be seamless and flowing, and well, *fun*. But it can also be a significant amount of work. It may consist of a concentrated effort to connect with individuals in a rather brief amount of time, which pays off handsomely in terms of meaningful captures but is, nonetheless, a heck of a lot of effort. Going into battle is an apt analogy, because it is helpful to dress accordingly, arm yourself appropriately (you already know about gearing up at this point!), know who is doing what and when, and of course, be able to anticipate what might happen next.

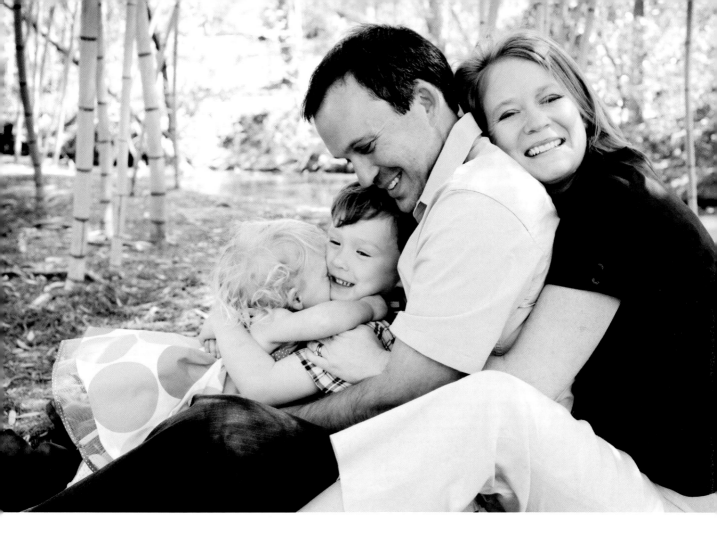

To continue with the battle analogy but incorporate a bit of a twist, when you photograph a family, there is surely a battle raging, but it shouldn't be between you and the family. Rather, you should both be on one side of the battle lines together, with self-consciousness—or sometimes lack of interest—on the other side.

So, if the session turns out to be a battle, you want to show that you are on the family's side, and that you're an advocate for each member. Too often, portrait photographers go into a shoot with the mentality that they need to overcome their clients' issues to accomplish a successful shoot. The problem with that mind-set is that you automatically place yourself in a combative situation with your clients, as if you are both fighting for different outcomes, but you're not. You want the same thing: beautiful photographs that showcase individuals

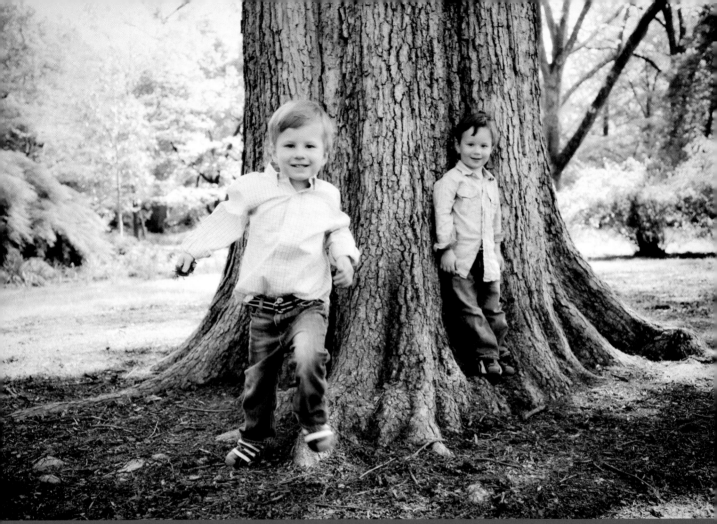

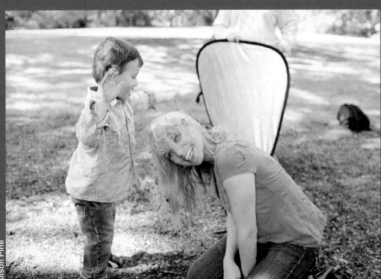

within a family, their relationship to each other, and the oneness of the family as a group. The sooner you show your clients that you want the same thing and use your expertise to help get them there, the more likely it is that you each reach your shared goal.

About the only time I seek conflict between my clients and me is when I stage a game with young children. I offer them the opportunity to throw (soft) things at me, or knock me down, or "attack" me—whatever makes sense based on our location—in exchange for them calming down long enough before the shoot to allow me to pull off a few great shots.

Dressing the Part

When you're dressing for battle, it's helpful to wear something that will help you win. I like to research "who" I'm walking into in terms of what I know about the family members, their lifestyle, their level of formality or casualness, and the age and interests of any children involved. I also keep in mind the location where we'll be shooting, because that comes into play as well.

Dressing in a way that offers me immediate access into their world isn't the same as changing who I am to fit their preferences: It's simply a way to shortcut the process of connecting with them quickly. Like it or not, research shows that we form an impression of someone in less than 30 seconds of our first meeting, and sometimes quicker than that. When people are trying to determine "who a person is" in that short time frame, they often subconsciously take cues from how people physically present themselves. If you want to be accepted in short order, dressing for battle means tripping a visual cue so they can immediately see that you're on their side, that they can feel comfortable with you right away, and that this isn't a hurdle that anyone needs to overcome.

If I know I'm photographing a family with several small children, I like to wear casual t-shirts, often those with commonly recognized characters on them, or simple clothing—jeans and sneakers or sandals. I also wear something I know might get dirty. However, if I know I'm photographing a family reunion with adult children at a graduation-related event, for example, I would wear a simple dress and comfortable but nice-looking shoes. I ensure that I fit in with them, so there's no need to overcome too great of an initial comfort gap between us.

OPPOSITE These high-energy twins were quickly losing interest in looking at either me or the lens. Given that there were leaves all around us, I told them they could "attack" me and cover me in leaves if they would at least look toward me just before doing so. I was able to get the shot I wanted, and they were able to act in a wildly disobedient manner: win-win. Their mom was such a good sport about the whole thing; she actually took these photographs. I felt compelled to snap a quick self-portrait, too.

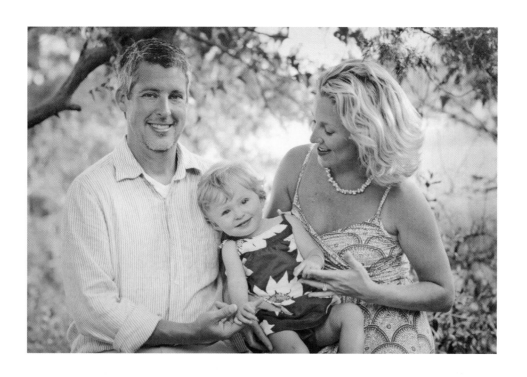

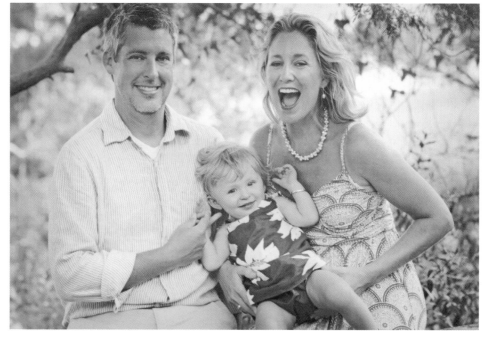

Who Does What, When?

What about determining who does what and when each of us plays our part? Well, first and foremost, we know that most family portrait sessions are initiated by Mom. In many instances, she is the reason you have a relationship with a new family.

What does she do? She decides to have her family photographed. She seeks out and hires a photographer, and she clears all schedules for a chunk of a day to ensure that everyone can be present. She then plans everything, prepares the family members, dresses them, feeds them, brings snacks for them, "waters" them ahead of time and brings more for the road, coordinates naps when possible, psychs them up just early enough, bribes them with a reward at the end, and promises her husband this won't take too long. She does any other activity she can think of that may be involved with orchestrating the looks, moods, and attitudes for an optimum capture experience so that by the time the family members show up for a shoot, they are already halfway through their own endurance event.

What I see when a family appears is a mother who is in need of a small break and a group of individuals to whom I owe gratitude at the outset—along with an assurance that I've got it from there. That means I know my equipment, I know my lighting, and I know the individuals who make up this family. I will be studying their relationships with each other, and I show exactly how grateful I am by pulling out all the stops—whatever it takes to pull off a successful shoot and make her and their efforts worth it.

What I expect of the family during the shoot has been communicated to the parents in advance. What I expect of the children is easy: I want them to simply behave as naturally as possible, and I will take responsibility for directing the flow of their actions. What I tell parents with small children is to please not worry about how their children will behave during the shoot. I tell them my goal is to eliminate barriers between me and my subjects, no matter what their age. I tell them that telling a child to respect me, or listen to me, or be polite with me only creates an additional barrier that I must overcome. That seems like a lot of telling, but explaining it in this way allows me an opportunity to get buy-in upfront from parents who typically feel uncomfortable letting their kids run around wild. I ensure them that I welcome wild—at least for the time frame we'll be together for the shoot.

The mark of a truly great group portrait is when the viewer can get a feel for the personalities of each family member.

Or, to put it more specifically, I assure parents that during a photography shoot, where we are striving to capture authentic images of children, is not the time to be actively raising upstanding members of society. This is the time to let them nakedly show me (sometimes quite literally) who they are. Once everyone knows their roles, I can then shift my attention toward preparing for the rhythm of the shoot.

Anticipate What May Happen Next

Another significant by-product of tuning into your subjects is that you start to garner a feel for what will happen next, especially as it relates to what will happen next between *individuals*. You start to tap into the momentum of their built-through-familiarity cadence of emotional exchange. Just as each individual is unique, so is each session, and thus has its own rhythm and its own tempo of high-energy moments and low-energy breaks.

Helping to create the rhythm for a shoot by leading the pace of it will enable you to better anticipate when people will laugh with each other, when they will roll their eyes, or when they will zone out from connecting with you or each other because they simply need a break. Gaining a feel for what will happen next can make a huge difference in the quality of your imagery. We've all seen those photographs where someone *just* missed the incredible moment or shot too soon before an expression fully formed. Anticipation is key to capturing images at "the decisive moment."

Interacting with Individual Family Members

The mark of a truly great group portrait is when the viewer can get a feel for the personalities of each family member, even as the individuals are showcased as collective parts of a whole: the family. To pull this off, you really need to know your subjects. And to pull *that* off, you really need to *want* to know your subjects.

Knowing your subjects, truly *knowing* them, means taking full advantage of the incredible door that opens between you and them when you show your subjects that you are genuinely interested in listening to them and they trust you enough to speak comfortably and honestly.

It's All in the (Family) Name

Last names, or surnames, often tell a story about where families originated, who they were, what they were known for, who they were related to, where they lived, or what they did for a living.

Curious about the ancestry of these often-heard surnames? Most likely, their names came about because of their professions or their well-known prowess: Archer, Baker, Butcher, Cook, Hunter, Mason, Thatcher, Weaver.

Often, names were created from geographical references, like Washington, London, Hamilton—or after features of nearby geography, such as Bush, Wood, or Stone.

Ancestral connections were big factors when it came to eventual family names. Richard's son became Richardson, as did Stephen's son (Stephenson) and Benson, Simpson, and Henderson, to name a few.

This evolution of last names continued throughout the world. In Greece, *pullus* means "the little," or "the son of"—so the last name Christopoulos meant that somewhere down the line, someone was the son of Christo, or probably more than a few someones.

Here are the top ten most common surnames in America today:

1. **Smith.** An occupational surname for someone who works with metal, such as a blacksmith. Because working with metal was such a common profession for so very long, it's not surprising that Smith would evolve to become the most common last name in the United States.

2. **Johnson.** An English surname, meaning a "Gift of God."

3. **Williams.** Means "son of William."

4. **Brown.** A descriptive name referring to a person with brown hair or brown skin.

5. **Jones.** Similar to Johnson, it means "Gift of God" or "God Has Favored."

6. **Miller.** A miller was also a very common profession; it described a person who worked in a grain mill.

7. **Davis.** A name referring to "the son of David."

8. **Garcia.** An Hispanic surname referring to the "son of Garcia" (the Spanish form of "Gerald").

9. **Rodriquez.** Another increasingly common name in America; it refers to the "son of Rodrigo."

10. **Wilson.** William was a popular name for a long time. In fact, it still is today. This surname refers to the more informal version, "son of Will."

Author David Augsburger wrote, "Being heard is so close to being loved that, for the average person, they are almost indistinguishable." The sense we get of being heard or seen is critical to how we process our perception of the depth of a relationship we have with another person. We all want to be seen as beautiful and interesting for who we truly are—sounds cheesy, yes, but it's an absolute truism.

Think about how many times you've been in a conversation with another person and felt like you were in it alone. Genuine connection is the opposite of that. This is important to acknowledge, because all too often, photographers are easily consumed by the many technical considerations of a shoot—lighting, camera settings, backdrops, compositions, grouping, posing, and so many other consid-erations—that it's easy to forget you have a living, breathing, feeling person in front of you who is pretty much being left alone. The last thing you want is for your subjects to feel alone—with you. Enabling your subjects to move away from aloneness, fear, self-consciousness, and even disinterest is a central part of the portrait photographer's job.

Know What Makes Them Tick… and Ticked-off

How do you look at a group and pull out the best in each different individual? You need to know enough about each member of the family to know what the person responds to and what shuts that person down. Then you have to work with those varied traits as best you can while photographing the entire family. That means pumping up the energy of the silly four-year-old to pull out that exuberant laugh while ensuring the young, obviously bored, teenager that you totally understand that this is not nearly as fun as shopping. For example, you might be telling the younger sister that her jump-to-sit move is absolutely fantastic, and that she's timing it spot-on with what you need for the picture while nodding to the teenager in assurance that you would never in a million years ask something so embarrassing of her. You get the fun, bouncy look of the child and the relieved smile of the teenager, but you are responding to them differently, at the same time.

This technique isn't just for communicating with children. It works for adults as well—especially adults in high-stress situations. Recently, I photographed a family of four—mom, dad, nine-year-old brother, and six-year-old sister. I'd been photographing this family since the youngest was barely a toddler, and I'd gotten to know them pretty well. I'd always photographed them as an entire family, together, but that doesn't mean we were always able to get them together as a family quite so easily. After speaking with the family at the beginning of the shoot, I realized just how crazy things were at work for dad. He was certainly prioritizing these family photographs by leaving the office early, but that didn't mean he was free from some of the urgent demands that he was being held accountable for during a rather critical time at work.

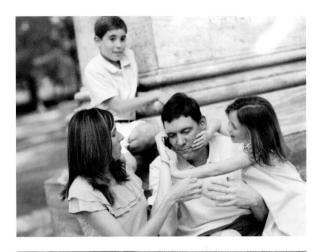

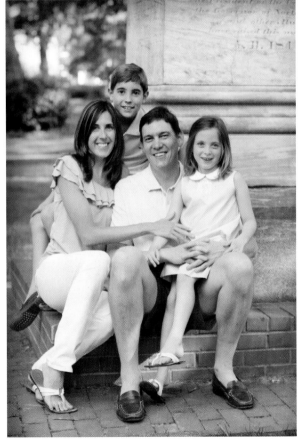

Remember that the goal is to have your subjects act as naturally in front of a lens as they do when one is not present.

Normally, when I go into a shoot with a family, it's like going to the movies: First, I ask that all cell phones be turned off. Second, I know the family will sneak in snacks. In this case, dad kept his cell phone with him for urgent calls, and we built a rhythm out of having fun when he had to take a call, complete with the kids exaggeratedly, but silently, pretending the call was for them. I consciously kept things light so he wouldn't feel badly, and so the whole energy of the session wouldn't keep changing every time the phone rang. This paid off because it kept the feeling of the shoot cute and fun, as I wanted it, and he was way more at ease than he would have been if he'd felt like he was feeling "accused" of not being 100 percent focused. None of us like feeling called out, especially when we feel it's not warranted. That's one of the reasons I make time to be photographed regularly, so that it's not a stretch to remember what my clients may be feeling.

Become the Subject

Have you ever been the subject in a portrait session? If you are a working photographer and have never actually been a subject in a session, please remedy this immediately and go get yourself shot (by, y'know, a photographer). Being the subject is an entirely different experience than running the shoot. Your overriding thought during a session is typically a question, repeatedly running through your mind and asked in different ways but basically coming down to this: Am I presenting myself in a visually appealing manner, or do I look like a complete idiot?

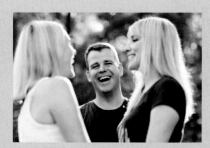

Rex Ballard

In this family portrait, mom and dad were keeping up with one toddler, one newborn, and a dog while we traversed through a rather large outdoor venue. They were both in great spirits but a bit frazzled from the coordination of managing so much. Taking the opportunity to smooth back a few stray hairs from mom's face, I playfully showed her just how gorgeous she could look in some photographs of just her and her husband if she made a certain expression, intentionally exaggerated. Just the goofy nature of the exchange eased any discomfort for both of them, and I immediately fired off a few sweet portraits of the two of them looking significantly more relaxed.

You very well may find that you'll be thinking of a myriad of self-doubts: Do I look natural? Wait, does natural look dumb? Is my smile working? Are my eyes frozen? Have I smiled enough? Am I smiling too much? Why can't I swallow anymore? Oh my Lord, have I developed a tic?

Add in several children that you want to have photographed with you, and you'll start noticing their behaviors: They are smiling too much or not enough; in addition, they are drooling, stuff is coming out of their noses, one of them is sitting on his sister, and—well, you get the point. As the subject, there is a lot going on in your head, and all of those wildly shifting thoughts and fears expand exponentially when you start adding family members to the mix.

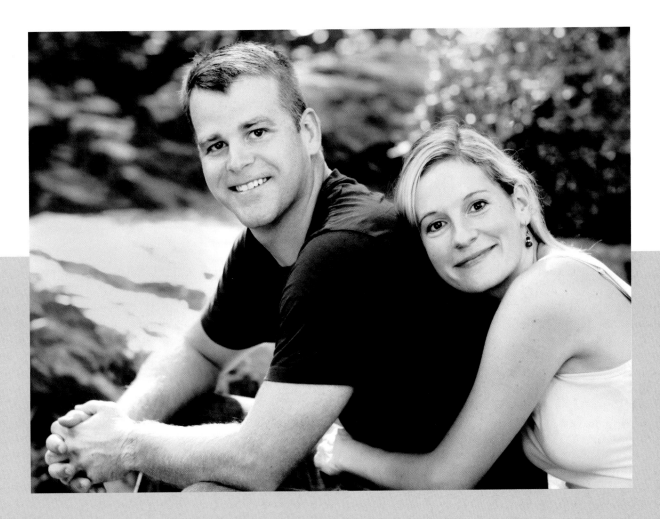

Imagine that on top of all of those thoughts, feelings, concerns, and insecurities, you're looking back at someone who is stuck behind a camera, fiddling with settings, checking the lighting, and clinically just shooting away. There's no part of that entire equation that adds up to you showcasing your authentic self and a photographer really honing in on that.

Remember that the goal is to have your subjects act as naturally in front of a lens as they do when one is not present. Because much of photography is about mirroring, start by recognizing that as the photographer you need to show your subject how comfortable *you* feel, how naturally you interact, and how lacking in self-consciousness you are. You put them at ease by actually being at ease.

In many ways, you are making a record of sorts of the interaction you have with your subjects, simply by capturing how they respond to you. If you were to turn the camera every other click and get your side, too, you'd have a full chronicle of the exchange and a pretty fascinating one at that. That said, I'm not sure how much a family would appreciate just as many photographs of you as you took of them—so it might be best to try this particular exercise during a noncommissioned session.

Look for the Laughter, But Tell the Truth

What do you see when you look at your subjects? What do you notice first? Is it the way the little boy is jumping up and down incessantly? Or is it the way dad seems to be humored by his son's antics? Do you notice mom's stressful gaze as she desperately hopes for just one great image? Or do you pick up on the lovely reason she cares so much about that image—the intense love she feels for her family? What do you see when you look at

these people who have entrusted you to document their belonging to each other?

Start from what you see, because what you as the photographer see *is* the story. You shape the view all others will have of this family when they look at these photographs later. I genuinely believe that a full objective account of a family is nearly impossible if you are a feeling, thinking, observant photographer. You have opinions, you look for what you believe, and these biased views will make their way into the images.

So, when you look at your subjects, do you see, as Richard Avedon was credited as seeing, "the promise of them?" Is there something compelling, rich, soulful, intriguing, beautiful in the subjects you photograph, and are you putting those qualities on exhibit?

What's their story? How consciously are you crafting their images? Are you cheering for your subjects or simply running them through the image mill?

Over time, I've come to notice that much of what I see when I look at children is the ease with which they laugh. Not all children and not all the time, no—but on the whole most laugh easily. There is more cause for laughter when you are a child. You may have heard the estimate that children laugh or smile 400 times a day, whereas adults only do so 15 times a day. After doing some research on those quoted numbers, I couldn't seem to find absolute statistics to support them. But here's the thing—it doesn't matter if those statistics are scientifically, unabashedly true or not. What matters is that's what I see.

I look for laughter. Even if it doesn't present itself immediately, I know it's there. I search for it, find it, and photograph it. If you look at the following photos of all the children, at different ages, from different families, all different ethnicities and religions, hailing from different

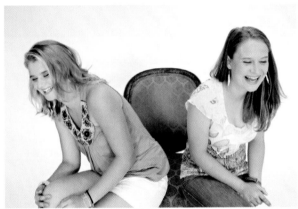

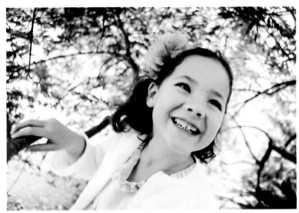

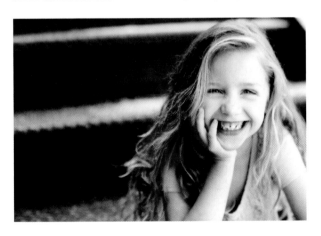

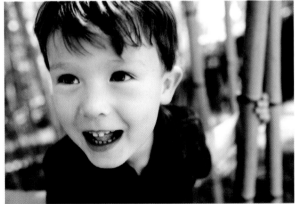

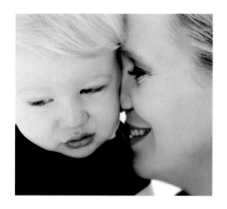

geographic regions—what is the link between these images? They were all photographed by me, and I was looking for their laughter. Each of these images holds a reflection of me, someone who was looking at them and knowing I would find joy.

Duality of nature exists in all of us. None of us are simply happy or simply sad, or completely joyous or totally angry. We are, all of us, a mix of emotions. And children are no different. Looking for joy is one thing; only capturing laughter is quite another. Connecting with your subjects means you get unparalleled access to much of "the all of them" in a rather short amount of time. Showcase a range of emotions, and you honor the whole person, which means you get to show the truth.

One of the best tools to have in your photography kit is *curiosity*—genuinely wondering why people act the way they act, think the way they think, and do the things they do. Because curiosity can trump fear, it's important to encourage your subjects' curiosity. Let them in on the process of how you're seeing things, why you're pulling this light closer, or why you're switching to a different lens. When you open up with a conversational type of stream of consciousness about how much effort you're putting into the process of photographing them, they can respond with interest and questions for you that naturally lead to real exchange. We often forget the fear after we move into wonderment.

Focusing on the "One"

After spending time connecting with each family member, the time comes to showcase each of them in the grouping of "one." I refer to family as a "one" because there is something beautiful in showcasing how a group of individuals can come together to form a union and how your separate subjects become one subject. Whether you are bringing two people together or a group of 25, you still have to do the work of drawing out each individual as you show each collectively in a group. To best many understatements, I shall just say, "It ain't easy."

It can be exhausting to pull off a great group portrait, especially when there are young, distracted children involved. But do you know what happens when you *do* pull it off? People will want that image, treasure that image, show that image to everyone they know, and then order it large and in digital format, at a premium, for safekeeping. They will buy it as gift prints for family, put it on the front of

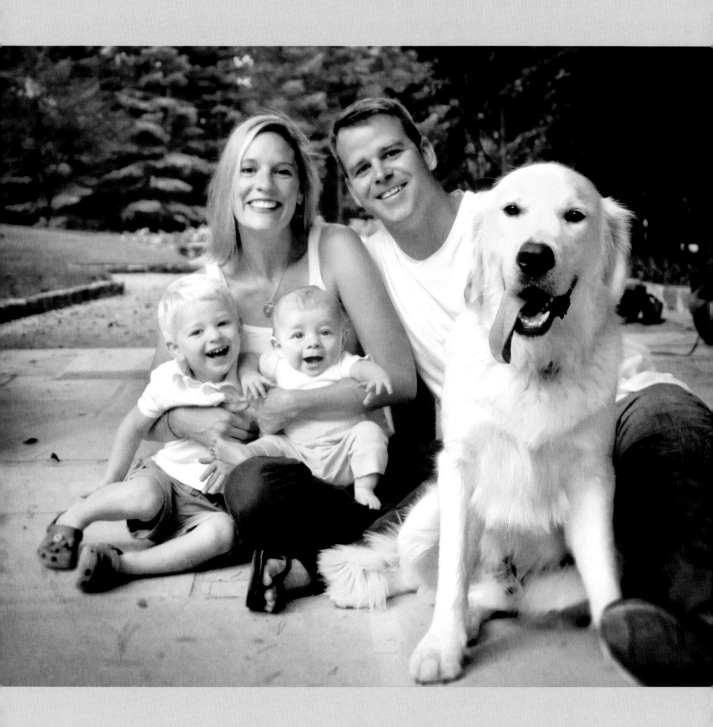

their holiday card or family album, and frame it big to place it over their fireplace. They will beam at who they are, that they are actually showcased as who they are, and you will feel rewarded on many levels for creating such a thing of beauty and for achieving such results.

So what kind of effort garners such results? Right out of the gate, some tips to consider when photographing a family include:

1. Consider the best time of day for all.

2. Determine the best location for the shoot.

3. Dress your subjects appropriately.

4. Try. And then try again.

5. Get close, but not too close.

6. Keep plane of focus in mind for large groups.

7. Help? Yes, please. We can all use some help.

8. Offer continuous positive feedback.

Let's explore each of these tips in detail.

Consider the Best Time of Day for All

When I look at all the factors that go into great photography, several parameters bubble up to the top when scheduling a shoot. For all on-location shoots, I consider the best time of day for lighting, of course. I consider the parents' schedule in terms of when they can take off work in the least stressful way. I consider the children's ability to skip school if necessary. And I consider how close we are to nap times or meal times if babies or toddlers are involved. But more important for me is the simple question: When is the best time of day for everyone's collective moods? This varies from family to family, and it's worth it to find out directly from the family.

Many moms I speak to say their kids are at their best right after breakfast, which can often coincide with excellent morning light. Others tell me it's after school, a snack, and a bit of downtime—usually around late afternoon, which is great for outdoor shoots in the fall and winter but not so great for spring and worse for summer (when most grade-school children are on a summer camp schedule).

But taking everything into account, I'll always choose best moods over best lighting or best location. When I can get all three, I absolutely will and do—but

if it's one out of three, I time the shoot for when my subjects are in a great place emotionally. I know I can control light when I need to do so. I know I can make any location look great with the right angles and creative framing. But I also know that I can work tirelessly with a child who is in a lousy mood and not achieve spectacular results, even in the most perfectly-lit bastion of Xanadu-like backgrounds. In all cases, I want to start with my subjects in a good mood and make the rest happen.

Determine the Best Location for the Shoot

If you don't think location (and a simple change of clothes) makes much of a difference, consider these two images taken just minutes apart—the first in a gritty alley, the other in a sunny park. Even though I had the girl change clothes and I changed the angle, the backdrop radically changes the feel of the image.

For some shoots, the location of the shoot can have a significant impact on the shoot. Consider how meaningful a specific area is for the family. I've done shoots near a memorial for grandparents who had passed on, in the home the family was about to move out of after 25 years, on the beach where mom and dad were

married a decade before, and in a newborn bedroom that was sitting empty for far too long before baby finally, blessedly, came along. These locations hold great meaning for the families being photographed there, and they are a wonderful conduit for bringing more significance into the shoot.

On other shoots, a family may not have a meaningful location in mind and will ask you to choose where to hold the shoot. Here are some factors to consider when you are selecting a location:

- What kind of lighting will you find?

- How close will you be to a restroom if there are little ones?

- Will you have to work around other people in your shot?

- Does this family naturally gravitate to a more rural look, a more urban setting, or a clean and simple background, or do they prefer a whole lot going on?

- Will they want to bring pets?

- Will they be up for a small hike if necessary?

Even though I have two shooting areas in my studio, one with natural light and one with controlled lighting, I find that I do about 85 percent of my shoots on a location outside of the studio. The reason is that I seek out variety and challenges in my shoots as well. I know that if I select a location that is fresh, different, and untried, I will be eager to figure out how I can utilize the surroundings to my advantage. However, just as often, I like to return to places that I know have worked time and time again, especially when I set a goal to find something new in each location.

Dress Your Subjects Appropriately

Clothing. I always advise family members to wear clothing that they know they look good in and, more important, that they feel good wearing. As much as completely matching outfits certainly do "go together," they don't offer much in the way of visual interest that can add depth and dimension to an image. I tend to avoid the matchy, matchy look, because families usually don't dress exactly alike in everyday life, and I want these images to feel authentic. That said, if mom absolutely will die without her two sons wearing the same shirt for some shots, I do my best to keep her happy—and alive.

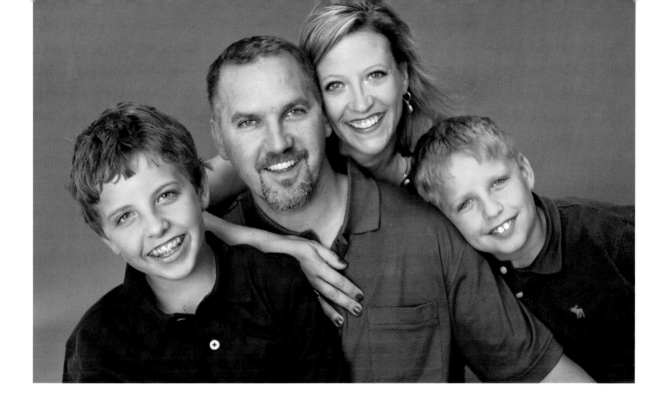

If you want to showcase a family as a cohesive group, it's helpful to ensure that no one family member wears starkly different colors or patterns. That one sore thumb will stand out from the others and not in a supportive, we-boost-you-above-us sort of way. The other significant detail to keep in mind is that if you want your photographs to age well, be sure to eliminate any trendy looks from the group wardrobe.

Think about flattering clothing. You aren't just a photographer, you are very much a stylist as well; utilize your hard-won experience to their advantage and emphasize the upside of wearing pieces that will look best in a printed photograph. For example, if you know your client is concerned about looking heavy in the photograph, suggest darker clothing and sleeves. If you can see that a beige piece of clothing washes out a person's face, let that person know that upfront. As a photographer, the last thing you want to be doing is "slimming" arms in Photoshop on an entire day's worth of images—or sitting there hearing how, in retrospect, your client wishes she'd reconsidered the color of her blouse and finds it difficult to love these images of herself.

Not too long ago, the rule of thumb was to avoid patterns or bright colors because they supposedly distracted from the face. I don't ask my clients to adhere to that rule because I often think bright, vibrant colors can look striking, as long as they don't clash with what mom, dad, or brother is wearing. Again,

The well-dressed man is he whose clothes you never notice.

—William Somerset Maugham

you need to create a great collective look—not bring together a bunch of solo artists and hope for the best.

As a general rule, it's easiest to simply ask the family to wear a selection of clothing in the cool or warm-toned color schemes. That helps you to avoid everyone appearing in black and that one extremely cheerful person in bright fuchsia.

Life is unpredictable, at best. There will be times when you've offered the best advice in the world, but your clients show up wearing something that isn't what you had in mind. In these situations, it's best to be more strategic about placing people in the shot, minimizing any possible

clashing patterns, and ensuring that the emphasis is on faces and expression.

Another wonderful workaround for working with clothing choices that may look great separately but slightly busy when brought together is to change your tactic and shoot with an eye for creating black and white images and utilizing a shallower depth of field. This is another way to minimize what you are less interested in showcasing while emphasizing what you care about most.

Try and Then Try Again

The insurance business is a mammoth industry because it's built around a basic premise that extends to us all: We simply don't know what can happen. We seek insurance so that we can gain assurance that, in a worst case scenario, we may still have *something*, and that that is surely better than *nothing*.

My business is insured, my equipment is insured, and—as best I can—my shots are insured. It's just that I am the one providing that particular insurance. When I'm out shooting, I do all I can to ensure that I not only get the shot, but in the case of a critical, not-easy-to-duplicate one, I get the shot more than once. I've seen others treat this responsibility a bit too lightly at times. For example, I once brought a second shooter who I'd never worked with before to help me photograph a wedding. As is common with weddings, the pace of the day started getting a bit crazy, and I asked her to please photograph a few groups for me. She seemed to be doing a great job of posing, but when I looked over, I saw that she had taken a total of two shots. That's it. Then she let the large group go and moved on to the next group. I quickly asked her to take more photographs the next time she arranged a group, just to ensure that we ruled out the blinkers. When she delivered the images to me later, I unfortunately found that my concerns were warranted. There were two

images of that group, and neither one captured everyone looking toward the camera or not blinking.

I'm not saying that you can't nab the perfect image right out of the gate. That can happen. But it doesn't happen often. If you're not a photographer who constantly looks at the back of your camera, which means you're a photographer who hopefully is spending more time looking at your actual subjects, you need to build in a bit more insurance—snap a few extra images even after you think you've nailed it.

That doesn't mean "spraying and praying"—hoping you get enough shots off that at least one of them comes out well. This type of mentality is about as far from thoughtful shooting as you can get. It will also set you up to spend an inordinate amount of time in postproduction trying to select the one successful image. Continue to shoot in a focused, engaged, and selective manner when you are pointing your lens at groups. Just remember to grab a few extra shots to be safe.

Get Close, But Not Too Close

What's your favorite lens? If you're a professional photographer, this question has been posed to you often. Heck, you've probably even asked the question at some point, too. Yes, lens choice makes a significant difference in the look and framing of an image. No doubt. And yet ask ten great photographers to name their lens of choice, and you may very well hear ten different answers.

From my perspective, I like the creative option of having multiple lenses at the ready so that I can showcase different looks of the same subject based on what I'm hoping to capture.

I like being close to my subjects, especially when there are little children involved. Not only can I work with them more directly, but I can literally drag them back into my frame when necessary. That said, I keep the concept of perspective compression in mind when I'm shooting. *Perspective compression* is the visual effect that determines how close or far away a background *appears* to be from the subject and is a combination of three factors—lens choice, distance from the subject (well, your lens's distance from the subject to be specific!), and shutter speed. Basically, perspective compression is yet one more aspect of photography where art and science mix. There's a science behind how compression works, and utilizing this phenomenon effectively becomes a significant aspect of the art of your photography.

We seek insurance so that we can gain assurance that, in a worst case scenario, we may still have something, and that that is surely better than nothing.

Using a portrait lens

Using a portrait lens and shooting a distance from your subjects spotlights the subjects first and utilizes the background as just that—a backdrop that serves to emphasize your subjects. The aesthetic advantage of shooting from farther back with a longer focal length is that you have a natural break between your subjects and the background, which breaks even more as you shoot from farther back—especially when they, too, are a distance from the background.

Using a telephoto lens

Shooting with a telephoto lens narrows the angle of view considerably and showcases the strongest emphasis on perspective compression, delivering a shallow depth of field and a strong separation of the subject from the background. Telephoto lenses visually compress distant objects so they don't look so far away, which is why you get such a better view of a full moon when you're photographing it with a telephoto lens versus a standard lens.

Be warned, though: Just as you can distort noses and ears by shooting very close to your subjects with a wide-angle lens, you can find a compounded effect of perspective compression by shooting with an extremely long focal length from far away. You may tend to see a flattening of facial features, which can then create an unattractive perspective distortion (which is why celebrity photographs taken from helicopters rarely show their subjects at their best!).

When shooting close enough to interact but far enough away to flatter, recognize that the distance of the lens to the subject changes the field of focus considerably. The nearer the subject is to the lens, the shallower the zone of sharpness. The farther the subject is from the lens, the more extended the zone of sharpness. This is why you can photograph two people at an f-stop of 1.2 if you step back far enough and get both of their faces in focus and a nice, creamy background as a result. Step in much closer to them while keeping the same aperture setting, and you may barely be able to get one person's full set of eyelashes in focus—that's how significant the distance of lens to subject is in relation to field of focus.

Keep Plane of Focus in Mind for Large Groups

The larger your aperture, the more crucial it is that your subjects be in the same plane of focus if you want to ensure that they are all captured in focus. In situations where you are working with a particularly large group and you must tier them in several rows, be sure to narrow your aperture sufficiently so that you extend the plane of focus.

Capturing a large group of individuals, especially in low-lighting situations, can be a difficult process. I rarely use a tripod, but when I know I'm walking into such a scenario, I highly advocate for one. I boost my ISO as much as possible before hitting noise issues, extend my field of focus, keep my shutter speed above 1/100, and use a remote trigger for my camera. I then let the group know in as exaggerated a manner as possible that this is not the time for breathing and certainly not for moving, so don't even think about moving an inch. Setting up the shot using an over-the-top request often elicits a great, controlled response.

Help? Yes, Please. We Can All Use Some Help

I've never shot a wedding without a second shooter, and I never would. There's simply too much that can be missed, and it's crucial to me that I deliver a comprehensive look at the multitude of activities occurring over the course of that big day. That, and I like the idea that someone else is there in case of emergencies. (If you've ever photographed a wedding, you know that lots of those seem to happen often, too.)

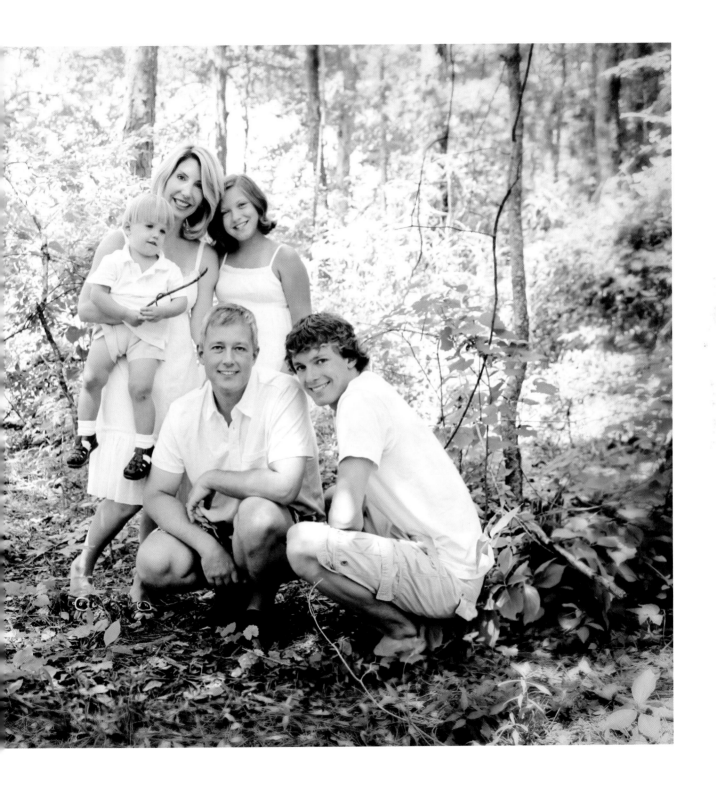

However, when it comes to portrait sessions, I used to shoot them on my own. I just never thought I needed the help. I'd often balance a reflector on my feet, or ask mom or dad to help out in a pinch. But the more I started focusing on how much I want to create a strong family portrait, the more challenging it became to try to "do it all." Couple that thinking with a few serial injuries—flying trapeze incident, flag football injury, chopping-produce-related stitched finger—and suddenly assistants not only sounded like a great idea but a necessary one.

What do assistants do for me during a portrait session? They hold reflectors and diffusers, help get this one's attention while I get that one's attention, carry a bag, change a lens, help keep the momentum going, add to the conversation, and sometimes download the session and back it up, too. One simple reminder when using assistants—make sure they and their equipment aren't in the shot. That said, a random spotting can certainly add some mind-bending elements to an otherwise OK photograph.

When your assistants remember to stay out of the frame (or you remember to remind them), they add even more

than just on-the-spot assistance. Their consistent help with lighting will enable your images to look consistently stronger. And they can often bring some creative ideas into the mix.

We can all use some help.

Offer Continuous Positive Feedback

When you finally bring all the details together and start photographing a family as one, be very aware of how you're coming across to that family. If you're working hard to make something happen and it's not happening yet, for the love of all things photographic, please don't say, "I'm getting nothing," or "I just can't seem to pull this off," or "Hmmm…this just isn't working…hmmm."

You may be talking about the lighting, the arrangement, your white balance, or your choice of lens, but what do the family members hear? "Wow, I'm a professional photographer, and even I can't get a decent photograph of you." Err on the side of sensitivity and recognize that they are taking all kinds of cues from you. If you show a lack

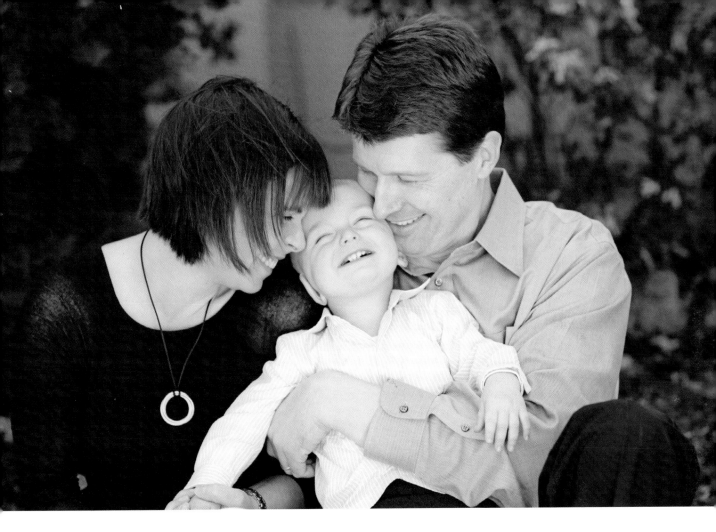

of assuredness, you will only make them more jittery, and the vibe of the session will disintegrate quickly.

Encourage often. Let them know that the shoot is going well and that you're capturing great frames, moments, and exchanges, even if you haven't yet grabbed "the one perfect photograph." They will feed off this positivity and relax, which only leads to better expressions. Compliment freely, but compliment from a place of honest observation, not by using gratuitous phrases that you repeat rotely. For example, I once was photographed for a newspaper article, and the photographer kept saying "Fabulous, fabulous. Absolutely fabulous. That looks fabulous. You're doing (wait for it...) fabulous. Yes, yes,

fabulous!" How much do you think that word meant to me after hearing it 20 times?

Give thought to your feedback and personalize it. What do you really see in your subjects that stands out to you in a positive way? What do you notice about the way they relate to each other that feels familiar and affectionate? Share these observations freely. People don't hear this sort of praise as often as they probably should.

And if you're feeling less than sure about what you're capturing, don't burden them with your insecurities because, I assure you, they are battling enough of their own. Even the most confident of individuals doesn't feel confident every day and in every situation.

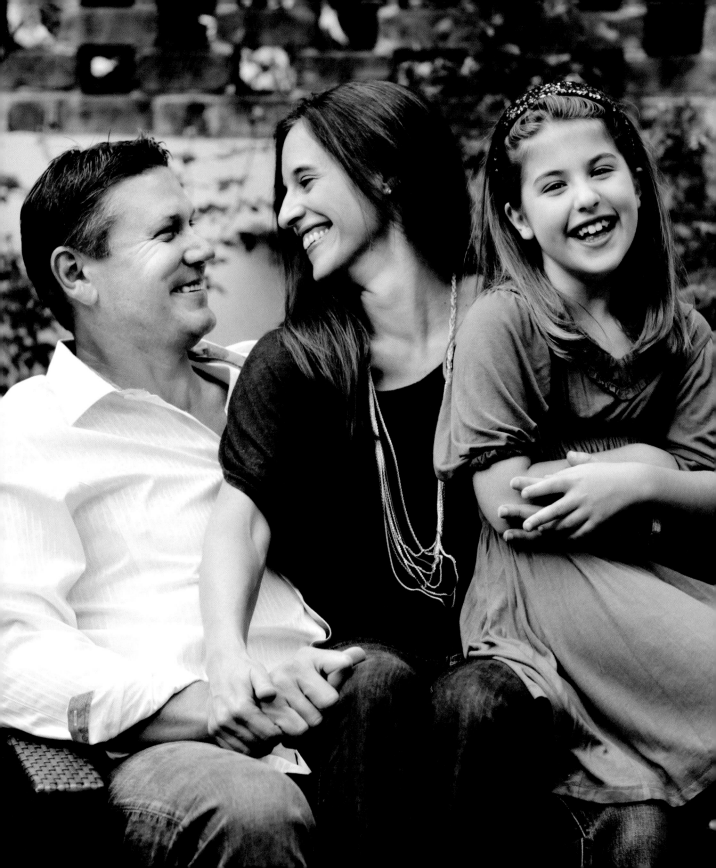

A Session in the Family's Home

A camera can get you close without the burden of commitment. It's a nifty device that way, a magical passport into people's lives with no permanent strings attached.

—Nina Berman

Ensure that you are going into a safe environment in whatever way seems most appropriate to you.

AFTER I'VE SPOKEN WITH A CLIENT about photographing their family, one of the very next decisions we make is *where* we should take the photographs. The typical options are either in the studio, on location, or at the family's home.

Photographing a family in its home is a great idea when there is a recent new addition to the family. You want to keep the child safe and sound in the baby's new room and get a feel for how the expanded family is coming together at home. Other great reasons to photograph a family in its home include times when there may be inclement weather, when the home is particularly important to the family, or when you have very shy members of the family who will feel more comfortable at home. Children who are at a key stage of potty training typically fare better in their home, as do exceptionally busy parents who can manage a shoot in their home but don't know how they could pull off anything else—a scenario that's becoming more common as we all seem to get busier.

Clearly, there are plenty of excellent reasons to conduct the shoot at your client's home. There are also a few crucial considerations to explore before heading over to the family's house.

Know Before You Go

The vast majority of people who will inquire about your services are people you probably do not know yet. There are two major schools of thoughts when it comes to those unknown to you: Don't talk to strangers, and strangers are friends you haven't met yet. The safest tack is probably to put yourself somewhere in the middle of those two philosophies. Don't be so overly protective that you cannot take advantage of welcoming new clients, but be careful enough to do some research.

How often would you answer a phone call from a complete stranger and immediately decide to go into that person's home to provide a service in exchange for funds? Probably not that often. And yet that is exactly what we do as professional photographers. My suggestion is to do a bit of research on who you will be meeting. Engage in a somewhat lengthy conversation. Perhaps confirm a few details the person has shared, such as the person's profession, community involvement, any connections that person has to people you may know. If this sounds a bit paranoid, I'll redirect you to the initial question. It's easy to get

caught up in the pace of your work and forget some of the basic rules of common sense. Ensure that you are going into a safe environment in whatever way seems most appropriate to you—but I encourage you not to ignore this entirely.

After you feel comfortable visiting a client's home, the next step is to discover what you're walking into for the shoot.

Location

How far is the location from your studio or working environment? If you will be traveling farther than an acceptable amount of distance, I suggest you charge an additional travel fee. Our studio policy is that any distance beyond 25 miles includes an additional $100 travel fee. Anything well outside of that range is considered a destination portrait and is priced very differently: Both travel fees and accommodation minimums are charged to the client.

The reason for these fees is because your time is valuable, and is more irreplaceable than any other commodity. When you are pricing out your services, you will find that the time you spend on a shoot directly impacts the costs you incur. This is also the reason many photographers charge additional fees for on-location shoots or any work outside of the studio. Personally, I do not charge extra to leave the studio because I find a value in varying my locations and working outside of the studio. However, if that wasn't a core value to me, I absolutely would charge a higher fee for out-of-the-studio shoots, because they cost me more time in the long run, including travel there and back and any additional equipment setup I may need to do.

The Quality of the Light

Most of the natural light you will find in a client's home comes from doorways and windows. Unless you know someone with a retractable sunroof or an extremely well-lit chimney, these light sources will be your only options for natural light. I am a big fan of opening the front door as widely as possible—especially the double doors I come across from time to time—and pulling my subjects into the front section of the house. This often means some serious furniture movement. Much of what you do in a client's home is figuring out what little "sets" you can create near the light you find; that is part of the fun of it, too.

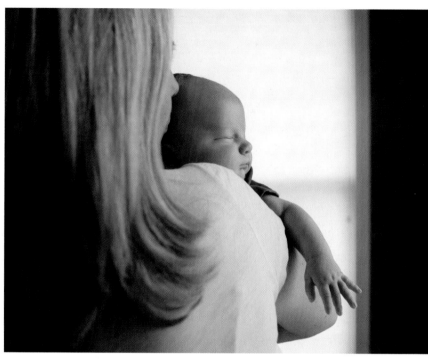

Window light can be absolutely gorgeous, especially when it's pouring through large picture windows that just happen to be technically diffusing a soft light and delivering a softbox-quality effect. Just like a stand-alone softbox, however, window light is a directional light and thus needs a complementing fill light, such as a flash or reflector, to manage any undesirable shadows that are being created. It's pretty unreal what you can create with simply this one main light and the fill you incorporate.

Other ways to control the effect of the natural light pouring in from a window include draping a sheer curtain across it to further diffuse the light or moving your subject away from the window to "decrease" the power of the light. You can position your subject in any direction toward or away from the window and get very different lighting, looks, and feels. Start by placing your subject at a 45-degree angle to the window and then adjust from there to see what looks best. Some of my favorite portraits were shot with my subjects' backs to the window, bouncing light back into their faces with a front-positioned reflector.

The Look and Feel of the Home

All homes are decorated differently and usually reflect the taste of their occupants. What that means, then, is that you never know what you're going to find until you get there—unless you ask first. If I know that my clients love big, bold colors and lots of them mixed (of course); assorted patterns; and fleurs de lis designs, I may want to advise them on the necessity of extremely simple clothing or the benefits of calming black-and-white photography. It's not uncommon to see a beautifully designed home that looks great as is but is a bit confusing, aesthetically, when you start to think of it as an option for a photo shoot. By the time you collect a family of five wearing varied clothing in a home that's surrounded with those patterns, the image in your viewfinder can end up looking like a page out of *Where's Waldo?*. And if your goal is to really showcase individuals and present clean, uncluttered photographs that assist in doing so, a seriously busy environment like that is not the best place for a shoot.

Consider bringing the entire family outside on a porch, into a yard, onto a sidewalk, possibly a field down the street, or even smack dab in the middle of the street. Keep in mind that most of your clients don't study photography, design, and composition, and have no idea why you wouldn't consider their living room the perfect place for photographs. Part of your already-involved job as a photographer is to educate them on why certain backgrounds are better than others, and then have enough belief in your viewpoint to change the course of the shoot once you know it's not working, so that you can truly deliver excellence to your clients. As Annie Leibowitz once said, "You have to make it work, whatever is going wrong. If I don't get a good picture, I don't blame my subject. I blame me."

Many clients want to know what they should have planned before you get to their home. Of course, I want to ensure that their family is in the best mood possible, so we talk through the basics of making sure everyone is well fed and well rested, at least. We also discuss how, even though we'll be in their home, we need everyone to be involved in the shoot. The client's home is the easiest place to "lose" family members, because they know exactly where all the distractions are—the TV, computer, toys, work, iPods, and so on. So it helps to have buy-in ahead of time from your clients so they avoid all of the potential diversions—similar to having to shut off your phone before airplane takeoff.

After that, I request an uncluttered environment. I tell them the house doesn't have to be spotless, not by any means! I just need some areas that are free of

Much of what you do in a client's home is figuring out what little "sets" you can create near the light you find; that is part of the fun of it, too.

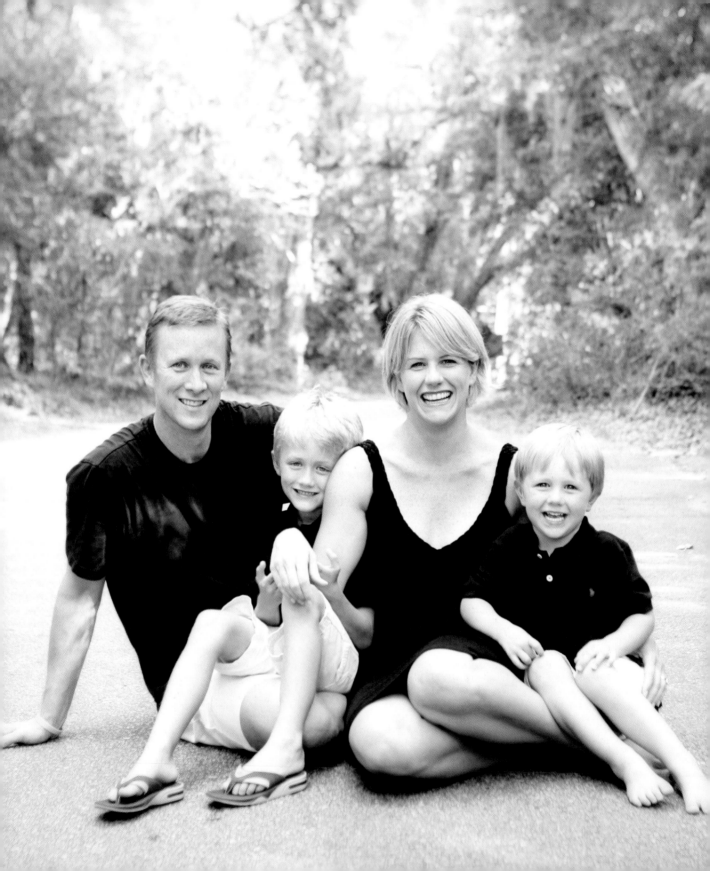

stacked papers, extra boxes, scattered toys, and all the things that tend to litter the typical family residence. This is where it becomes important to better communicate your vision of what clean and uncluttered might mean. I take the next step with them and then describe how I view a clean palette for a shoot as a way to really show off the people in the photograph. By describing what I am referring to as "clean"—typically free of a significant amount of conflicting colors, patterns, imagery, knickknacks, and the like—they more easily buy into my vision for the shoot. Through personal experience, I've found that the more specific I am about describing what an uncluttered environment means to me, from a photography perspective, the more likely I am to discover better locations available for me to shoot when I arrive at the home.

Consider bringing the entire family outside on a porch, into a yard, onto a sidewalk, possibly a field down the street, or even smack dab in the middle of the street.

DID YOU KNOW?

Homes and Homesickness

Homesickness is a medically recognized form of depression described as an emotional reaction where an individual connects a feeling of lowness and missing with a longing for familiarity, such as that person's home or the family that occupies it. Studies show that most people have felt homesickness at some point in their lives—a yearning for and grieving of a familiarity that feels too far away. This form of depression is called "homesickness" because of the simple fact that most people identify a location, their "home," as the nucleus of what they hold most dear: their family, pets, prized possessions, and keeper of memories. It's most common to experience homesickness while:

- Away on a long trip, especially one that becomes longer than planned

- Starting a new phase in life, such as going to college

- Attending a sleep-away camp or visit away from all family

- Being hospitalized

- Experiencing an inability to return home for an important holiday, such as Thanksgiving or a wedding

- Moving into a new house or apartment

- Experiencing a major change in family, such as a death, separation, divorce, or remarriage

- Being overworked and away from home too often

Although associated emotions of loss, melancholy, anxiety, and minor physical ailments tend to be more mental than location-based, the resulting depression can be surprisingly powerful in its nature, even capable of debilitating an otherwise nondepressed individual.

Reference: Fisher, S. *Homesickness, Cognition, and Health.* London: Erlbaum (1989), and Carden, A. I., & Feicht, R. "Homesickness among American and Turkish college students." *Journal of Cross-Cultural Psychology*, 22, 418–428 (1991).

Wardrobe!

The last major request I have for my clients is for them to simply have several outfits ready for the shoot in addition to what they may be wearing as their preferred attire. I like being able to quickly select alternatives, if necessary, because it's helpful to be able to manage any clothing disasters on the spot or simply just improve coordination of the family's clothing. And because I like to show an assortment of images after the shoot, which is more easily produced with a variety of clothing changes, helping to orchestrate additional outfit changes enables me to better do that.

Arriving at the Home

Once I arrive at the home, I prefer to immediately put down my gear and simply talk to everyone there. This usually involves a tour of the home, if I haven't seen it already, and some conversation about what we'll be going for, because we can now see our options together. This exchange tends to naturally evolve into a discussion of what we can do with the photographs from the shoot, for example, identifying which walls might be perfect for certain wall displays, which framed pieces my clients might be looking to update—anything that will be helpful to keep in mind while we're shooting.

Jessi Blakely

If the family has small children, I ask the kids to give me a tour. Even though that means I sometimes wind up in someone's favorite closet or taking the circuitous route via the doggy door into the backyard, I get to see what they see—the more magical sections of their home, according to them. This also gives me a chance to build a rapport with children that has nothing to do with photography, which often goes a long way toward quickly getting past the whole lens awareness thing.

I find, too, that I get a chance to just explore with my camera. As much as I have a good eye for locations and framing, it still helps me to look through my lens and really see what I'll get. What would it look like if I shot from the top of the staircase? How about taking a shot from a belly-to-the-floor angle over here? How would an ultra-wide lens work from the back of this corner? Just five minutes of prep work with your camera and no subjects can offer you a wealth of inspiration to bring into the shoot.

Meeting the Furry Ones

Another upside of waiting a few minutes before I start photographing family members is that I also get a chance to meet any pets, which I always try to incorporate into the shoot. Sometimes families are very eager to include their furry folk; other times they seem indifferent as to whether or not they are even included. In the end, they nearly always invest in a portrait with their pet. It's an interesting phenomenon, but sometimes they don't even know how significant their pet is to them until they see the connection they have with them—or the connection their children have with them—in an actual photograph.

Stand-alone portraits of pets by themselves, just doing their thing (often, hanging out), are more popular than you might expect. Remember, though, that photographing animals is a skill unto itself, requiring boundless patience and cat-like reflexes (ah, wordplay). If much of the job photographing people is getting them past lens awareness, there is absolutely no requirement for that when it comes to pets. They could care less if you're holding a camera or a thermostat. If they can't eat it, swat it, or catch it, they're not that interested either way. Because they have no desire to wait for you, ensure that you have your camera settings in position and are as prefocused as possible so that when that perfect moment arrives, you are prepared to snap it. Note that the burst of light from a flash can not only startle an animal, but it can often detract from the natural color of its fur (except for a dark-furred animal that may benefit from some of the shadow detail that will be enhanced by adding fill flash to the portrait). For the most part, you're better off killing the flash and using natural light.

Sometimes they don't even know how significant their pet is to them until they see the connection they have with them—or the connection their children have with them.

Finding Other Surprises

If I'm lucky—and sometimes I plan to get lucky—several members of the family won't be ready when I arrive. This gives me an opportunity to catch them in a more natural state. Often, mom hurrying everyone to get ready adds additional stress to an already unusual situation (remember that it is quite unusual to spend hours just being photographed). If you can convert that stressful time into a planned part of the experience, you end up getting some great photographs

you wouldn't have achieved otherwise, and you get the opportunity to eliminate some unnecessary tension. I'm a big proponent of eradicating any unwarranted anxiety. It doesn't help the mood of the experience, and it often shows on my subjects' faces more than they would guess. If your goal is to photograph your clients as who they are, and who they are in that moment is a pack of stressballs, that's exactly what you'll capture. And photographs of stressball packs rarely inspire positive emotion.

Another side benefit to arriving a bit early for a shoot—or, again, building in the expectation that you won't really start shooting for another 15–20 minutes or so—is that you get some unhurried time to look for the things that show how these individuals make up a family—things like several jackets in different sizes hanging together or a table all set for dinner. I recently came across a collection of bicycles, one for every member of the family, and I took an extra five minutes to arrange them a bit more artfully. The resulting photograph is the perfect "fine art" piece for the family to frame and showcase in the home. Even though it's not an image of family faces, it conveys a great sense of what the family enjoys, and that can be a rather meaningful expression of what connects them.

The Actual Shoot

When all is said and done, we've shot in nearly all the useable locations inside and outside the home.

By the time we get to the actual "photo session" portion of the experience, we are hopefully past any anxiety about how everyone will look or act, and we can simply begin a new conversation—one that doesn't end until I shoot the final frame. We'll often start by bringing the entire family together in the best-lit spot in the house. I'll use the reflector, as well as additional lighting when necessary (more about that in Chapter 9, "A Session on the Move"), and initially just focus on getting a great, clear shot of everyone's faces. The family-all-together-looking-at-camera shot isn't a particularly creative one, but it's often a treasured one—especially if everyone is looking honest and at ease. While I'm setting up that shot, all kinds of little experiences are happening here and there. The daughter may be looking up at mom or little brother might be leaning forward to hug the dog. I like to zoom in and frame some of those moments separately in the midst of securing the larger shot. When it comes to delivering the images, I'll offer my subjects a variety of styles from which to choose. If I happened to get three great family shots, I'll show each in a different processing and framing style. Often, they will choose one for a large portrait and others for albums or holiday cards or gifts (recall how they will put great shots everywhere?). Give them a bit of variety, and they'll happily invest in more imagery.

After I know I've captured at least one good shot, we'll break from the group and just move about the house in smaller groups. I might work one on one with the children; shoot just the couple that heads up the family, alone; or take great individual portraits of adults in single-parent households. The vast majority of the time I'm shooting with as high of an ISO as I can without having to worry about noise in the frame (ISO 1600 is often just fine with the newest cameras) and a shallower depth of field (often 4.0 and less, remembering to step farther back to get more individuals in focus when shooting the larger group shot). And I'm doing it all fairly fast (a shutter speed over 1/100, at the very least, to eliminate unintended motion blur).

Stepping Outside

I like to spill outside as often as possible, using all porches and outside stairs, backyards, fences, trees, benches, or anything I can find. Larger reflectors make for terrific shade creators when needed, and I don't hesitate to use them for that purpose. It's simple enough to have an adult hold the reflector low (to spread

the shade wide) and at an angle (against the sun, again to increase the width of the shade), allowing just enough break from the overhead light to allow us to shoot where we want outside regardless of the time of day.

When all is said and done, we've shot in nearly all the useable locations inside and outside the home. And I've been sure to hone in on any more important areas—the new baby's room, the fireplace that's used as often as possible, the basement where everyone plays games. One of the greatest benefits of shooting in a family's home is that you are often surrounded by rooms, environments, and mementos that are meaningful to each member. Incorporate these elements into the frame, and you boost the meaning of the portraits.

A Slice of Every Day

In addition to the normal images we might get at a portrait session, we also have the opportunity to capture more of a slice of everyday life. Asking ahead of time what the family really loves to do in the home allows you to incorporate just a bit of that experience in the shoot. I often find that, although my clients will frame portraits and candids, they love the idea of an album of prints that center around a small theme: making snow angels in the backyard; baking cookies in the kitchen; bath time, books, and being tucked into bed. You also have the option of creating an entire shoot from "a day in the life" perspective. For instance, you meet the family in the morning, as early as when each member is getting up, and you stay with the family until the last member is standing. These documentary-style sessions can truly capture a family's life at the family's current stage, but these sessions are a different animal than the regular portrait session, so they should be arranged, prepped for, and delivered

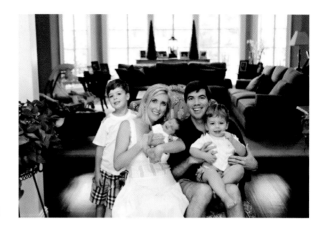

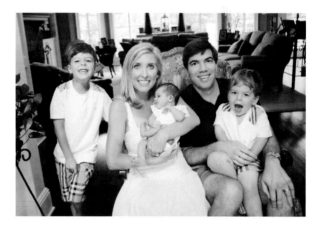

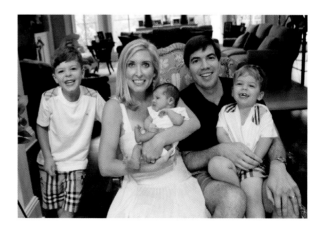

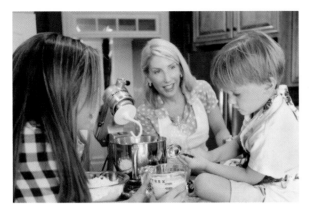 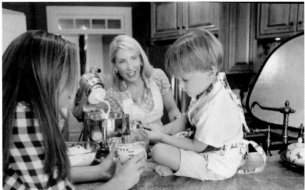

in a different manner. And because they are often shot in areas that are not always as photogenic or well-lit as portrait sessions, be prepared to fill in light as needed (see the reflector wedged in between the counter and the cabinet in the above figure). You often have to make lighting work whichever way you can, but it's worth the effort in the long run.

When the shoot is done, and it's time to pack up my gear, I thank all the family members for their time, cooperation, and general fantasticness, and I remind them of the next steps, which include meeting at the studio to view the photographs together. I also tell them about some of the shots I feel we got and how they will fit with what they wanted to hang on the walls in their home or in the albums we discussed at the beginning of the shoot. I do this because I know that by enabling them to better understand the final product options from the shoot, it's easier for them to then show up to our consultative sales session with more of a plan of how everything will come together, which makes everyone involved much happier.

I then head back to my home with the smell of somebody else's dog on my clothes—and consequently suffer the jealous sniffs of my own dog. She eventually forgives me, but not for at least three to four minutes.

A Session in the Studio

Above all, I craved to seize the whole essence, in the confines of one single photograph, of some situation that was in the process of unrolling itself before my eyes.

—Henri Cartier-Bresson

What I love about traditional portraiture is that the bar is set high when it comes to striving for excellence in technically proficient capture.

WHEN MOST PEOPLE think of the traditional family portrait, a formalness of sorts comes to mind. Everyone is positioned *just so*, down to the pinky. The lighting is broad and often flat, the composition is standard but pleasing, and the focus is not so much on expression but on capturing the likeness of the individuals in the frame. When I first decided to become a professional photographer, most of the work I saw was traditional family photography. The interesting thing, though, is that I liked it less then than I do now. Initially, I saw it as stiff, lacking in emotion, depressingly standard, and—frankly—boring. However, as I've become significantly more versed in the technical aspects of lighting, posing, manual capture, metering, and composition, I've come to appreciate what I see when I look at quality traditional portraiture. I also see where contemporary portraiture has excelled in comparison.

What I love about traditional portraiture is that the bar is set high when it comes to striving for excellence in technically proficient capture. There is strong focus on quality lighting, utilizing fill light carefully and applying rim lighting conscientiously and regularly. Composition may be standard and predictably triangular in form, but it is also visually appealing. And although much of the contrast in

DID YOU KNOW?

A History of Same-sex Marriages

Even though same-sex unions are increasingly making up the basis of the new modern family, the debate over the state of marriage today is still a controversial topic. But same-sex marriages have existed in one form or another since ancient times. In fact, references to relationships date back to the Ming Dynasty. Various historical documents record legal arrangements as having been sanctioned throughout the world and, in fact, Emperor Nero was recorded to have married a slave named Hierocles.

In a.d. 342, Christian Emperors Constantius II and Constans outlawed same-sex marriage in Rome. But that didn't put an end to formal unions, with historic documents recording rituals and ceremonies over thousands of years. Nonetheless, it wasn't until 2001 that the Netherlands became the first country in the world to legally grant same-sex marriages. Since that time, many countries have joined in to mutually recognize same-sex marriage. Currently, the United States does not recognize same-sex marriages on a federal level but same-sex couples can marry in certain states.

Sources: Neill, James. *The Origins and Role of Same-Sex Relations in Human Societies.* McFarland, 2009.
Scarre, Chris. *Chronicle of the Roman Emperors.* (London: Thames and Hudson Ltd, 1995), p. 151.
"Same-sex marriage around the world." CBC News. www.cbc.ca/world/story/2009/05/26/f-same-sex-timeline.html.

traditional images may be mild and rather timid compared to today's more modern look, the highlights and shadows in the photographs are well preserved; you rarely see broken highlights or crushed blacks in a quality traditional portrait.

What contemporary portraiture excels at, as a general shift in attitude, is documenting expression. Although traditional portraits may be artfully arranged with a sense of aesthetic balance, contemporary imagery strives to tell you something about who the family is and how these individuals care about one another. If you can show that *and* keep the rest of the critical pieces in place, you have achieved a genuinely compelling portrait of a family.

Studio Portraits

Photographing family portraits in the studio conjures up the concept of a more traditional style because that is the location where formal portraits have historically occurred. And just as the way we capture images changes, poses change, backgrounds change, lighting styles change, and outcomes change. But the way we set up a portrait is still similar to traditional means. If we are going for a certain type of photograph, a more contemporary one, we need to position the lighting correctly and be ready to go when the moment we're trying for occurs. Because if you're going for expression and moment, which sometimes only happens for a microsecond, it's imperative that you be prepared for when it does.

Take the following example: For this particular shoot, we used one chair, one background, and basic front lighting. We needed a bit of help getting everyone on the chair, and we were going for one photograph in which mom was holding her brand-new baby while receiving a kiss from her toddler. Seems easy enough, right? Well sure, unless, of course, you've ever photographed a newborn and toddler together and offered direction. Then you know that it's anything *but* easy to achieve.

We started out by simply getting the toddler motivated to stay put, which required a great deal of enthusiasm on all of our parts. When asked if he could give mommy a little kiss, he said, "Sure." Then he kissed the baby instead. He started to leave the scene once he was finished, and we had to talk him into trying again and getting back into place. Because he was an affable little fellow, he tried again and actually did kiss mommy, as encouraged, but we lost the baby a bit in the process. The toddler left the scene again and thus more prodding was needed to get him to return. We succeeded in placing him back in the scene and gave it a final try. That time we nailed it—the image we were going for all along.

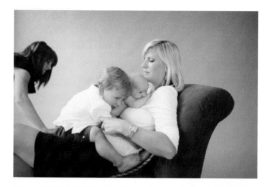

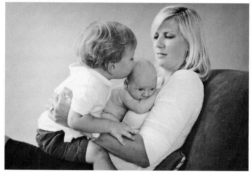

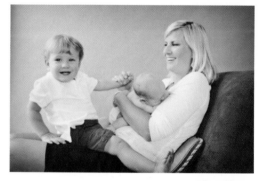

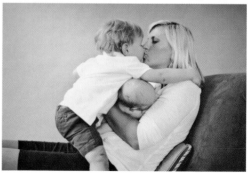

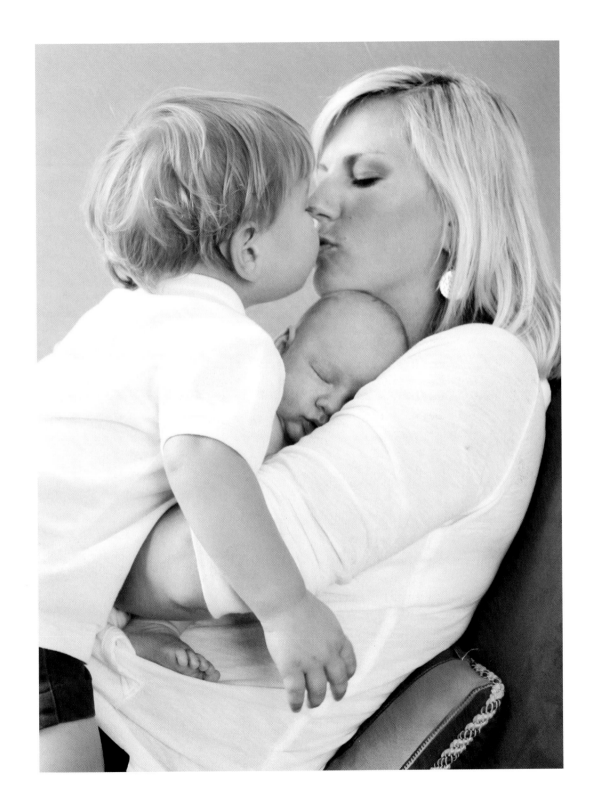

I find that one of the underlying purposes for why I photograph a family is to find something real about them—that belonging I mentioned.

Backgrounds and Settings

My take on backgrounds in the studio is that I prefer to *either* have something that enhances the images—perhaps a certain color that may work with the family's clothing or brings out a dominant eye color—*or* I like the idea of the background disappearing almost completely, as in you hardly notice it at all. A purple-blue background might be perfect for enhancing the color of someone's violet-toned eyes, for instance, whereas a white background might fall out of focus rapidly when it is positioned far behind your subjects who are strongly in focus and filling the frame.

However, I always try to avoid a "fake" background. I know that green screens are quite popular, allowing you to fill in whatever you like as a background, as are mock nature scenes or cityscapes, or even a blue sky with clouds. Some families might love an image like this behind them for any number of reasons. But I find that one of the underlying purposes for why I photograph a family is to find

something real about them—that belonging I mentioned; how they can be grounded in each other; how they can find laughter together; or how they go through somberness together. Whatever it is they experience, whoever they are together, that is what I most want to capture. And I find it difficult to blend the real and the fake in a way that doesn't leave viewers with some disconnect that they may not be able to technically explain but they feel nonetheless.

A Place to Settle Down

A shoot in the studio typically begins with a family walking in with all kinds of stuff: multiple clothing outfits, diaper bags, strollers, makeup, curling irons, hair dryers, toys, stuffed animals, snacks, beverages, photographs, or tear-out sheets of images they love. The list goes on and on and on. It's not uncommon for them to make several runs to and from the car to make sure everything has been collected and deposited in the studio. It's for that reason that our meeting space is located next to the front door. With a simple round table surrounded by comfortable chairs, the space can double as a holding location for everything it might take for a family to feel like it is ready and set to go.

Once everyone is settled, we check out all the clothing offerings and select something to get us started. Recall that I ask my clients to bring in multiple options because I bear in mind that they don't "do this" every day, so I can't expect that they will know what will look good on camera, especially when worn in a group. Simply telling them to all wear something comfortable doesn't typically work well; they may be extremely comfortable in exceptionally busy clothes that clash terribly. One of the simplest ways to manage wardrobe discussions is to ask them to at least bring some solids in a similar color family. That way we will at least have one set of clothing to fall back on in the worst case scenario that nothing else, at all, coordinates even remotely well.

After some getting up to speed, similar to the time I like to spend getting to know them a bit better at their home, I try to start out with a photograph of the whole crew together. I keep my eye out for anything I might spot in the meantime, because this is exactly when young children, especially, start roaming around the studio and exploring, and then dashing back to mom and dad for support. This can make for some fun and unexpected images.

Creating a Space for Movement

Even though we have a large studio space and a large background option (12 feet as opposed to the standard nine feet), I still find it a risk that the images can become too staid when we are in the studio. For that reason, I encourage movement during the shoot. I light the entire shoot widely with continuous lighting, which allows me to offer more freedom to my subjects to move about a bit. My shooting style is also one that is responsive to what is happening in front of me, as opposed to overly directing it, so I am used to moving as needed with the flow of the action.

I light the entire shoot widely with continuous lighting, which allows me to offer more freedom to my subjects to move about a bit.

Keeping subjects in one spot and discouraging a natural flow of activity is a hallmark of the traditional portrait, and one of the reasons it is stereotypically perceived as having a rather stiff look and feel. No one really holds their chin exactly like that or splays their fingers apart quite so expertly, and I would suggest that the viewer can sense the unnaturalness of such a lack of movement. To be clear, I do appreciate the right angle that clients may hold their chin so it looks significantly more flattering than, say, when it is smashed up against one's face, for instance. I also like hands that look less clumpy and more elegant with fingers a bit apart. But there are ways to achieve these more attractive looks that appear more honest and engaging. And this is exactly what I try to achieve when I pull everyone together for a family portrait in the studio—an attractive, expressive, and alive feel of all family members together. However, this is more challenging to achieve in a studio than anywhere else, simply because you almost have to work against a backdrop to keep the life in the image. So many other places you will shoot can offer a great deal of zest by the very surroundings your subjects encounter as you move about during your shoot.

The upside of shooting a family portrait in the studio is that you can control the lighting and the look of the space, and you can eliminate any distractions in the background by selecting it quite precisely. If you find you are struggling with the look of a studio backdrop, you can also just fill your frame with your subjects, benefiting from the controlled light and even temperature of your space while focusing on the subjects front and center. The other way to avoid too much of a "backdrop" look is to pull your subjects away from it as much as possible to create more depth, which tends to often look more interesting as well.

In keeping with showcasing a sense of flow and motion, get in the habit of working as expediently as possible. This is particularly true when working in a studio

environment that may not offer as much energy as an urban shoot, for instance, or an early evening at the beach. The practice of trying to keep a family together for the length of time it takes you to pull off a great image can be highly fatiguing to the spirit of a small child. Not to mention the fact that it can physically tire out adults who are trying to keep everyone together and keep a certain look on their faces.

I've witnessed photographers keeping a family in one position for rather extraordinary amounts of time while they fixed this, that, and all the rest, and then double-checked it all one more time. I'm all for ensuring that you're capturing a shot technically well and lighting it beautifully, but if you cannot do that in a fairly brisk manner, practice on nonhumans until you can. By the time living, breathing, must-stretch anthropoids show up for the shoot, you can keep the

rhythm going in a manner far more conducive to eliciting genuine animation and connection instead of recording tired, forced looks that were clearly held for far too long. Keep in mind that you should be ensuring quality first and then looking to speed up the process second. This is immensely different than nervously racing through a process and then trying to fix it later in postproduction. If you need to keep your clients waiting a bit to ensure you've "got it," that's definitely preferable to fudging it as best as you can and hoping you can make necessary corrections later to account for a poor setup.

Working with or Without Props

As mentioned in Chapter 4, "Setting Up a Working Studio," I rarely use props in my photography. Perhaps the primary reason for this is that when I first started photographing clients in the studio, I recognized that much of the studio photography I saw shared a common theme: Many subjects were posed with props that were used in shoot after shoot—so much so that after viewing enough of one photographer's work, it almost started feeling like the people were the props and the items that were being utilized repeatedly in each shoot were the subjects. I noticed that to such a degree that I became wary of utilizing any item that might show up time and again; instead, I chose to either not use anything at all or to invite my clients to bring in something that might be meaningful to them, and thus unique to their imagery.

What constitutes a "prop" may vary widely, but in general it would include items such as rocking horses; toy boxes; stuffed animals; little painting easels; realistic-looking animals, such as bunnies, puppies, and kittens; wooden blocks; rubber duckies; sand pails; birthday cakes; large alphabet letters; oversized books; large wooden cutouts of shapes, such as hearts, moons, and stars. The list really could go on, but the point is that I felt like rotating recognizable props in and out of my shots would devalue the authenticity of each family I photographed, from *my* perspective. If you are already utilizing a wide variety of props in your shoots and you and your clients are loving the results, then please keep doing what's working for you! I just found that it didn't work well for me, so I resist props and shoot very few images using them. Instead, I rely on my interaction with individuals to garner their interest, and I am constantly re-angling my shots and switching up the look and feel of the images so that I can keep visual interest in the frame without additional accoutrements.

One great benefit of using even the most casual of stools and chairs is that the same subject who might feel he has to perform on a studio set might totally relax when he sinks into a comfy chair.

Posing Stools and Chairs

Being able to seat your subjects changes the mood of the image, typically offering a more relaxed view of individuals, especially when they genuinely seem comfortable and at ease. Having a few simple ways to seat individuals will go a long way toward ensuring more variety in a studio shoot and offering additional ways for them to be posed more attractively. The tried-and-true method of simply seating everyone on the floor of the studio atop a seamless background is brilliant in its simplicity, but there are some people who will balk at the idea. Sometimes it's because it feels too casual; other times there may be a medical concern or knee or back problems, and with much older adults, it may simply be too much of a strain. For those reasons, I offer multiple seating options when I am posing groups and individuals. Simple options include backless stools; industrial-chic chairs; small, armless living room chairs; settees; little sofas; benches; and much more. What I want to avoid is bringing anything into the shot that stands out too strikingly that might be noticeable in multiple family portraits. I don't want to stumble across the same problem I am trying to avoid when it comes to utilizing props too frequently.

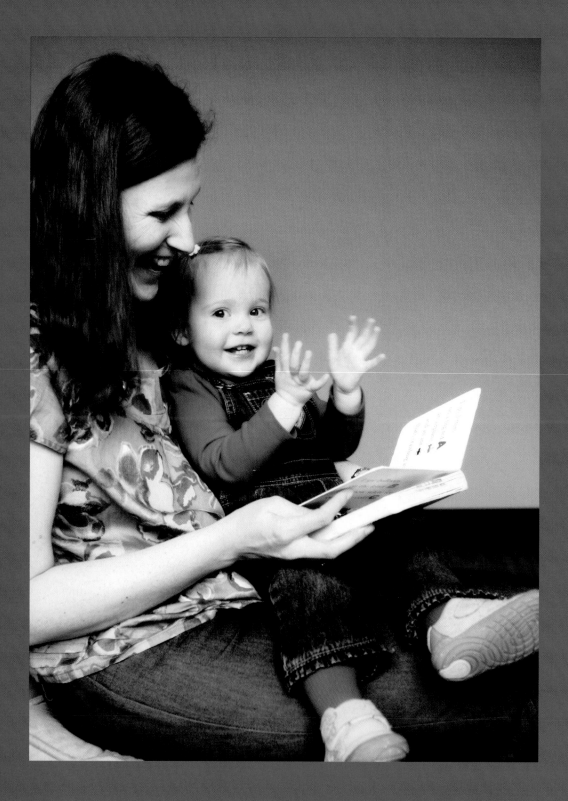

Stepping Off the Seamless in the Studio

Just like it can be more fun to drive off the main roads, I utilize all the space in my studio so that I can produce a variety of images, even when I'm in a designated area. That means the walls are painted an assortment of colors, and I shoot against a variety of them. I also like to bring in insulation board, paint both sides of it in two different colors, and clip it to a backdrop pole. I play with a variety of drapings and fabrics that are stitched together and shoot wide, with my subjects a distance from the backdrop, so that you can't see the stitching. And I position clients directly on the floor and shoot from the top. I even enjoy working with shadows that are created against the wall and various times of day to produce visually appealing images from lighting shifts that completely change day to day.

The point of incorporating music to such a degree is that its presence can completely change a room, a mood, and a subject's response.

Ambience

It would seem that I could skip over any suggestions about keeping a studio clean, and yet I have visited a number of photography studios that are anything but. It's almost as if some shooters become so honed in on their craft (a noble thing) that they develop a sense of tunnel vision about the appearance of their space. No matter where you are meeting clients, try to step back and see the space from the view of someone who is walking in for the first time. Is the area clean? Uncluttered? Inviting? Is there a sense of welcoming ambience? If there is a bathroom in the location, is it, um, unpolluted? Does it invite a person to use it, not just for basic needs, but also to change clothes, apply makeup, check appearances in the mirror—any number of reasons a person might use a bathroom? Is there ample space to change a diaper, if needed?

Adding Music

A measure of your professionalism will be assessed based on the ambience of your location, fair or otherwise, so respect that your clients' first impression of your location will be largely based on how they feel when they walk in. A wonderful addition to any shooting space is music, which can evoke a fantastic array of emotions. The photograph doesn't capture audio, but it absolutely can capture the sense of joy children feel when dancing along to a favorite song or the sense of serenity that may calm with more soothing melodies. I installed a surround-sound system that draws from subscription radio, so we can play ad-free music, as well as playlists we create on iTunes and CDs our clients might request we play. I even have a separate option to play a premium service Internet radio station that can be customized to each client based on the client's favorite songs or artists. The point of incorporating music to such a degree is that its presence can completely change a room, a mood, and a subject's response. It's a vital part of every studio shoot I do.

Photographing with Studio Windows

I utilize the windows in our studio to the maximum degree I can. That means I not only rely on them for a main light source, but I also shoot against them as a background tool and alongside them as a composition tool.

Being able to control the light they offer is fairly key, so I have two sets of shades custom fitted to them, which actually allow me three options when it comes to controlling daylight. The first shade is a pure blackout shade, or a flag (more information on this in Chapter 11, "Lighting"). This allows me to block out any light that may be trickling into the studio and thus rely solely on my studio lights

to create whatever lighting configuration I want for the shoot. The second shade is a soft diffuser shade. This allows me to just soften the window light if I want to use it but only to a lesser degree. And, of course, if I want to use the full extent of the light streaming in through the windows, I roll up the two shades completely and don't utilize any filter at all.

Stepping Outside of the Box

I have never shot an in-studio session without leaving the studio at some point. There is simply too much to offer my clients in terms of additional variety to only stay inside the space we're in. The outside of each photographer's studio space will vary tremendously, of course, but if you at least have a shady spot nearby, I highly suggest you use it! We tend to utilize the front outside wall of the studio, the stairs nearby, the alleyway behind our studio, the conveniently located small patch of grass next to the building, and the walkway to other commercial spaces—basically, anything and everything we can. Why limit our experience to a backdrop or a wall when we can include little teasers of the whole world? I do this to keep the shoot interesting for all of us, and because it changes the energy of the whole shoot to shift to a different location, even if it's only three minutes away. Especially when dealing with small children, it becomes imperative to change the scenery just to hold their interest and to uncover new expressions and interactions. A child who may be calm and peaceful in the studio can feel a bolt of excitement just being able to run freely along an outside sidewalk. Remember that I am going for a spectrum of expression when I am conducting these shoots—so shaking things up a bit is a near requirement in terms of being able to achieve that.

What Happens While the Shoot Happens?

Photographing a shoot in the studio comes with a couple of real benefits. First and foremost, from an ease of transition perspective, it's great to have a clean, open space for clients to use the restroom, change clothes, and see how they look in the mirror. For the highly self-conscious, the studio is certainly a more appealing option, because your subjects get to see how they are looking as things progress. This can sometimes be a factor when you are on location. If your subjects want to check their hair, makeup, or the fit of their clothing and have no way to do so, they can become preoccupied and not really "there" with you. If you are shooting in a controlled space, however, this is not as much of a problem because they can check their appearance frequently.

For any downtime, there is also the view. Not the view outside the studio windows—we're located in a commercial space—but the view of what we showcase inside the studio. We display a great deal of work in our studio, and our clients have plenty of time to view the wide variety of framed pieces, couture boards, and canvas collages, as well as flip through multiple album options. In many ways, it's like waiting in the showroom while you take your time deciding on what you want. It's not uncommon to end a shoot with clients remarking on how they will probably get something like this or that (pointing) when they come back to order prints. If you know you'd like to meet with your client to pre-sell them and are struggling with when you can fit in such a meeting, you may want to strongly consider photographing your clients in a studio space, because this is essentially what is happening in real time.

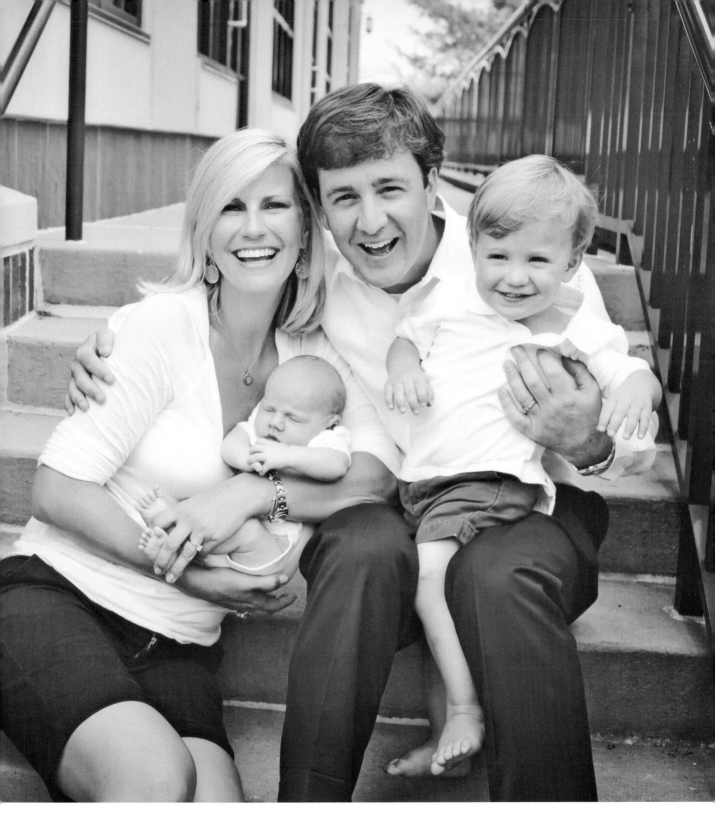

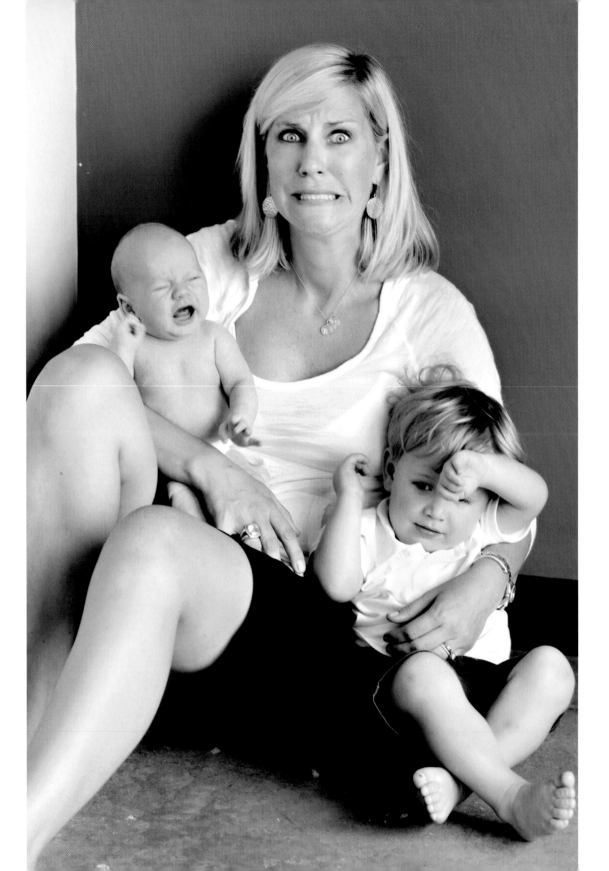

The Studio Shoot Wrap-Up

After we've shot our final frame, I remind my clients that I'll be seeing them back in the studio in a couple weeks to look through the final images. I also help them gather up their assorted belongings and walk them to the car—or at least to the front door of the studio. All in all, a studio shoot has such a different flavor from other types of shoots because it feels a bit like we all just camped out together. Clothes are everywhere; children have been making all kinds of runs to the bathroom; and we've hiked all over our space, back out, and then in again for more. At the end of a couple of hours or more, everything gets packed up and is smushed back into the car. We may not smell like a campfire afterward, but there's often a lot of singing throughout the experience, and I've been known to hand out s'mores-like treats to any takers. Then finally all the family members limp away more exhausted than when they'd arrived—but we're all glad we put in the effort it took to do it.

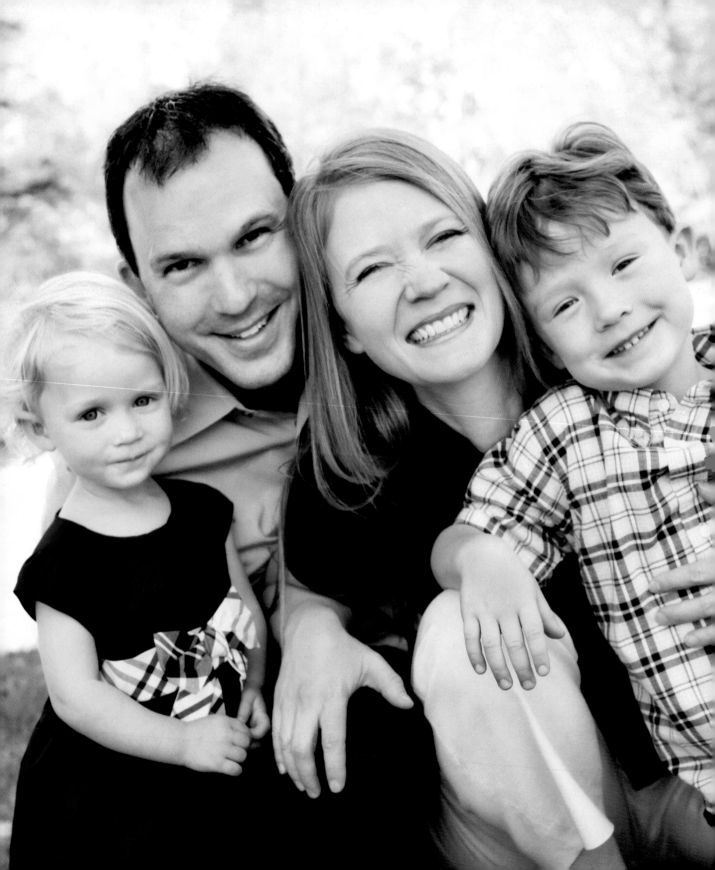

A Session on the Move

Nature is by and large to be found out of doors, a location where, it cannot be argued, there are never enough comfortable chairs.

—Fran Lebowitz

There's just as much to be careful of as there is to love when shooting in an urban location.

I THINK OF MY FAMILY PHOTOGRAPHY SESSIONS on location as mini field trips. That's a rather apt take on it because we really are taking on an adventure of sorts. And, from my perspective, if it doesn't feel like that, we're not maximizing the possibility of this experience. I believe we should be exploring, we should be finding new areas to discover, we should be alternately blending in and standing out from the backgrounds, and we should be finding a spirit that is unique to these experiences compared to any other location. As to how we decide where to go comes down to a combination of several factors: the personalities of the families I'm photographing, the time of day we'll be able to shoot, and the locations that are available to us based on time of year and proximity. All of these factors blended together make up why we choose particular locations for particular families at rather particular times of day.

The Urban Shoot

Take, for instance, an urban shoot—where we walk downtown and hop in and out of alleyways, lean up against murals, duck into cafes and restaurants, and pose just to the edge of overflowing trash cans. These photographs can look cool and funky, and add such a different feel to the images than if, say, we were shooting in a traditional home environment. When I reference particular times, I'm not just talking about wanting to shoot during the best times for lighting— although I will get into that fairly soon—I'm also saying that certain locations are better suited for family shoots at certain times. I want us all to go into the shoot wholeheartedly and come more alive from the area we're in as opposed to feeling shut down by it.

So going to a crowded downtown area in the early evening is practically an invitation for self-consciousness for everyone involved. Not only do we have to combat the fact that people will stop and stare while we're shooting, but the flow of our rhythm together is constantly disrupted—and I have to constantly re-angle my compositions to keep other people out of our shots. Add to that family members whose nature is more introverted, and we have to work that much harder to draw them out in a natural way.

There's just as much to be careful of as there is to love when shooting in an urban location. Right out of the gate, when you're photographing a family with small children, you need to be extra conscious of what you might find in some of those visually striking alleyways. I make it a point to do a scouting exercise

before ushering a family into a possibly dodgy area, even if it means walking ahead of them just in case. The other factor to watch for is what exactly has been written on some of those exceptionally photogenic walls you want to position your subjects against. I once listened to one of my little clients practice her read-by-phonics on a phrase she hadn't read before; it was one of the more colorful phrases spray-painted on the building ahead of her. She pronounced the short command perfectly but was surprised to hear no one congratulating her. This is not good

for client referrals. Although it is pretty cool to know that those reading programs really do work.

When meandering around a busy downtown area, look for particularly impactful architectural framing tools—not just doorways and windows, but boxy structures, sleek metals, large signs, and fun neon advertisements. Note, of course, that when you're shooting next to bright colors, you need to be aware of color casts. Those especially vibrant colors will bounce up across your subjects' faces

and leave them looking green, red, purple, or whatever the color on the wall. It's pretty tough to remove that cast from your subjects' faces if you want to keep an image in straight color. So if you don't want to be forced to convert the shot to black and white or another color-toned style, prevent it from happening in the first place by separating your subjects from anything too vibrant, or shoot in a direction that offers more neutral light.

Ignore the Location

There are all kinds of places to shoot on location, but the intriguing truth about shooting out and about is that sometimes it truly doesn't matter where you are at all. If you're shooting in clean and tight, the only aspects of the shoot you have to think about are good outdoor lighting, pulling your subjects far enough away from any background, and shooting wide open with enough sharp focus on what you want in focus—and, really, you're fairly set. Another easy option is to just shoot straight down on the ground—a clean and rather soft ground (like grass).

Note the red color cast on the subjects from the neon sign.

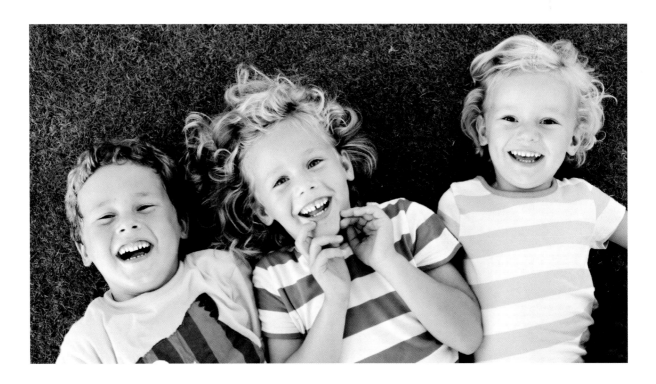

That's the beauty of being in control of a shoot. The way you see an image is the way it ends up being seen. We, as photographers, have the power to frame our subjects however we choose. Knowing it will completely change the way viewers experience the subjects is an extremely liberating realization. As in the entirety of life, things are hardly ever "just the way they are." It's often just the way we see them. And if this is an expedition, I get to lead it. In fact, I'm being commissioned to lead it. Look at the following two images, for instance. Do I see a man and woman in love and in sync with each other, or a mother and father surrounded by the beautiful chaos that is *having children*? I choose how I want to portray their relationship—and their scene—by determining what is in the frame.

Shooting Clean and Tight

At times you'll find many, many things are going wrong. Maybe the location you're at isn't nearly as appealing as you thought it might be. Or the tricky lighting is even trickier than normal. Or you were trying for a brand-new location and missed the mark but want to be able to pull off the shoot anyway. I use the shooting clean and tight technique if I am dealing with any of these scenarios or am simply forced into a location that wasn't my primary choice.

To better demonstrate how you can really shoot anywhere, I usually seek out pretty awful locations when I'm conducting a workshop, just to show my participants how it is possible and how you can make something happen anywhere and under nearly any condition, especially if you want to showcase your subjects specifically. Basically, this is a rather straightforward technique that involves either framing your subjects as tightly within the composition as possible—thereby eliminating extraneous, less attractive elements—or shooting with some good distance from your subject, utilizing an extremely shallow depth of field. With fast glass, you can ensure that hardly anything but your subjects' faces with be in focus, so many of the surrounding details end up looking more like soft shapes in varying colors.

A perfect example of this is a family shoot I had scheduled recently. We were to meet downtown near a university campus and simply move about from there. Unbeknownst to us, we had scheduled the shoot at the same time as a special campus event that had most of the area blocked off entirely. Just before the shoot, we found out about the event and decided to change it to the clients' home. That wouldn't have been a problem except that the client really wanted the look of an urban shoot, and we couldn't change the date based on a few limiting circumstances. So we did the next best thing, which was merge a family home shoot with an urban-ish shoot. We walked around the clients' neighborhood and found elements that could very well look like a "downtown" shoot, but I shot in a way that kept details purposely out of focus, so that you couldn't tell where the shoot was. The shooting clean and tight method is a great way to capture the feel of a location that you might not be able to get to while respecting that some situations are simply out of your control to regulate.

I tend to keep expectations as open as possible with my clients for a reason. For example, I might tell them, "Let's start there and just see what unfolds." Or, "The shoot will last about two hours or so, but be prepared for three, and we might easily finish in one." I don't want to get pushed into a routine, because I honestly

The shooting clean and tight method is a great way to capture the feel of a location that you might not be able to get to while respecting that some situations are simply out of your control to regulate.

believe established routines are not beneficial when you're in the business of being creative. I also think that telling individuals too much of what to expect can dim the adventurous element of a shoot, which just gets in the way of us finding something new together.

Outdoors and Au Natural

When you want to bring in a more natural feel to the shoot, you have a host of options. Don't just get stuck in the rut of shooting at a local park. You, your creative energy, and your clients—past, present, and future— simply deserve more than that. There are few routes that will lead you to creative burnout faster than just doing the same thing every time, the same way, over and over and over.

Try to shoot in exotic botanical gardens or a dark, woodsy area. Shooting in a wide-open field, especially if there's tall grass or flowery areas, can offer all kinds of options, as does a shoot at the lake, up in the mountains, or next to a beautiful putting green that is vacant as far as the eye can see. A fun shoot in a neighborhood during a light rain can produce all sorts of expressions of aliveness. Sessions at the beach have even become their own genre and are wildly popular along the coasts (see the section "The Beach Destination"). Meeting at any wide-open location is a fantastic way to manage restless children who just want to *go, go, go*—and, preferably, *all the time*.

Taking Charge

As with urban shoots, I am constantly looking for natural-framing elements when I shoot outside, such as low-hanging branches, trailways, horizon lines, tree trunks,

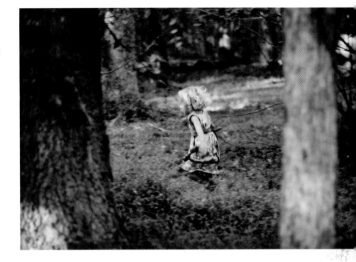

and patches of rocks, shells, leaves, or whatever there is to be found. If I shoot at a brand-new location that I haven't had a chance to scout yet, either I find what I can find or I determine that we'll be shooting in two locations that day, saving a tried-and-true option for a backup when need be.

I once decided to try a brand-new location when I'd been out on a new route (I actually find a lot of locations while out hiking or running). A trail into the woods opened up into a beautiful clearing that included a meadow with a couple of benches and a small stream nearby. It looked quite idyllic when I passed by, so I made a mental note to return there with clients as soon as I could.

In fact, shortly thereafter I made plans with a client whose family I'd photographed several times before. She was looking for a brand-new location for photographs of her family, so we decided to meet at the trailhead and hike in the ten minutes or so until we got to the clearing. My client had a family of five, with three young children, but they were a pretty active bunch, and I photographed them while walking along the trail. Once we got to the meadow, the kids immediately broke into a gleeful run.

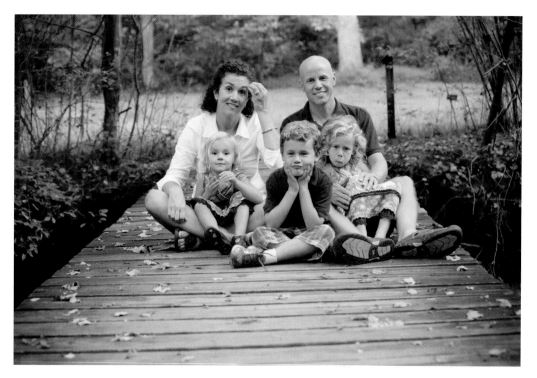

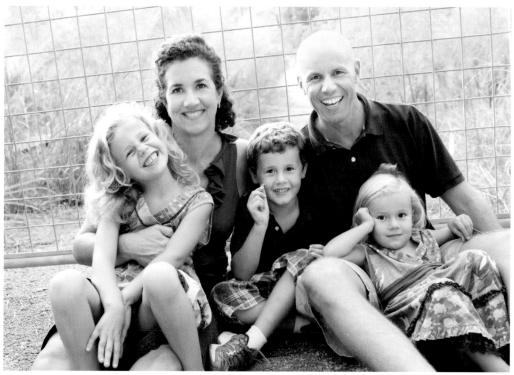

I was setting my camera bag down to switch to my 70–200mm lens, with the intention of being able to stand back and get them in action, when I felt my first bite. I brushed off the mosquito but then quickly noticed there were several more. After peering through the long lens, I immediately saw that the kids were battling insects, too. The entire area seemed to be infested with mosquitoes—worse than I'd ever seen before or since.

Both parents had very easygoing personalities (a joy to work with) and were rather tolerant about the whole situation, but I couldn't even take a shot without seeing a mosquito land on a child's face. About five minutes into the session and about 35 bites that I, alone, had sustained, I raised the white flag. Whether it was the stream, the slightly wet meadow, or just some freak thing causing the infestation, I knew I wouldn't be returning to that location again.

We managed to switch to another location nearby, and the entire tone of the shoot changed from frenzied and frustrated to soothing and fun. Notice the look of the faces in the first image while everyone scratched away bugs and forced a relaxed feel, complete with an all-out pout, versus the second one, where we actually achieve genuine comfort and happy togetherness. When you know something's going wrong, you need to step in and change it. I say that often because of how often it is true. That really is the responsibility of the photographer.

The Color of Light

The best time of day for shooting anywhere outside is generally during early morning light or late afternoon or early evening light. That's when the light is not yet or no longer high in the sky. At these times, you don't have to worry about harsh shadows, dappled light, or even more difficult to move past, your subjects' involuntary

squinting. You also get to utilize a more complementary light—a more yellow/white light that comes with early morning and the warm and golden light in the early evening. Shooting at sunset and even right after sunset can offer beautiful changing lights, moving from gold to orange to purple. There is such a striking color to light, and depending on the time of day you shoot, you'll see a range of hues and be able to use them in a variety of ways.

The Beach Destination

Over the last ten years, I've shot at several dozen beaches and have learned so much about this particular type of shooting that I honestly believe I could devote an entire book to just beach photography. For now, though, I'll be content with just writing this section of this book. Having shot in a variety of locations in multiple countries,

I can say that there are quite a few considerations to keep in mind when selecting a beach as a location for a shoot:

- How crowded is it?
- How wide is the actual beach area, and how much remains after the tide comes in?
- Where is the sun rising and setting?
- How buggy is it?
- What kind of wind shelter is there?
- How clean is it? How much debris is washed up on shore?
- What kind of natural seating elements are available?
- How rough is the water?
- How long does it take to get to the shooting location?

There are another 50 questions you could use to evaluate a great beach at which to shoot, but this list should at least get you started when it comes to thinking about selecting a location. Given all these data points, the one question I consider the most is *How crowded is it*? I can deal with any other problem, although lack of any sort of wind shelter is a close second. But not having enough space to move about, shoot in all sorts of directions, and really feel the freedom that the beach offers to such sessions is a big miss when you consider why beach sessions are so compelling in the first place.

One of the greatest ways to photograph families on the beach is to keep in mind that you are showcasing individuals, the essence of a location, and the wonderful mix of how they come together. I shoot far more landscape-style photographs when shooting at the beach than I do in any other location. There's simply so much to

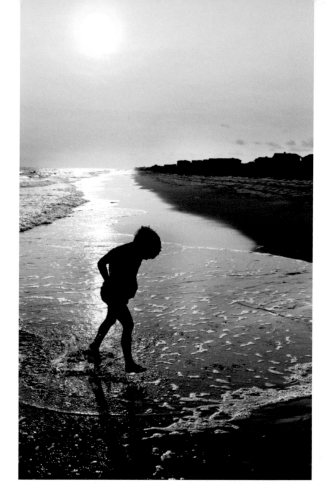

be found within view that's worthy of being captured. A beach location also provides a great opportunity to bring several families together—whether they are all friends who vacation together or multiple generations who meet up for a week together on the coast.

Sand: The Joy and the Pain

When you're thinking about shooting in sandy surroundings, recognize that although sand is your friend, you definitely need to be cautious when considering how to best care for your camera equipment. I make it a point to shoot with two cameras with two lenses affixed, so that

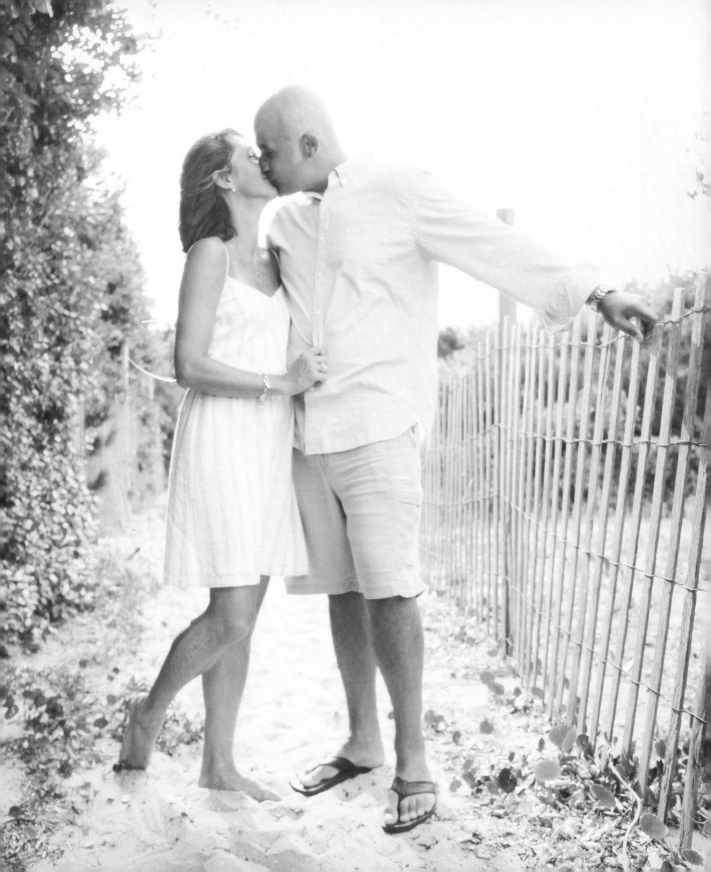

if whipped strongly into a subject's face either by wind or a taunting sibling. Once, a little sister threw sand so forcefully into her brother's face that not only was he coated in it, but he took in a full mouthful of it. His parents spent 20 minutes trying to completely wash it out of his eyes. Needless to say, that session started off a little rough. We had to build in another half hour of nothingness until he was finally OK again, just so we could lessen the trauma enough to begin once more.

Debris: Friend and Foe

Debris can vary wildly based on what it is and how much of it you have to deal with given the lay of the beach. Having to constantly step around jellyfish and dead crabs is not a recipe for boundless joy. Finding large chunks of driftwood, however, is fantastic, because they can act as photogenic makeshift benches. Intricate shells look gorgeous in macro shots, as do starfish, turtles, and conches. Man-made additions to the beach can add significantly to the character of an image—objects like canoes, fishing boats, weathered beach homes dotting the coast, or beach-worn but inviting boardwalks.

I can lessen any chance of sand flying into the sensor when I change lenses on the beach. At times, I will change lenses, but those times are few and far between. Another concern about sand is how it can land in the eyes of your subjects. Because sand is such a soft substance, it can layer beautifully, creating perfect footstep markings, and be a canvas for any drawings children may make. It's also the ideal element for building sand castles, which can keep children occupied for hours.

On the flip side, however, sand can easily be picked up by wind, which looks beautiful in a frame but can be painful

Great Horizons

When shooting out toward the water, be mindful of the horizon line. Either keep it very straight or obviously tilted—a slight tilt, one that's not committed to a full tilt, can be confusing in composition. Also, keep in mind where you position the horizon line in your frame. Purposely placing it off-center looks more natural, as opposed to positioning it halfway into your image, which is a common practice that tends to look forced and choppy. Consider positioning it up or down to meet a lower or upper thirds area of your frame, and you'll create a much more pleasing arrangement.

Mind Your Filter

I don't tend to use filters often at all. My mind-set is that I don't want to cover up rather expensive glass with a much cheaper filter. With that in mind, however, I'll sometimes use a polarizing filter when I'm shooting at the beach, simply because it can change the scene pretty dramatically, depending on what I am shooting. Polarizing filters can add a lot to the blues and whites of a typical beach shoot, enhancing the contrast and color of the sky, thus increasing the vividness of the scene. And, because polarizing filters reduce reflections, they tend to kick up the clarity of the ocean, which can be a much more appealing view of an otherwise cloudy mass of water.

DID YOU KNOW?

Sands of a Different Color

Beaches are the most common forms of shoreline that exist in the United States—and much of the world. When most people picture the beach, they think of a white sandy one, but in reality beaches come in all colors and textures. The "normal" beach colors actually range from whites to golds to caramels, but sands have been found in reds, blacks, oranges, greens, pinks, and purples as well. Most of the time, the color of the sand on a beach is due to a combination of the makeup of the ocean floor and the effects of the surrounding landscapes:

- Red sand beaches consist of deep, red-black sand that is a result of nearby areas that are rich in iron.

- Black sand beaches can be the result of fine sands that are dark in color or tiny fragments of lava from nearby volcanoes that have been refined over time.

- Orange sand is a result of volcanic deposits but also orange limestone found in the area.

- Rare green sands pull from large quantities of olivine, a mineral that forms the semiprecious gem peridot.

- Pink sands are even rarer, occurring in areas that are near large, coral reef formations that contain miniscule organisms with red skeletons that fall onto the ocean floor and mix with the sand.

- Purple sands pull in their unique color from manganese garnet nearby or the mineral piedmontite.

Rainbow beach on Fraser Island in Australia has been documented as displaying more than 70 separate colors. The predominant color depends on the direction of the wind and the pull of the waves. Digging deep into the beach sand showcases the multitude of colored layers that give this beach its name.

Sources: Clark, John. *Hawai'i Place Names: Shores, Beaches, and Surf Sites.* Ulukau, the Hawaiian Electronic Library, University of Hawaii Press. September, 2010.
Weibel, Barbara. "Cooloola National Park System, 2011," Hole in the Donut Cultural Travel, http://holeinthedonut.com, 2011.

One detail to keep in mind is that if you are pairing a polarizing filter with a very wide-angle lens, you might find some uneven polarization because the angle of polarization varies with the angle of the sun. So if you are shooting with the 16mm focal length of a 16-35mm lens, for instance, part of the sky might look deeper, richer, and darker than another part of the sky when the disparity of that depth of color isn't displayed in "real life." Another good reason to consider using a filter at the beach is to better protect your lens from the elements.

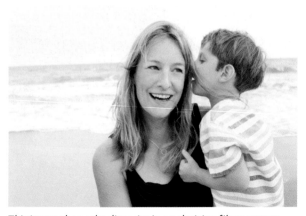

This image shows the disparity in a polarizing filter capture.

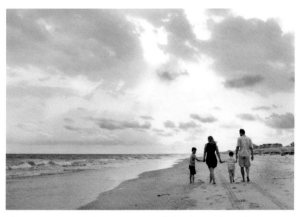

This image shows the deepening of the sky with a polarizing filter.

The Actual Ocean

When shooting at the beach, I use the ocean just as much as I use the sand in several ways:

- As an end-destination location for my subjects while I shoot from the beach
- As an extension of our shooting space for my clients to walk along and casually dip into as I follow along or shoot from ahead of them
- As a landing spot for me as I back up into it while shooting my subjects who are still on dry land
- As a backdrop for portraits

Beach Associations

Just because you're shooting at the beach doesn't mean you need to stay on the actual beach. I am often hopping around pathways, near beach fencing, along sidewalks leading to the beach, or at major landmarks associated with various locations—like lighthouses or monuments.

Fill Me In

Earlier I mentioned that I use a reflector on nearly every shoot I do. One major exception is when I'm photographing beach shoots and there's any sort of wind that's a bit stronger than a breeze, which is probably about half of the time. In those cases, I am still cognizant of ensuring that I fill in shadows because they are often even more prominent when on the beach, simply because everything is that much brighter and there's very little natural shade. Fortunately, lighter sand acts as a natural fill when you are shooting close to the ground. When I am photographing small children or a family lying down on the beach, I rarely have to worry about additional fill. In all other cases, though, I will use fill flash if I cannot correct it on the spot.

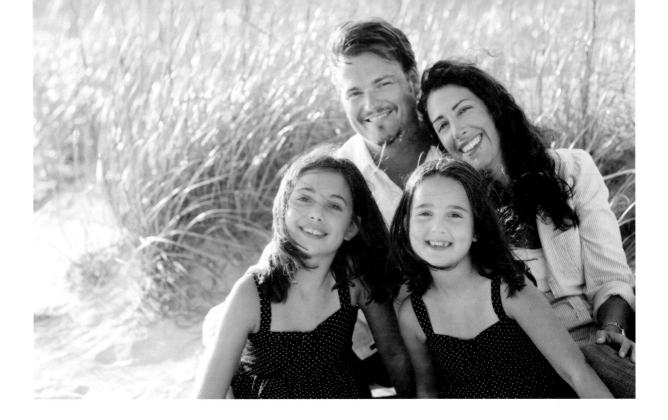

Most shadows that I need to worry about at the beach are the result of people who are wearing glasses or hats, or are positioned a bit off from the sun so that they are being shaded by someone next to them or sometimes by their hair or their nose. If I can make little adjustments on the spot, I will of course do so. I am careful to do so with full sensitivity, though. People have all kinds of reasons for not wanting to remove a hat or take off sunglasses, often motives you might not consider. One of my clients had just had major surgery and wore a hat to hide the scars while he healed. Another client told me she would never remove her glasses in the glaring sun because she didn't like how the skin around her eyes looked. In those cases and many others, my primary concern is for their comfort and ease with the shoot, so I quickly and casually concede and move on, respecting their feelings.

The trick to utilizing fill flash on the beach is to not blast with full power but to try to expose for the sky and simply fill in the light with an amount of flash that has been lowered to fit the scene, so that your subjects are well-exposed and you have controlled any unintentional shadowing. Keep in mind that shooting too close to your subject with fill flash can easily overexpose them and completely ruin the point of adding fill flash.

The Rain

Some of the more beautiful shoots I've captured at the beach have been during lightly overcast weather or even during a drizzle of light rain. But that's very different than shooting in the pouring rain or during an all-out storm. I mention this because it's not unusual for my clients to get caught up in the efforts they made to schedule a shoot in advance and then travel to it, especially if it's a fair distance from their home. With that single-minded focus, they can sometimes lose sight of the very real dangers you can encounter when it comes to coastal towns and storms. One client asked to continue a shoot while a seriously strong lightning storm was rolling in. Looking at the ominously dark sky and bright white flashes and then back to her two small boys, I politely said no. We left the beach just as the thunderclaps were starting to shake the ground. This woman clearly loved her children like crazy, but it proved that it's not difficult to lose sight of the bigger ramifications of bad weather. That includes all kinds of bad weather. Once I had to leave an island just before a photography workshop finished because a hurricane was due to land in a few hours. While 20-foot swells were starting to roll in, the other three instructors and I, as well as 60 participants, began leaving on ferry after ferry as soon as we could get out.

I bring up weather because the easiest way to manage possible issues is to create a shooting schedule that allows for immediate reschedules due to unforeseen difficulties. When I do destination shoots—travel to a certain location, like the beach, and photograph a number of sessions through the course of a set amount of days—I leave several spots purposely open, so that we can book them when needed. Of course, that doesn't help if the client knows that there are no guarantees with weather and decides to travel in for one specific time only. In those situations, I have let them know my schedule and have made them aware that I will reschedule immediately in case of bad weather—and they have determined that they will only be available for just one time. When the time comes, there's really not much more that I can do. And sometimes you need to just find peace with that. Do the very best you can, and let others make their own decisions.

Some of the more beautiful shoots I've captured at the beach have been during lightly overcast weather or even during a drizzle of light rain.

What Matters

Just like shooting in the studio or at a client's home, I still look for elements that matter to the family members and work to incorporate them into the shoot. Sometimes it's the actual location—a treasured beach house, perhaps—or an element that represents something significant to them that has a shared meaning—like an activity they share. One family I have photographed on numerous occasions has incorporated basketball into its life in a big way. The father was a pro NBA player for 14 years and is currently a basketball analyst for ESPN. Their son plays on a team, and they have two hoops around their house. The family just loves the game, so we were sure to showcase not just the ball, but also the family team spirit in this simple image.

On the whole, I find great joy in shooting on location. There is always something new to find, albeit not just a little to be cautious of. But the experience of finding it all out together really does translate to imagery. When my clients are trying something new, the buzz of that can appear in their faces, and it's that active alertness that I want to tap into when showing something about all of them as a family.

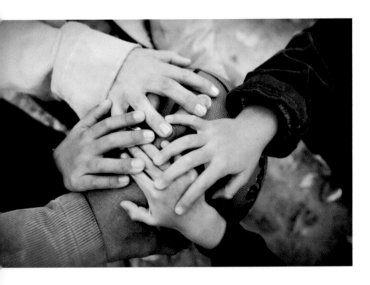

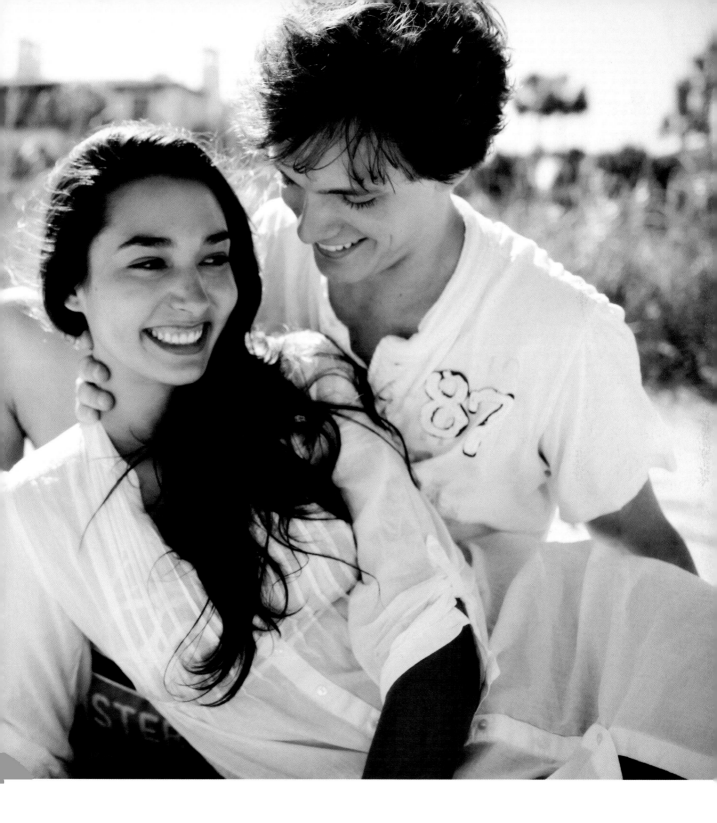

The Aesthetics

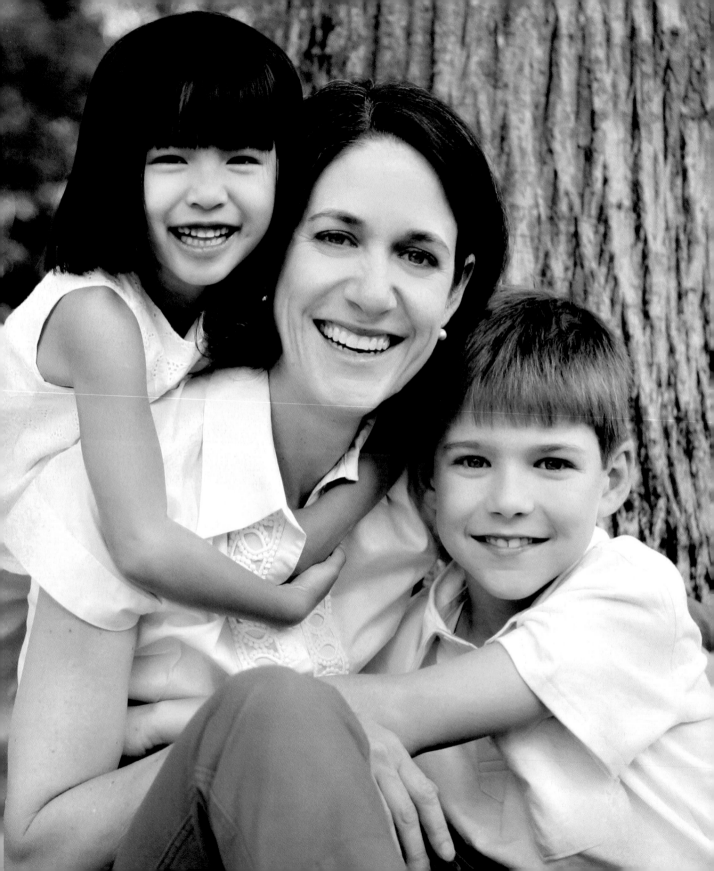

Designing the Frame: Posing and Composition

Consulting the rules of composition before taking a photograph is like consulting the laws of gravity before going for a walk.
—Edward Weston

IN THIS CHAPTER about posing and composition, I'll describe considerations you may want to explore to position subjects within a frame in the most compelling way possible. I have earnestly studied all of these rules and concepts, and probably more important, I have practiced each one in more than a thousand full-portrait sessions over the last decade (no exaggeration, believe it or not!). Here's what I know to be true, given theory and actual practice.

First, some of the oldest rules in the book are relevant for a reason—they just work—improving your imagery time and again. And so I'll use them time and again, and remain grateful to the first person (and the many who built upon that initial offering) who discovered such connections within visual communication and took the time to explain it to others, thus creating more beauty in the world.

Small shifts in the way your subjects hold their bodies can really make or break the portrait.

Second, some of the best composition styles and posing tools I use I discovered on my own and haven't really seen elsewhere. When you find that you are creating your own look and feel, that's when you know you've figured out a style that's all your own. I happily share them here, but I ask you to look at my techniques and the styles, as well as the ideas of others, as a way to kick-start your *own* unique offering. Your imagery really does stand out the most when it comes directly from you and what you most want to show, and in a manner that only you can really accomplish.

Even though I clearly shoot in the contemporary style, I need to reiterate that there is much to love about the traditional style of shooting portraits. It's not just the lighting, the framing, and the artistic perfection that goes into creating a beautiful traditional portrait; it is also the excellence in posing and composition.

Posing a Family

Keep in mind when posing a family that the family members are "one" and that this is a significant aspect to how you showcase them as belonging to each other. This has everything to do with paying attention to how they nonverbally relate to each other and their proximity to each other in the frame. How do their heads line up? Are they all in a row, a sharp harsh line—or do they follow a natural curve? Is there a flow to how they are positioned together? Breaks in physical closeness show up much more dramatically in a photograph than they do in everyday life, so togetherness is key to showing this "one" ness.

From a technical perspective, consider how well you are keeping everyone on the same focal plane if you want to ensure that they are all in focus. It is not difficult

to miss achieving a sharp focus on all faces, especially if you are shooting with a shallow depth of field or standing too close to your subjects, or when one of your subjects suddenly shifts in or out of the focal plane, even if you have everything set up perfectly. This occurs rather easily when someone leans toward the lens or away from it.

I also turn my subjects away from the camera a bit while having them look back toward me. If you can position your subjects at about a 45-degree angle away from the lens but still have them turn their faces back in your direction, you have created an attractive s-curve, which is much more appealing than having them directly face the camera. When an individual faces the camera directly— head and shoulders straight and wide—the pose can look quite unflattering in a still image, especially for a woman. Small shifts in the way your subjects hold their bodies can really make or break the portrait.

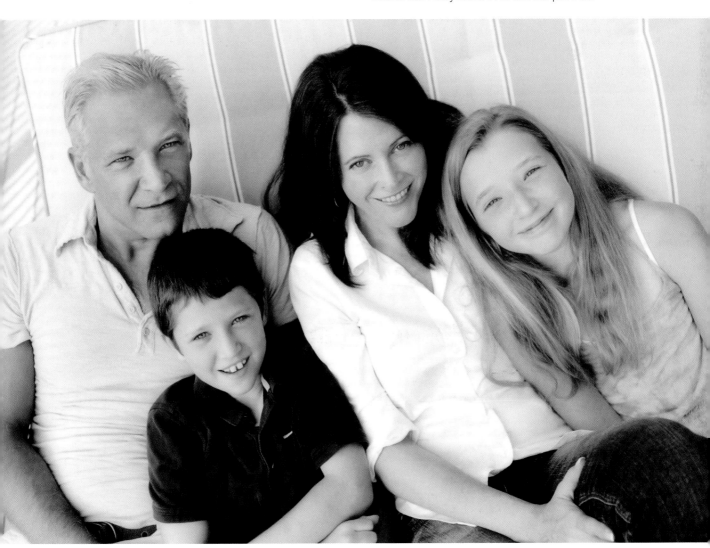

Posing Considerations

Consider the following pointers when you're thinking about how to best position individuals within a family portrait.

Stand or sit well

When subjects are standing, remind them to put their weight on their back foot and separate their legs so they are not together. The reason is that they elongate the body and shift their hips and shoulders into a more attractive angle. When seated on a stool or something similar, try to encourage them to raise the leg that is closest to the lens, which will tilt the torso and shoulders a bit away from the camera.

Chin up?

Why, no—not exactly. It's more like project the chin. This works well for all individuals: With the chin slightly down and out combined with a slightly higher camera angle, the subject looks so much better than when the chin is tucked in or even smashed back with laughter. I make it a point to show my clients how both options can look by doing it myself, and my unbelievably unattractive example makes believers out of them on the spot.

A weighty matter

Be cognizant of your subjects' insecurities. If you know your clients are weight conscious, pose them in a way that optimizes the benefits of *short lighting*, which is when the shadow side of the face is closest to the lens. This makes your subjects look more slender, simply by how shading is used. Note that when the shadow is on the opposite side of the lens, it is called *broad lighting*. Combining excellent posing with proficient lighting is nearly as effective as utilizing the Liquefy tool in Photoshop, saving you time afterward in postproduction.

Not so close

Keep in mind that anything that is close to the lens will be displayed more prominently. That includes commonly forgotten appendages, such as hands and feet. Unless you are purposely exaggerating a certain attribute of your clients— maybe you very much want to focus on family members holding hands, for instance—keep in mind that proximity to lens means *bigger*.

Watch the hands

The hands tell us so much about how our subjects are feeling. If they seem to be smiling but their hands look like they could be breaking rocks, there's a disconnect that's confusing to the viewer. I make it a point to check the eyes, the expressions, and then the hands. I encourage them to soften their grip or slightly separate their fingers. Depending on how you deliver this message, it can be a soft reminder that can illicit a more natural reaction overall.

Tilt shift

The traditional rule of thumb is not to tilt a man or boy's head to his higher shoulder, whereas for women or girls, they are encouraged to tilt their head a bit toward their shoulder. This is referred to as masculine or feminine head tilt. It seems a bit pedantic, but I've noticed when I pair children together, especially, that a bit of a head tilt in the girl looks far more engaging than none at all (**Figures A–C**).

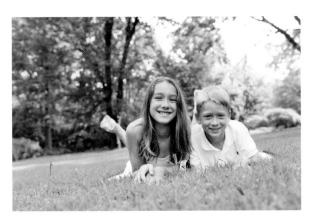

Figure A This simple image of a brother and sister lying in the grass looks a bit more casual because of how she kicks her legs out a bit, but there's a slight separateness between them that doesn't convey their closeness.

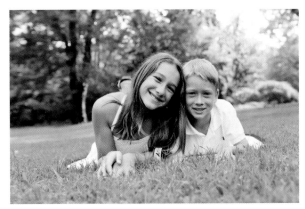

Figure B Suggesting that the girl lean her head in remedies the lack of perceived closeness and displays more engagement. Unfortunately, her kicked out leg is now producing a foot that looks like it's growing out from behind her neck.

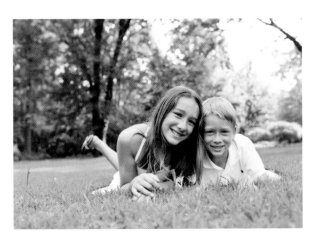

Figure C Simply suggesting that she swing that leg back out remedies the neck-growth situation—and, voilà, we have our final image. Even though I step through it here in detail, note that the entirety of this actual exchange with my subjects takes all of about eight seconds.

Organic Directive Posing: The Best of Both Worlds

I practice what I have coined "organic directive posing," which is simply combining the posing techniques of traditional portraiture with the free-form, expressive feel of contemporary photography. I consider this the act of paying attention to the angle of the face and the positioning of the body with an emphasis on showcasing what is most attractive about my subjects and being aware of background and foreground specifics. My belief is that it is *my* responsibility to get to where I need to be to better showcase my subjects, as opposed to forcing them to reposition themselves and inadvertently breaking the flow of whatever magic is hopefully happening.

Say, perhaps, I want to capture a sweet image of a mom and daughter. I see that they are quite interactive with each other, and after observing them together, I might decide to showcase their affectionate connection with

Figure A I asked the daughter to face her mom and show through her eyes how much she loves her. I put a strong verbal emphasis on "how much"—purposely stressing the fact that I want it all to come through her eyes but in a rather silly manner to produce an animated result.

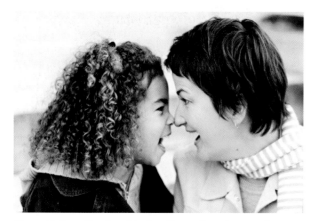

Figure B Once the daughter has thrown laser beams of exaggerated love at her mommy, I remind mom that she has to accept them with her eyes—again, in a completely over-the-top way. Remember that I'm not looking to keep any of these images and normally wouldn't shoot them save for instructional purposes. But these are getting me to where I want us to go.

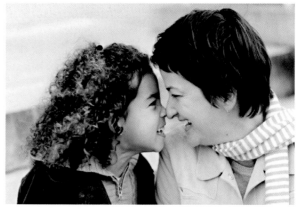

Figure C After mommy looks all open-eyed at her daughter, they both just crack up. This is a lovely image, and I'm happy with it, but if I'm going for a bit more affection and ease, I'll wait just a heartbeat for one of them to move more naturally into place.

each other. A great way to get started with organic directive posing is to suggest some sort of start and then proceed to make a game out of it. See the progression of suggestions in **Figures A–D**. We start simple and arrive at what I was hoping to find all along.

Would you say that the final image was posed? I guess that would depend on what you consider posing. I would suggest that it certainly was—but in an organic way. I let them adjust themselves, and I gave them voice prompts to achieve what I know I was looking to capture. That sweetness between them was already there. I just highlighted it by gently nudging them toward an image that would really showcase it—and them.

Figure D Ah, and there it is. As the little girl tilts her head in laughter, we have achieved a beautiful, natural-looking, slightly inspired-by-silly-direction photograph that showcases the endearing connection between mom and daughter.

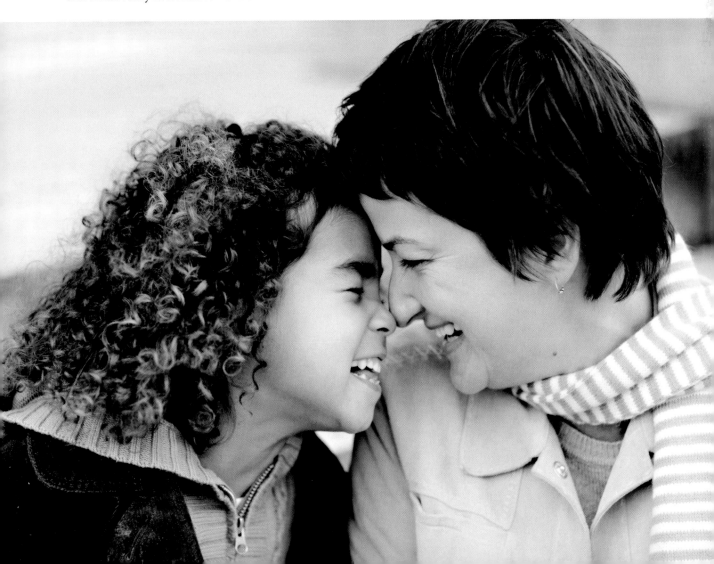

Mirroring

Mirroring is another technique I use often in posing. It is simply the act of showing my clients what I'm looking for by doing it first. Sometimes this includes literally sitting in the spot I want my subjects to sit and leaning forward in just the way I want them to lean forward. Then I pop up and let them take their places. I know that they won't copy me exactly, and that's a good thing. Exactly copying me takes away too much of the spontaneous nature of what can unfold when they position themselves and add the "them" factor. Another way I use mirroring is to show them, from the other side of the lens, how I want them to hold themselves while they are still in position. I might tilt my head a certain way, or I calm my face in a way that shows them what I mean. Sometimes it's a twist in the hips and a general leaning forward—whatever subtle adjustments I think will really capture my subjects in a more attractive and comfortable way.

I find that it's often simpler for families to see what's expected of them as opposed to having to just guess at what looks best when they aren't the ones who have been studying posing, lighting, and composition for years. They come to you because they value your expertise in this field. So, you need to provide it.

Outrageous Suggestions

Another way I might oh-so-organically direct a family pose is to suggest something slightly outrageous. The word "outrageous" is very much used in context here. I mean, I don't suggest that my subjects set fire to a car or stage an uprising in a foreign land. I might simply ask one sibling to pretend to lick the other's cheek. This tends to set off a chain of reactions that often ends rather well, all things considered.

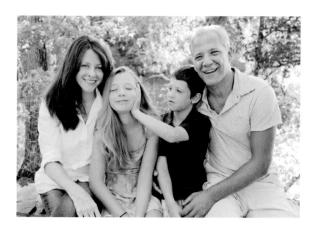
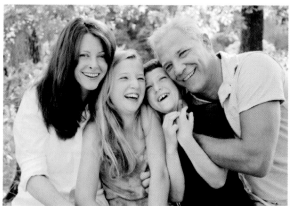

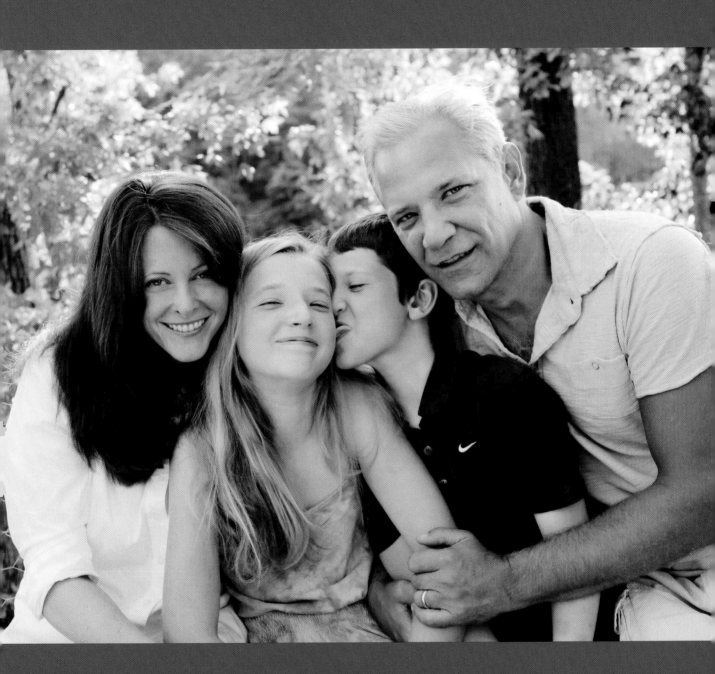

> *Because, really, there's not much out there more photogenic than people's honest, natural tendencies when truly captured well.*

Natural Interaction

Another way to pose people is to just vaguely clump them together and simply let them naturally interact with each other with no guidance from you whatsoever. This is relatively close to documentary-style photojournalism in that you are clearly only capturing what is unfolding between them. But even so, in the case of a family portrait, it still helps to at least get them started in a spot that is well lit and to subsequently position yourself well.

All in all, I don't see posing as something you should necessarily do to an excessive degree. My concern is that by the time you reach perfection, you've also lost the spontaneous emotion that is so captivating in people. So although organic directive posing won't make you a true documentarian who doesn't interfere in anything and simply captures what he sees, it does put you somewhere in the middle of a posing specialist and a photojournalist. A constant, shifting mix of both roles allows you to really hone in on perfecting the rhythm and pace of exchanges in a way that enables you to capture your subjects in the most emotive, attractive way possible while, blessedly, also ensuring that you don't stifle their natural tendencies. Because, really, there's not much out there more photogenic than people's honest, natural tendencies when truly captured well.

Composition

In *A Primer of Visual Literacy* (MIT Press, 1974), Donna Dondis defined composition as, "The interpretive means for controlling the reinterpretation of a visual message by those who experience it." In other words, as the photographer, you get to help determine what your viewers will experience when they look at the image. But as Ansel Adams so famously said, "There are two people in every photograph, the photographer and the viewer." And they both determine what is seen. This means that we, the photographers, can create an experience that we'd like to showcase. But we must understand that viewers will still take their own view and include their own thoughts and their own perspective to create a total experience unique to themselves. Like many somewhat conflicting viewpoints, the closest-to-truth answer of *what is true* is likely somewhere in the middle.

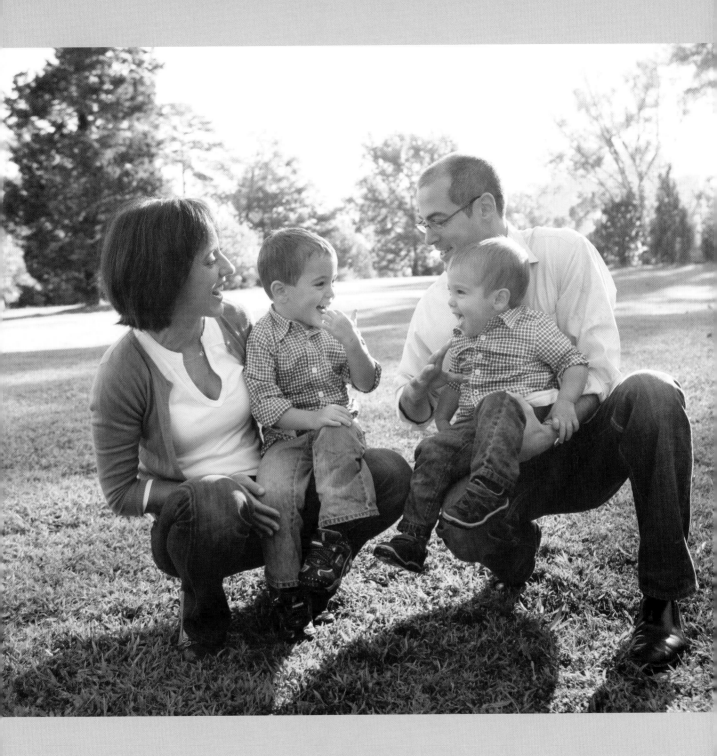

When considering composition, it helps to deliberate on what the intended end result is.

I believe there is a monumental difference between snapping a picture and crafting an image that expresses something emotional, authentic, or arresting about your subjects. When considering composition, it helps to deliberate on what the intended end result is. How does the composition of your photograph incorporate what you most want to express and what you most want the viewer to experience? How do you provide elements in your image that allow the eye to be led through it in a compelling way?

If you want to show an active child hurtling herself through a frame and only barely throwing a spirited look back at the shooter (me) while she continues on her merry way, you will better express that by positioning her as nearly on her way out of the frame, as shown in the following image. If that same shot were composed so that she was in the upper-right thirds, the image wouldn't evoke nearly as much of a catch-her-while-you-can essence, which is a notable take-away from this image.

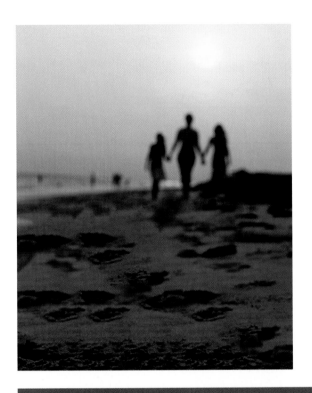

With this mind-set, you may find yourself thinking further about how you view a frame. What do the subjects' positions in the composition tell you about their pace, their significance, or the value placed on their inclusion in the image? What about any other elements that make up an image? Composition is, after all, a form of organization. It is the act of arranging shape, negative space, contrast, color, lines, and points of interest in a way that is as eye-catching, compelling, or as meaningful as possible.

Let's step through some concepts that relate to composition. Some you may already be well versed in; others may be relatively new to you.

The Origins of Composition

The origins of composition were actually as practical as they were inspired. Take, for instance, Thomas Gainsborough, a much-revered eighteenth century English painter. One of the reasons he became known for his unique work was because he utilized negative space in a rather distinctive way. A portrait of a couple, like his famous "Mr. and Mrs. Andrews," painted in 1750, appeared to be more of a landscape image that just happened to include people. It very much followed what we commonly know as the rule of thirds, with a full two thirds of the portrait containing just a scene of the landscape. This was quite a different look for the time, but it turns out he painted this way very much on purpose—and for a very practical reason. Thomas Gainsborough enjoyed painting scenery and landscapes, but to sell his paintings, it was necessary to paint portraits—so he would combine them. That way he could sell his paintings to the wealthy and still continue to do the work he loved.

However, he did this for some time after he no longer wished to continue. In fact, he wrote this of accepting portrait commissions, "I'm sick of portraits and wish very much to take my *viol-da-gamba* and walk off to some sweet village, where I can paint *landskips* and enjoy... life in quietness and ease."

Sources: Boulton, William Biggs. *Thomas Gainsborough: his life, work, friends, and sitters.* Methuen, 1905.
Whitley, William Thomas. *Thomas Gainsborough.* Smith, Elder & Co., 1915.

Rule of Thirds

If you've read anything about composition, you've read about the rule of thirds. This is generally considered one of the most basic rules of thumb when it comes to visual composition. Imagine the frame of your images being divided by two horizontal lines and two vertical lines—creating nine equal boxes and four distinct axis points. The school of thought is that our eyes want to go to one of those distinct points when they view the elements of most importance in a photograph. By placing your subject in the upper-right thirds, the lower-right thirds, the upper-left thirds, or the lower-left thirds, you bring more balance into the frame, and the viewer of the image can actually interact with it in a more natural manner.

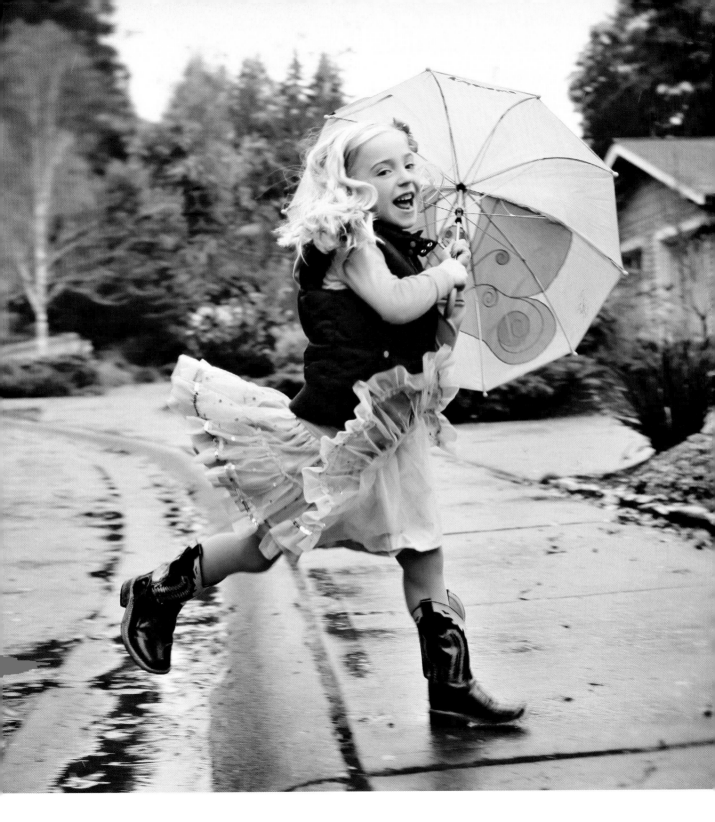

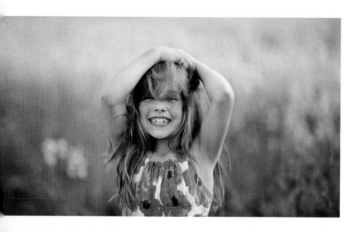

Center Composition

Although arranging your subjects off-center tends to be a more intriguing way to view them from a natural balance perspective, sometimes composing your subjects smack dab in the middle of the frame can really emphasize a particular quality or strength about your point of interest.

Simplify or Manage Distraction

Images that contain too many elements, or clutter, will distract the viewer from seeing the main point of focus or any primary objects that the photographer is hoping to show. Because the viewer's eye is drawn to the point of most contrast, consider how you are positioning lights and darks in an image. How can you adjust, or rearrange, the elements in your image to better represent your subject(s)?

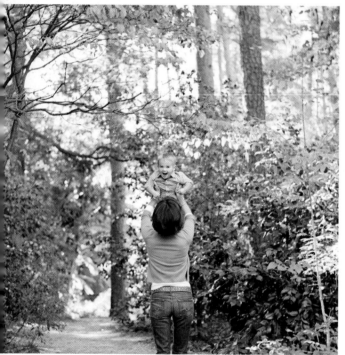

In the following two images, you can see how adjusting the color of one shirt shifts your focus back to the intended point of interest. In the first image, the little girl's stepfather is wearing a bright white shirt, and it pulls your focus in even before you get to the most prominent part of the image, the engaging subject standing in front. In the second image, he has changed into a darker shirt and is not nearly as distracting. Not only does the change in clothing affect the way the viewer first sees the elements in the image, it actually brings back an overall calmness of the visual. Whereas before you might have bounced around between the disconcerting, multiple attention-grabbing components in the frame, now it simply feels more relaxing and natural to just look at the little girl and barely register the now-balanced touch points of those who clearly belong with her but are softly out of focus in the chairs behind her.

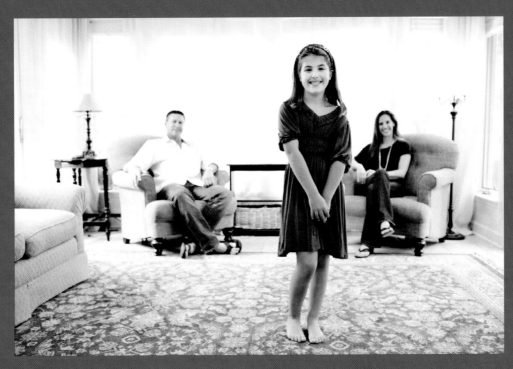

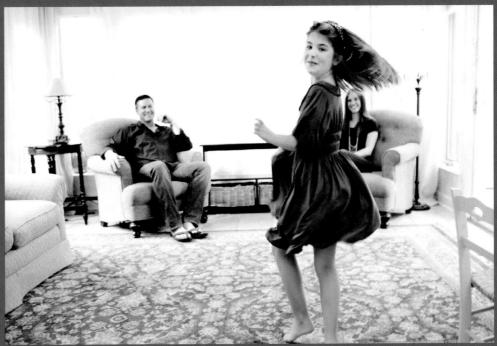

The Triangular Composition

Similar to the "rule of odds," which suggests that an odd number of points of interest in the focus are more interesting than an even number of them, the placing of your subjects in a triangle formation of sorts is meant to convey a more pleasing shape to the eye. This type of composition is particular popular when it comes to group photography, or family photography, when you often have more than two people to pose together. But it also is a captivating shape to create with even just two people; however, it may require more work on your part to creatively find it.

Little Subject, Big World

Capturing, in essence, a landscape photograph can be a wonderful way to show some perspective and really highlight the environment, especially if it's a location that holds great meaning for your subjects.

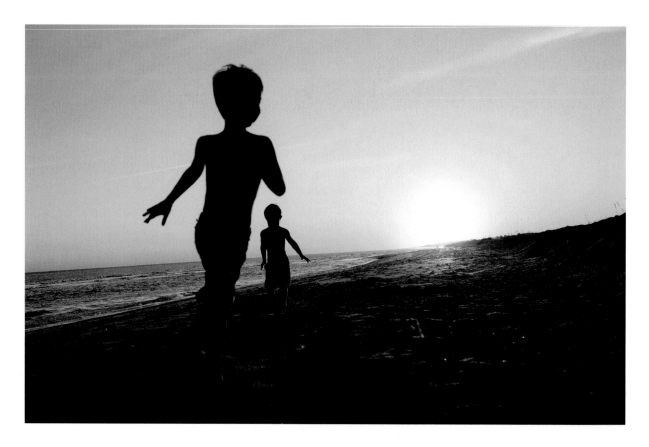

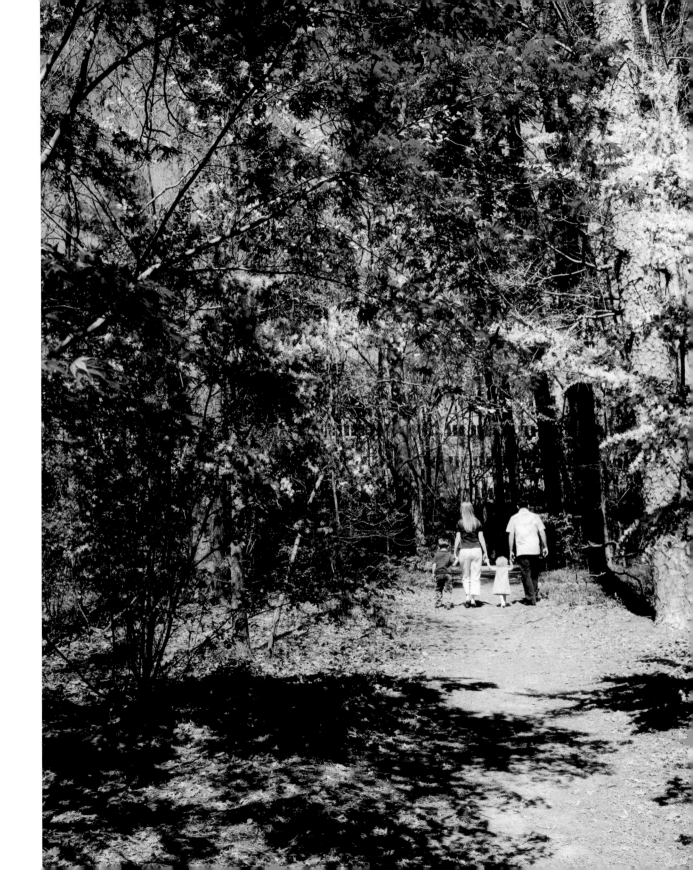

Leading Lines

If one of the purposes of a strong composition is to lead the viewer's eye into the frame, utilizing leading lines is one of the most powerful ways to do this. Whether they are technically straight lines, diagonal lines, or flowing creases or pathways that lead to the point of interest doesn't matter as much as the fact that they are pointing the way to your subject. Ensure that the path to your subject is "clean." You don't want to interrupt the viewer from actually getting to the intended focal point because of distracting elements, such as overly bright spots or breaks in the direction of the lines—unless, of course, overly bright spots—like sun tracks in the grass—*are* the leading lines.

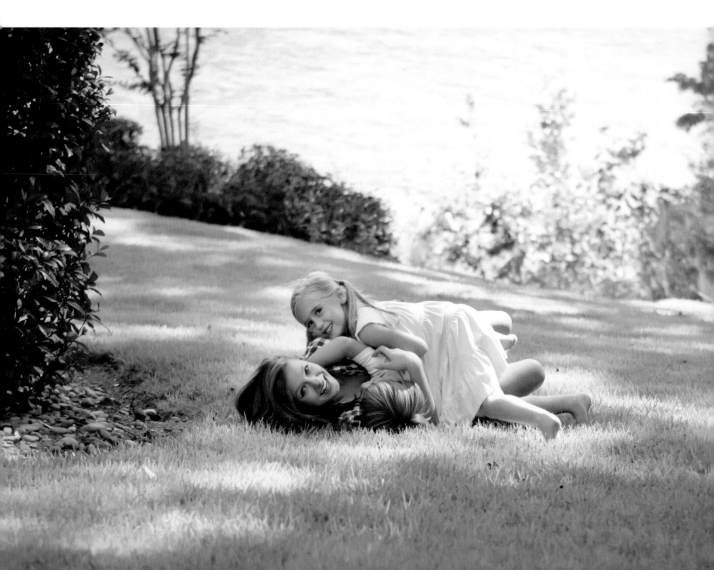

Bird's-Eye View

Shooting from above your subjects is a way to break with how people would traditionally view a family. This can be a bit tricky to pull off if you're literally standing over a group of people (long pants are greatly preferred when trying such a thing). Other ways to capture such a composition is to shoot from a small stool, ladder, tree, boulder, table, or whatever you may find. For the purpose of keeping this section more practical, I won't speak to aerial photography, although that's probably the best representation of bird's-eye viewing you're going to achieve—just not so much for normal-sized-people family photography. The biggest consideration to keep in mind, outside of my rather helpful parenthetical note about pants, is that you will be shooting with an ultra-wide lens and most likely setting your aperture to a rather extended field of sharpness to ensure that you shoot everyone clearly from such an up-close, up-top perspective.

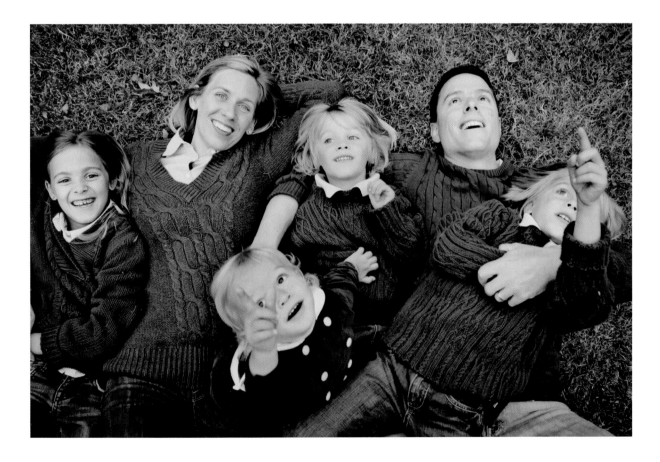

From the Ground Up

Although many of my portraits of children are shot from their level, to show what they see and better represent who they are, I also like to mix it up often and shoot quite low, tilting the lens up to capture something different, and I think, often more interesting. This regularly means a plain ol' belly-to-the-ground shooting style. Depending on the surface from which you're shooting, this can be a physically arduous way to shoot. And I have experienced all kinds of ramifications from shooting in this manner.

For instance, one time I photographed family members at their home, shooting inside and outside their house. As it turns out, when I'd gone out into the backyard with the kids, the parents stayed inside, so they didn't see that I had been lying in their grass to shoot upward while the little ones ran around the yard. If they had been there, they probably would've suggested I not do such a thing. I found out later that they had just sprayed their grass with a new chemical treatment, which is why I had burn marks on my stomach for nearly two weeks afterward—painful, itchy, dark burn marks. The last thing you're thinking of when you're photographing children is that you're going to be experiencing chemical burns as a result. Fortunately, this is a more extreme example; usually, I just end up mucky and in need of a good sponge bath.

I've also learned from a very close call to at least look at the ground before I lie on it, given the sorts of things that tend to be dropped on the ground, not the least of which is animal droppings. I may, of course, suffer bug bites and other assortments of indignities, like possible kicks to the body as I am being jumped over. But in the end, it really is worth it for this unique capture of my subjects. No, really—it honestly is worth it.

Just a normal view of my beat-up knees and foliage-strewn legs after any given shoot.

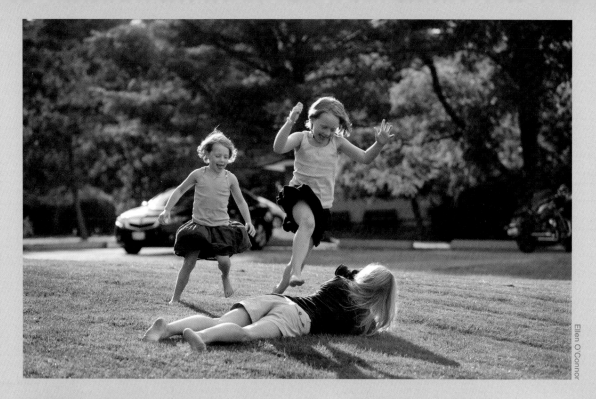

Ellen O'Connor

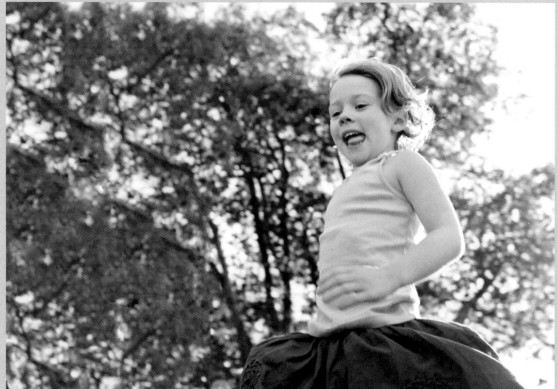

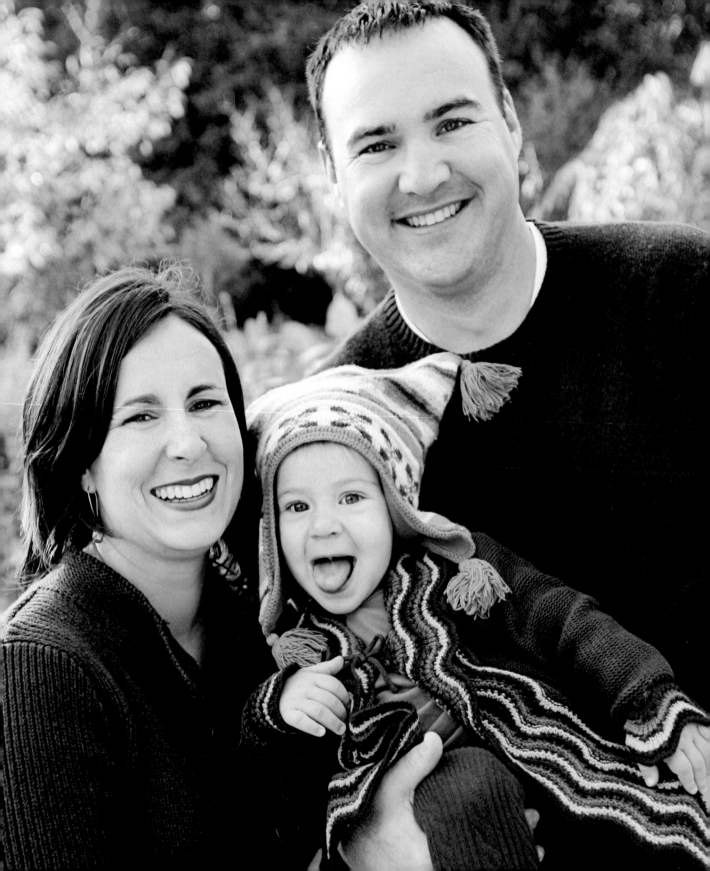

Lighting the Frame

To love beauty is to see light.
—Victor Hugo

THE CONCEPT OF LIGHT has inspired many a heart, mind, and song—even the existence of day. It's a powerful concept, a verb, a tool, and a school of thought. It also just happens to be the primary instrument photographers use when practicing our craft.

We all know that light is how photography works, but what specifically can we better know to enable us to photograph families in any location, no matter what the situation? A worthy goal for any photographer is to be able to create a strong portrait no matter the situation. If a jumble of family members—and the best of intentions—is like the bag of groceries on the kitchen counter, you should be the chef who has studied all the recipes and who has the know-how to put it all together to create an amazing meal. But to do so you'll need the aid of a few cooking utensils: Sometimes you'll simply use a knife (reflector). Sometimes you'll use a full-service

food processor and professional cookware (a detailed five-point lighting setup). I could go on and on. Honestly, I think I could write ten pages using just a whisk metaphor. But perhaps by now you more than understand the analogy, and we can move on to actual lighting details.

I'll begin by stepping you through how you can keep your lighting simple and effective, and then wrap up this chapter with a step-by-step reminder on what to look for when lighting portraits.

From my perspective, I can achieve the most amazing capture, the most endearing expression, the absolutely sweetest interaction in the world, but if it's not well lit, I've lost the opportunity to do that image the justice I should have. If it's overexposed (detail in the image is completely lost), underexposed (details in the shadows are lost, or too much grain/noise is apparent when trying

DID YOU KNOW?

"The Electric Wizard"

It's pretty fascinating that the same individual credited with developing the first electric lightbulb is also the same person who invented the motion picture camera. Pretty fascinating, that is, until you know that he actually held 1,093 U.S. patents in his name in addition to many patents in other countries. His name was none other than Thomas Edison. Some of his other inventions include the phonograph, the stock ticker, a mechanized vote recorder, a battery for the electric car, recorded music, and, oh, *electric power*.

Not a bad life's work for the seventh of seven children who received only three months of schooling by a reverend who actually referred to him as "addled," because

of how often his mind seemed to wander. He was home schooled for the rest of his education by his mother. He later referred to her as "the making of me."

Considered the inventor of the lightbulb, Edison actually built on the contributions of others, making significant improvements to the workings of incandescent light. His first bulb lasted for 40 hours. By comparison, today's incandescent bulbs last for about 1,500 hours. Throughout the course of his life, Thomas Edison eventually became less focused on creating new ventures and more involved in business, founding more than 14 companies over time, including the "powerhouse" General Electric, now one of the largest public companies in the world.

Sources: Stross, Randall E. **The Wizard of Menlo Park**, Broadway (March, 2008).
Josephson, Matthew. *Edison*. New York: McGraw Hill, 1959.

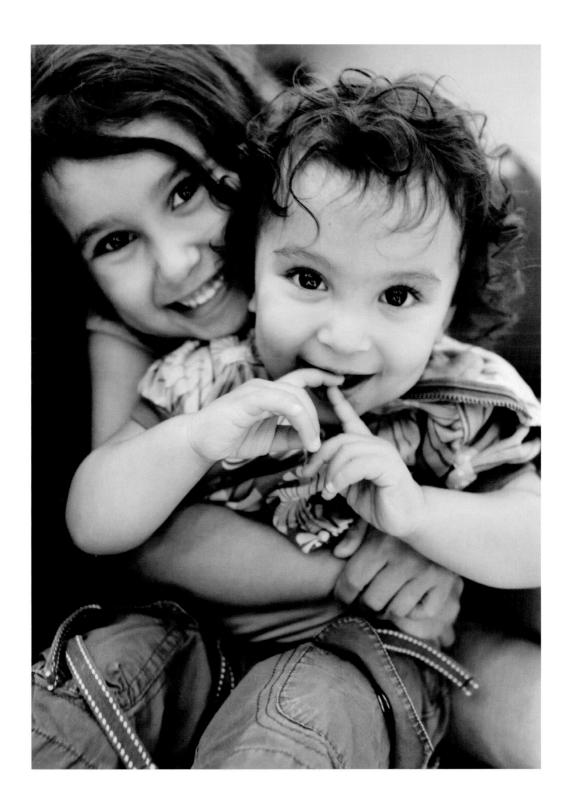

Learn the basics
of lighting: Keep your
lighting as simple
as possible, practice
often, and know
what to look for when
lighting portraits.

to lighten), or even lit in an unappealing way (exaggerates unattractive quali-
ties), it is because I didn't light it well. And, to be honest, not lighting an image
well kinda drives me crazy, because I absolutely know it could have been better.
I mean, I saw it with my superior-to-camera-technology eyes, and I knew what it
could've been. And I didn't get it. Grrrr.

Lighting 101

The best method I'd suggest for avoiding the outcomes mentioned in the pre-
ceding introduction is also the most straightforward. Learn the basics of lighting:
Keep your lighting as simple as possible, practice often, and know what to look
for when lighting portraits. And why practice often? Well, because if you're
shooting in a contemporary style, you are most likely photographing subjects
who breathe, move, and change position, and who will leave your carefully cre-
ated, very controlled lighting setup. Practice allows you to better know how to
quickly adjust on the spot, be able to mindfully shift what you need to shift, and
be able to adjust to rapidly changing circumstances. If you don't know how to
do those tasks, you will undoubtedly lose the opportunity to fluidly light a shoot
in motion. Speaking just for my work, nearly all my best family portraits were
captured while my subjects were very much in motion.

When I first started shooting in the studio, I used my light meter to check every-
thing, brushing it up against many a cheek. After a while, though, I started using
it less and less because I realized that it truly didn't jibe with the way I was shoot-
ing, which was free-form and very much reacting to my subjects' actions. As it
turned out, my subjects never seemed to stay still. They most certainly wouldn't
stay put in the spot I lit so beautifully for them. In fact, they actually still don't.

Case in point; when I was photographing this little girl in her parents' side yard,
I shot the first image utilizing a combination of a well-positioned main light
(the sun) and a strong fill light (a reflector located off to the side). When she
moved and playfully crawled toward me, I could tell she moved out of the spot
of sunlight and as a result was a tad bit darker. But my eyes adjusted, so she
didn't seem that much darker. According to my camera, though, she became
significantly darker as she moved away from the main light. And with no fill light
whatsoever, she became all shadow, and I lost not only the well-modeled lighting
of my subject, but also any significant aspects of what makes a portrait come
alive—good dynamic range and catch lights. This is what not adjusting your
lighting on the spot will leave you with.

A well-lit outdoor shot is a pleasing combination of main light, fill light, and rim lighting.

As the subject moves out of the lighting setup, there is no response in terms of changing technical settings or lighting, so the subject becomes noticeably more blurred and underexposed.

There continues to be no change in technical settings or lighting. By the time the subject has completely left the lighting setup and has approached the lens, she is not only underexposed, but her (very cute but) looming presence has eclipsed much of the light behind her, and the entire scene now looks a bit darker, too. Note that there are no catch lights, and there is loss of detail in the shadows.

What Is Good Lighting?

Good lighting depends on what you're trying to achieve. You might want an image that is big, bold, and bright. Or perhaps you prefer a sun-washed and more broadly lit image. You might possibly want the portrait to be sharp and finely modeled, or half lit, or back lit, or dark and deeply shadowed. What you want to achieve is completely up to you and what you're going for in terms of the feel of the image.

When I'm controlling the light in the studio, I adjust my lighting setup as often as needed, but mostly I try to keep everything as uncomplicated as possible. Why? I choose to spend an inordinate amount of my focus on interaction, because it's my intention to stay exceptionally connected to my subjects throughout the shoot. That means I want to start with a setup I know I can move on the fly and not have to stress about it and have it constantly distract me as we move through the session.

I typically work with four light sources in pretty much every shoot.

Main light does most of the actual lighting of the portrait, and many people choose to photograph with only this light. It's also referred to as the key light. This is the biggest or strongest light and is the primary source used for lighting your portrait.

Fill light doesn't always have to be a light. Its purpose is to "fill in" the shadows that the main light has either created or didn't reach in the first place. If it is a light, it is the secondary one and is sometimes equal to but not brighter than the main light. If it is used for the purpose of bouncing light, it takes the shape of a fill card, a reflector, or a panel. But it can also be *any* source that bounces light back to your subjects to soften shadows.

Hair or rim light separates your subject from the background (particularly important when you're photographing a dark-haired person against a black background, for instance) and adds some dimension to the composition. You position it a bit higher than—and of course behind—the subjects' heads to light the back of their hair and shoulders.

Ambient light sources include any other light sources you have to contend with outside of the other three lights that you are hopefully managing.

I typically work with four light sources in pretty much every shoot: main, fill, hair (rim), and ambient light.

In addition to these light sources, I frequently use flags and a variety of diffusers, which include silks and scrims. Basically, these products provide varying levels of fabric that will do anything from slightly dim a light (silk) to diffuse it (scrim) to block it entirely (flag). My softboxes are nearly always covered in diffusion panels, and the impact of my window light is usually softened. I find that a flag is perfect for when I am photographing a darker-skinned subject in bright white clothing and need to calm the light hitting the whites to better manage the highlights in the image.

You don't necessarily need these specific tools to soften and diffuse light when you are shooting outside of the studio. I've hung bed sheets over windows and used my sheerest reflector to calm the effect of sunshine. And, of course, anything that blocks light can act as a flag. Once, while photographing three siblings together, I asked their dad to please step backwards, over to the left, and pretty much not move for a bit, so he could block the sun for me. I didn't think much of the request, but I noticed that the kids were cracking up looking at him standing behind me. I turned around to see why, and he had a humorously offended look on his face. I asked what was wrong, and he said that he knew he'd gained weight since the kids had come along but he hadn't realized that it'd come to this: He was now big enough to block the sun.

Lighting in the Studio

Earlier in the book I touched on the color of light when I talked about good times to shoot (Chapter 6, "Interacting with Your Subjects") and how to properly set for white balance (Chapter 5, "Technically Speaking"). So you'll recall that light is measured in kelvin. The cooler lights, the more bluish-white lights, are typically measured at over 5,000 kelvin. The warmest lights, in the color range of candlelight, are measured at around 1850 kelvin. Obviously, when you're considering how to balance ambient light, it's quite advantageous to think of the color of all the lights involved, not just the brightness of them.

If you are mixing tungsten light (around 3000k) with overcast daylight (around 6500k), for example, you have to pay attention to managing the balance of these two colors in a way that doesn't leave your clients looking rather wonky, professionally speaking, of course. But if you are mixing light from your on-camera flash (around 5500k) with regular daylight (around 5000k), you have much less concern when it comes to bringing these two lights together in a visually pleasing way, which is why I often pair these two light sources together easily.

A straightforward look at a simple lighting set up in the studio. All forms of lighting are included: a main light and a fill light (both with diffuser panels), a hair light, and two forms of ambient light—natural daylight from the window and overhead fluorescent lighting.

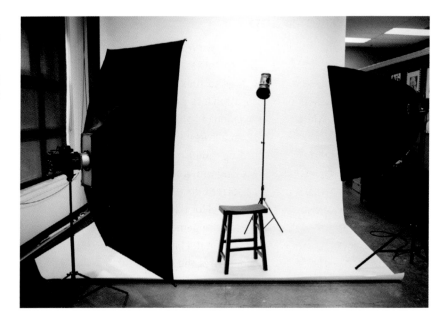

When I'm photographing in the studio, I can choose to keep or do away with two of the ambient lights you see in my studio image. Eliminating the overhead fluorescent lights is as simple as flicking off the switch. The other ambient light source is the light from the windows. In Chapter 7, "A Session in the Family's Home," I showed our double-blind system, which allows us to either diffuse or completely eliminate daylight.

Continuous vs. Strobe Lighting

Along the lines of keeping my lighting system flexible and easy to adjust, I tend to favor continuous lighting when photographing family portraits, as opposed to strobe lighting. The difference between the two is that continuous lighting is just that—lighting that is very much *what you see is what you get*. Exactly how you light the scene (and the individuals in the scene) will photograph just like what you see before you click the shutter. Strobe lighting, on the other hand, is just like flash—it lights up when you trigger it and needs a bit of time to recycle so it can be

fully powered for the next shot. You cannot see what will be captured until you trigger the flash.

When I first started shooting, I only used strobe lighting because the technology behind continuous lighting was simply not there yet, meaning not powerful enough, the lights became too hot to be safe around children, and the color of the lighting options wasn't optimal. Instead, I shot with strobes and a cord that connected my camera to the lights, so they would trigger when I clicked the shutter. This led to an inordinate amount of tripping over cords—mostly by me. A lot has changed in just the last few years, though. Today's strobe lights are simply triggered by a third-party wireless device, like the pocket wizards that I keep with me often. I find that strobes are still more powerful than continuous lighting options, but I don't always need the level of power they provide for every shoot. And, even better, today's continuous lighting systems are more powerful and cooler to the touch—even after they have been on for a while!—and they now come in white balance–friendly daylight fluorescents.

Typical Studio Setup

During a typical studio shoot, I might pair two Westcott Spiderlite TD6s with two 36 x 48-inch softboxes, which are now shallower than ever, or one large softbox and one 12 x 36-inch stripbank on a third, often less-powerful light, such as a TD3. With that combination of lights, I can create a wide swath of well-lit area that allows my subjects to move about the 12-foot backdrop rather freely. Or I might change it up a bit if I'm working with a small family and use only one 36 x 48-inch softbox on a continuous light with a large reflector panel for fill and a dialed-down hair light. Either of these arrangements offers a good amount of even light, even if it is a bit of a flat light, that generally covers the entire area they would normally move about during a shoot. I've come to find that all I need to do is adjust my lights here and there as we move about, and maybe punch up a bit of the sometimes flatter lighting in post. As a result, I've made the entire shoot a much easier experience than it would have been just a few short years ago.

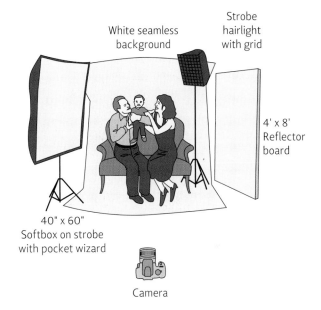

A typical lighting setup in the studio.

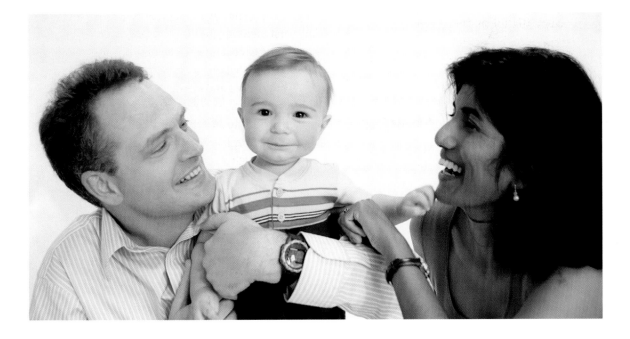

A shoot in the studio doesn't necessarily need to be on a backdrop, of course. The following image shows a bit of a different shoot; some subjects are lying down while one is sitting up, and we are also photographing them in a rather confined space just under a large window in the backroom of our studio. We created a bed-like area for them to lie on, which consisted of covering several pillows under a small, faux, down comforter (available at most home goods stores for about $30). In this instance we opened all of the shades and let the sunshine pour in through the windows. That, and a separation of the subjects from the wall, created our rim light.

We used one main light and two fills. The first main light was our softbox with a diffuser panel set at about 45 degrees toward our subjects. The second fill was a reflector panel that was created from two large art boards that were taped together. I use this type of fill frequently when I'm photographing babies or toddlers. I like that there will be no cause for alarm if it tips over, because it's relatively light. The last fill contributing to this image is the one provided by the extremely bright-white blanket underneath my subjects.

Lighting in a Client's Home

Lighting inside a client's home involves a keen understanding of how to best use whatever natural light is available, as well as some basic know-how when it comes to determining which pieces of additional lighting gear would be most useful. In addition, it's important to address the issue of proper white balance, which is often of more concern inside a darker interior than when shooting in the studio or outside.

A large picture window off a large tungsten-lit room may pose more problems than expected when it comes to balancing color, especially if it's a very cool light outside (more overcast or earlier in the morning). The good news is that there are easier ways to manage color temperature concerns than ever before. Especially when shooting inside a home, it's convenient to know your camera (or at least many cameras) has a built-in aid: the White Balance Auto-bracketing (AWB) feature. If you don't want to—or don't have time to—set a custom white balance, the ability to auto bracket white balance can really save you a great deal of time in postprocessing. This feature will give you a set of three images with various blue/amber and magenta/green bias from the core White Balance setting. You then have the option to view them and select the one that looks best to you. Check out this handy feature on your camera and see if it doesn't save you some valuable time.

When I'm shooting in a client's home, I always try to use AWB first. The more I can process all my images in post in a batch, all set to the same White Balance setting, the faster I can fly through my editing. When AWB doesn't work, I adjust to the most suitable white balance and then consider which type of additional light I will be using. The options I utilize most often are a reflector; a portable, battery-powered video light; and an on-camera flash.

Outside of shooting evening events, there are, in fact, only two occasions when I might use my on-camera flash. The first is when I need a pop of fill light; this can occur in a multitude of situations. The second is when I'm shooting a session in a client's home. Bringing along a simple on-camera flash can assist you in a variety of ways. Let's circle back to the same considerations I'm mindful of when lighting my subjects in the studio.

The good news is that there are easier ways to manage color temperature concerns than ever before.

Main Light

There are certainly times when I've found myself in a darker environment than I expected when I'm at someone's home. In times like this, I still prefer to not bring along a studio lighting kit because I feel like it roots me too firmly to one location. It also appears big and bulky, and tends to upset the natural flow of the shoot right from the start. Especially if I'm photographing quickly moving subjects—which is nearly always the case with small children—I want to be able to adjust just as quickly and move when needed. In those cases, I need the light to move with me. Basically, using a very portable on-camera flash offers me the freedom to bring my main light with me quite easily.

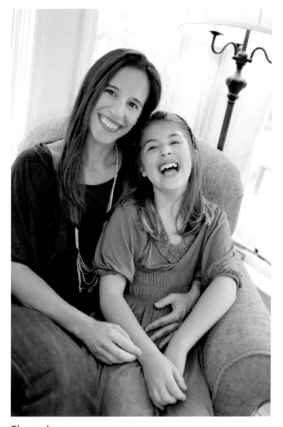

Figure A

Fill Light

Utilizing your flash as a fill light, by powering it down and stepping back enough from your clients to not wash them out, is an excellent and portable way to record details in your images that would otherwise be lost to shadow.

Hair or Rim Light

Sometimes separating your subject from the background isn't enough, especially in dimly lit locations. Remember that you have the option to set up a flash on a simple stand and remotely trigger it to create more separation between your subject and the rest of the background, positioning it similar to how you would in the studio— higher than most of the heads.

Ambient Light

All too often, you are lighting for the subject at the expense of lighting certain elements in the subject's environment that tend to look dark, clumpy, and utterly lacking in detail when left unlit. Remotely triggering a flash positioned in the background can help to enhance details that would otherwise not show up in your image, often due to weak ambient light.

The other great consideration when it comes to ambient light is what kind of light sources are being used around the house. As more homeowners move away from using traditional incandescent lights (the much warmer-colored ones), replacing them with environmentally friendly, energy-saving bulbs (many of which come in much cooler tones), the less sure you can be about what color of light you'll actually be getting when you turn on a lamp. In this example, mom and daughter were curled up on a chair we'd moved back into the corner to be able to take advantage of the flood of sunlight that was naturally being diffused in the window-heavy room (**Figure A**).

The quality of light from a window varies in relation to how the windows are facing the main light and any other ways that light may be diffused before it moves into the home. In this case, the window light was naturally being softened because the windows were tucked under an extended roof.

The bulbs in the lamp actually turned out to be cooler fluorescent lights as opposed to orangey tungsten lights, which suddenly made my job a lot easier. All I needed to do was bounce the similar-colored light from both the windows and the lamp back up into their faces (**Figure B**).

Note that I've cropped the photo in two different ways: The first way shows the entire scene to better see the lighting. In my opinion, the angle of capture and proximity to subjects exaggerates the size of the daughter's hands, simply because of how close they were to a wide-angle lens. In such cases, I would

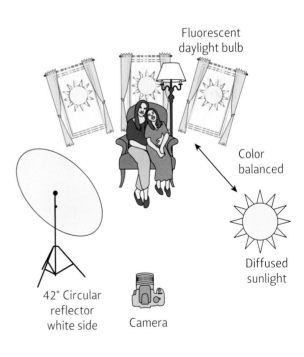

Fluorescent daylight bulb

Color balanced

Diffused sunlight

42" Circular reflector white side

Camera

Figure B

You can easily apply translucent, colored diffusers to the front of your flash, allowing you to color correct to an even more powerful degree if you aren't able to make it work otherwise.

normally crop a bit tighter, being careful to avoid cropping at any joints, and end up with a photograph that is more close up, thus avoiding the close-to-lens hands issue.

If you find that you've done your very best to achieve proper white balance but still aren't managing to correctly capture the color of the scene—or, even more important, the feel of what you want conveyed in the photograph—you can also try applying a gel to your on-camera flash. This is about as uncomplicated as it gets nowadays. You can easily apply translucent, colored diffusers to the front of your flash, allowing you to color correct to an even more powerful degree if you aren't able to make it work otherwise. Most gel filters for on-camera flashes are exceptionally economical (less than $10).

Another great way to isolate your subjects when shooting in the home is to simply have them pose against a wall or on the floor. In the following image, brother and sister lay down on the ground, and I shot over them. I photographed them together, and I also repositioned my on-camera flash and reflector to take individual portraits of them in the same position.

In this first photograph (**Figure A**), you can see the tiling on the floor behind them, as well as the edge of my shoe (bottom left). I find the lines—and my darn foot!—to be distracting elements, and I want the distractions out of the image. I am also looking at the brother and sister's expressions, and they are both conveying a separate feel to me.

I remove all the distracting elements in the frame in Photoshop, make a few light touchups, and burn in a slight vignette on the left side of the photograph only (**Figure B**). But I still feel the disengagement between brother and sister because of their very slightly contrasting expressions. In cases such as these, I will either work to get them both to the same genuine place, or I will zoom in on one or each of them separately and create individual portraits.

Because I did zoom in on each of them separately, I pull a separate image of just the sister and style it in a bit of a different way, so it will stand apart from the one of them together (**Figure C**). I love all the hands together, and how the tips of her right fingers just graze her chin (totally not encouraged, but very much appreciated).

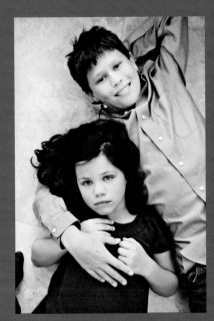

Figure A

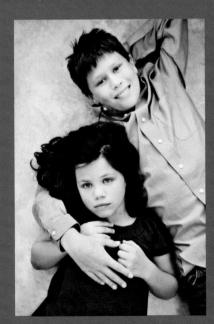

Figure B

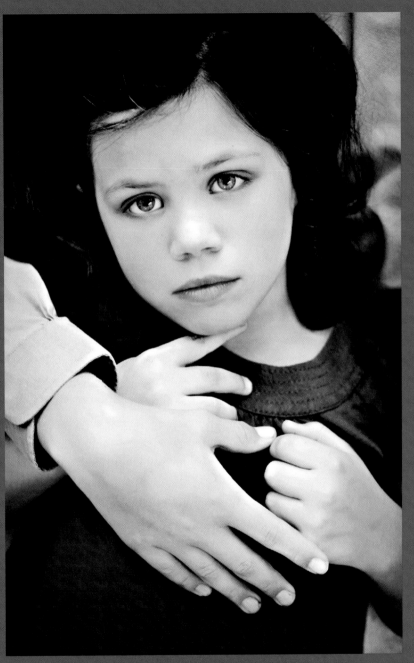

Figure C

Outside the Home Lighting

Of course, whenever I am photographing a shoot at a client's home, I take them outside for some portion of the session. These two little cousins needed a way to be positioned together in a comfortable way, and bringing out a chair from inside the house was the simplest way to create that look. Plus, the chair was quite cool looking, which didn't hurt the overall look of the image.

Because these two little ones were backlit, all I had to do was use a long panel reflector positioned across from (and of course under) the sun and to the right of the camera. Just the very act of bouncing the main light creates a diffusion effect, so our two little subjects received the same lighting treatment as being

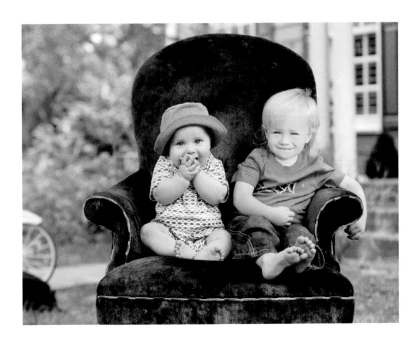

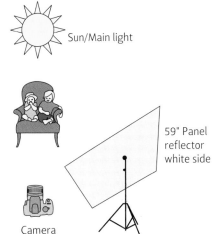

Sun/Main light

59" Panel reflector white side

Camera

positioned close to a very large softbox in the studio. Because shooting with a larger softbox close to your subjects will also produce larger catch lights, this positioning helped to bring even more life into an already lively image. Notice how I situate the two boys within the frame and use other elements in the background to bring in visual interest. Without the bike on the left side, this becomes a less balanced composition and a less interesting photograph. In addition, the vertical lines (the columns in the back of the right side of the image) and horizontal lines (the piping along the base of the seat of the chair) are nice and straight, also adding to the tidy feel of the overall composition.

When I say I go outside every time I shoot at a client's home, I mean every time. I even go outside when it's inclement weather. We can nearly always find a patch of covering somewhere that protects us from the rain but still gives us a refreshing burst of natural light and fresh air. One other lighting technique I'm drawn to is warm backlighting that shows the invitation of home. I turn on the lights inside the house, open the blinds, and position my subjects against a window. This arrangement creates some very warm depth to the background of an image. I find this image (on the left) far more appealing than simply shooting against a closed and dark window shade.

Lighting on Location

The easiest way to be able to better "see" light is to remember that it always travels in a straight line. That means that it will travel from the main light source, which is often the sun when you are shooting outside, and very possibly bounce from one or more spots before it reaches the subjects you are photographing. Depending on where you are shooting, much of your lighting may very well be coming in with its own fill light, often bouncing up from the ground when your subjects are standing in the shade.

And just as in every other situation, I am still looking for all of the following light sources.

Main Light

Main light is the sun in every shoot in which I don't use an artificial light source instead.

Fill Light

Fill light can be so very many things when you are out and about, not just a reflector or fill light, but the sidewalk, a door, bright blades of grass, the sand, snow, bodies of water—really, anything that bounces light back to help fill in shadows.

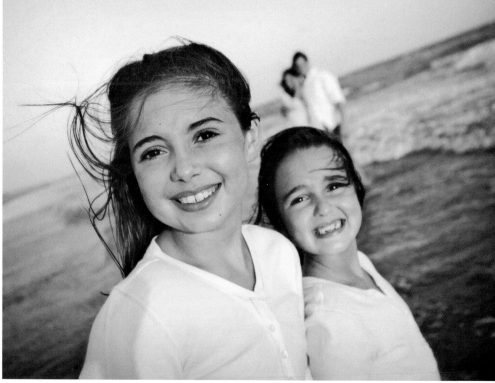

A common miss when using a reflector for fill is to forget how close it often needs to be to your subject when you really want to maximize the light bounce. Remember that proximity of the fill light not only better lights your subject, but also enhances catch lights in the eyes. This ties in to one of the most basic principles of lighting: The closer the light source is to the subject, the larger the area that is lit; the farther the light source is from the subject, the less the area that is lit. This principle is just as true when using a reflector, of course: The closer it is to my subjects, the more widely I will be able to light them. Inversely, if I'm going for a more dramatic portrait with sharp lighting and only a small area of the portrait lit, I will move the reflector farther back and often switch to the silver side.

Because my shooting style is very much about clean, simple portraits that focus more on authentic expression than dramatic lighting, I normally position the white side of the reflector as close to my subjects as possible. Sometimes this means propping the reflector on the ground right in front of my subjects and tipping it up a bit, just enough to catch the light. Sometimes it just means plopping it right in someone's lap.

You can even take it a step further and have your subjects hold the reflector; a technique I practice on occasion.

Although when it comes to silly, small children, there's no telling what kind of imagery this can lead to, really.

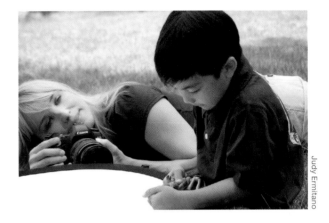

Judy Ermitano

Hair or Rim Light

I like to utilize hair or rim light (or backlighting, or even side backlighting!) to my advantage, aesthetically. One of my favorite ways to shoot is with the subject's back to the sun. Shooting this way can create so many looks and feels. Often, a slight washing out is part of the look, conveying a lightness that very much reminds you of a sun-soaked day.

Ambient Light

Being aware of ambient light on location is more a matter of looking around and confirming if you are shooting near any other types of light. You might be outside in one type of light but near a porch light, which brings in a very different color. Unless you recognize the effect of the other light, you won't be able to control your white balance as well as possible. It always helps to look around and see all the light, so that you adjust it when necessary.

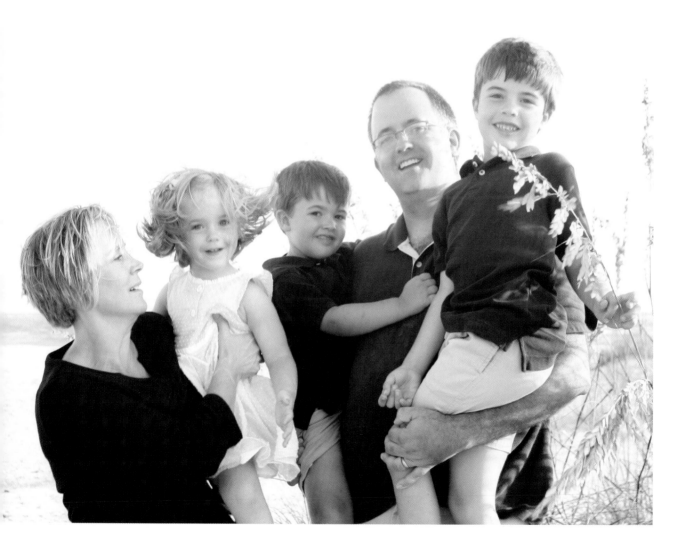

Working with Dim Light Backlighting

We were photographing this little girl and her family outside in a rather woodsy area, so the actual scene was darker than it appears in this photograph. My subject was directly back lit, and the light was being strongly diffused, filtered through multiple tree tops. I used the silver side of a 42-inch reflector positioned directly underneath her and across from the sun. What I found was that I still needed more fill, so I used on-camera fill flash here as well.

Most of the time when I'm using a reflector, I use the white side or a muslin side. In situations where there is strong backlighting and/or dark environments, using the silver side helps to better fill in the shadows, and adding in some fill flash helps to maximize catch lights. What's not difficult to do with that technique, however, is catch the edge of the reflector or some flare from the brightness of the reflection of the silver side.

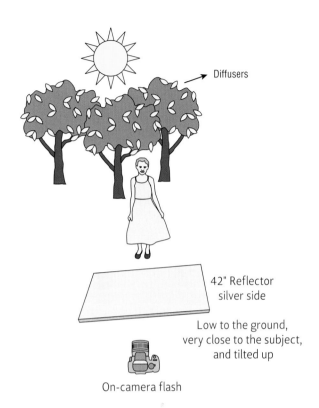

Diffusers

42" Reflector
silver side

Low to the ground,
very close to the subject,
and tilted up

On-camera flash

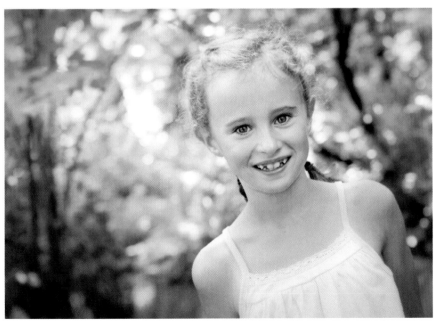

For example, these two sisters in the image below were extremely backlit, and I used a combination of the silver reflector and fill flash to bring some light back into their faces. Note, however, the hint of flare in the bottom right of the image. This could have been prevented by tilting the lens hood a bit farther away from the light, thus eliminating the flare.

Working with Very Sharp Back Lighting

During a workshop in Montana in the winter (32 degrees below zero; I'm not kidding), we decided to jump outside for a bit to get a different image of mommy and daughter. Directly behind them is a bright, white snow bank. Overhead, to the left, and behind them is a bright, glaring sun (which wasn't bothering to actually heat us but looked nice and pretty up there all the same). As the two

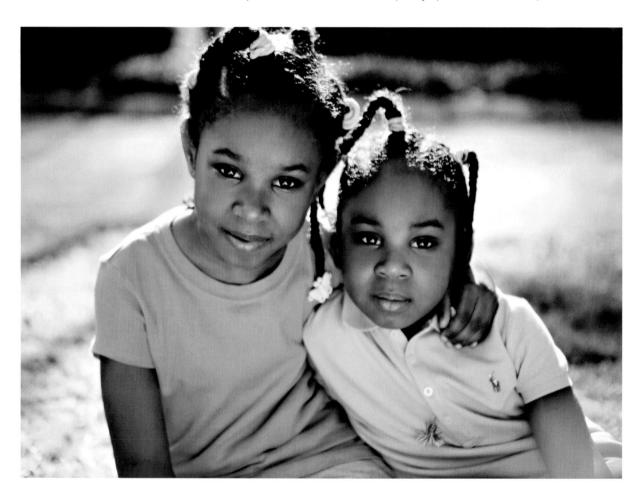

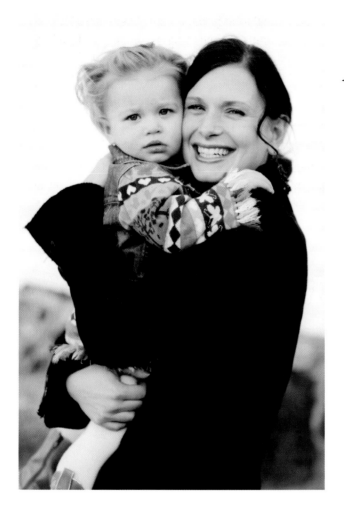

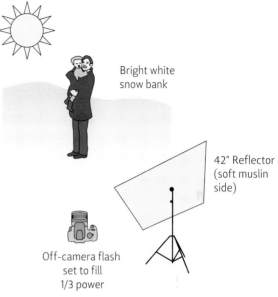

Bright white
snow bank

42" Reflector
(soft muslin
side)

Off-camera flash
set to fill
1/3 power

of them huddled together for warmth, I knew I'd need to reflect some of that very powerful light back up into their faces. But the silver reflector would be too harsh, and the white reflector still seemed to reflect too much light back. So I used the muslin side of one of my reflectors—a cream, soft fabric that provides a more subdued fill light. It did a great job of lighting them from the front, but I still needed a bit more pop to achieve stronger catch lights. Shooting with just the very front panel of my Metz 58-1 flash did the trick. I simply "bounced the flash" up toward the sky (completely eliminating it; it certainly wasn't going to be bouncing back from the sky!), and the tiny pop of light on the front lit up their eyes without adding any extraneous light elsewhere.

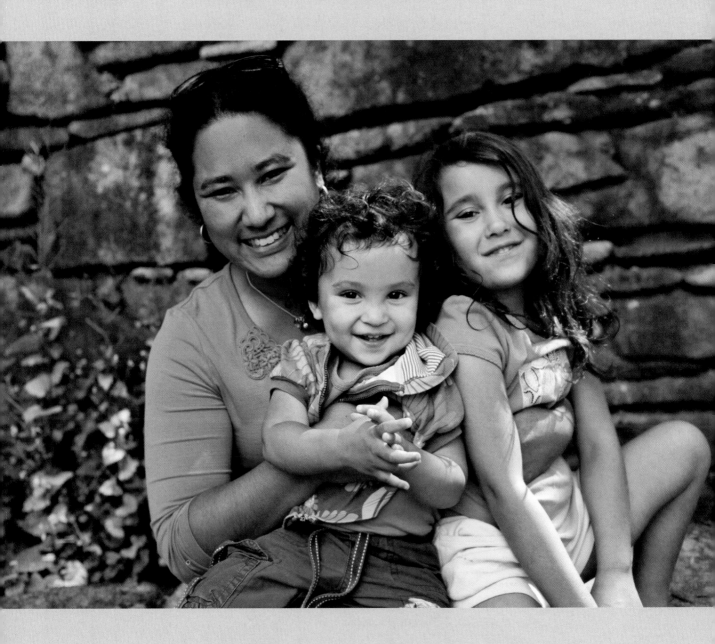

Working with Side Lighting

Another common way to photograph families outside is to utilize controlled side lighting. This is when the main light isn't coming from in front or behind the subjects but is very much coming from the left or the right. As long as you are diffusing the light enough to manage harsh edge lighting and preventing squinting in your subjects' eyes, it's quite OK to have some uneven lighting along parts of their bodies. I just don't want any unintended patchy light moving across their faces.

Seated on a waist-high stone wall outside, the light on Mom and her two girls is clearly coming in from the right side, as you can see in the older sister's hair and the way it lands on the right side of the younger sister's clasped hands. A reflector positioned to the bottom left of them helps to softly fill in any parts of their faces that were missed by the beautifully diffused main light. And they are positioned far enough away from the wall behind them to be well separated from the background.

Seeing the Light

Learning to better see the light sounds more like a step toward enlightenment than a suggestion for improving your photography. And yet that's exactly what will enable you to step up your game when it comes to lighting. It's not just about having all the equipment you need or shooting on only the most perfect days at only the most perfect times. It's about seeing an entire scene and knowing what you have to work with, what you have to combat, and sometimes, what you can get away with—at least enough to get you through to postproduction where you can better enhance what you couldn't completely create at the shoot. Making adjustments to a photograph after the shot was taken isn't new to the digital age; it's

been around in one form or another almost as long as photography itself. Or, as Ansel Adams rather humorously said when referring to his own efforts to improve imagery after capture, "Dodging and burning are steps to take care of mistakes God made in establishing tonal relationships."

Steps to Better See the Light

Probably the simplest way to start training yourself to better see the light is to start with the most powerful light you will be using on every shoot: the main light—whatever that is. Start by determining the origin of the light and see where it goes next, remembering that light moves in a straight line. Discern exactly how it reaches your subject, what it adds, and what it misses. Then look for what needs to happen next. Do you need to add a fill? If so, what is the best method to utilize? Do you need a slight bump of light to direct at your subject, or do you need a much stronger fill light, or possibly several fill lights? After that, you need to consider how well lit your subjects are from all angles, which should lead you to think about a hair light, or backlighting. Then check for any ambient lighting you should be considering as it relates to adding in or subtracting from the overall scene and determine how to best control it.

If you can do this simple walkthrough each time you are in a new shooting situation, you are quite on your way to capturing well-lit images. Once you get past this initial stage and seeing the light becomes second nature to you, you can take it to the next level and start considering more creative ways to light your subjects. Not only is this a great way to keep your images interesting, but you might also find a style that suits you much better than what you've been using all along.

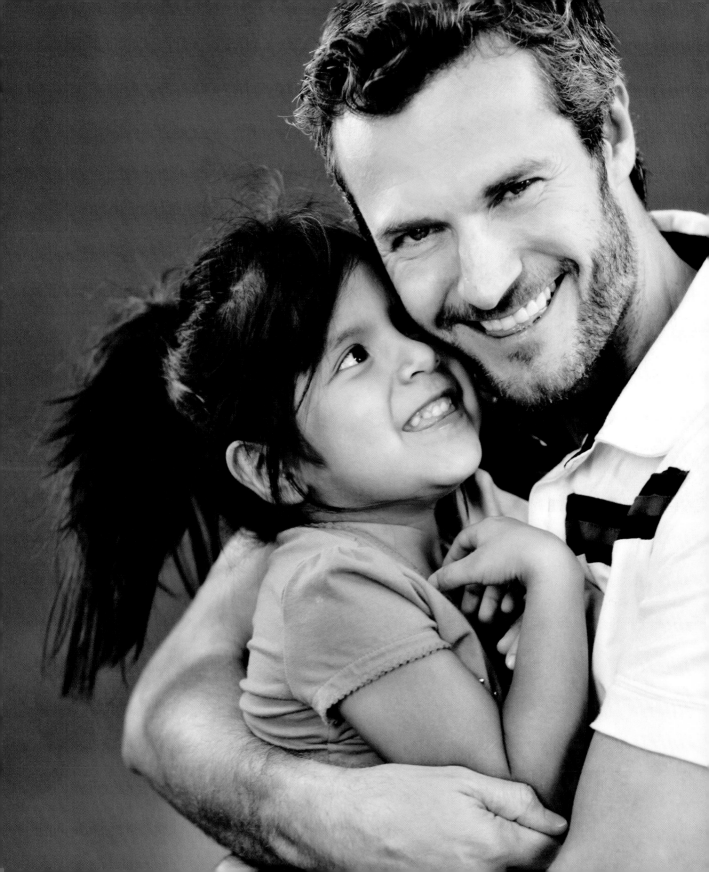

Conclusion

The conclusion of a book is where you tell readers that you hope they learned something, enjoyed what they read, or are closing the book feeling inspired, but that, really, *this is the end now*. Fortunately, I cannot in good conscience say that this is the end. It's hardly the end, and that's the thing about photography—there's always more to master. Even if you learn everything you think there is to know, the entire industry can change in a matter of a few short years. And then you have to relearn it all. This just happened with the transition of film to digital, and then again with the move from wired to wireless. My goodness, we see it in real time with each new release of Photoshop.

Billy Crystal once said, "Change is such hard work." But as we well know, change is also inevitable, and as Gail Sheehy stated, "If we don't change, we don't grow. If we don't grow, we aren't really living." I agree with her, wholeheartedly. I comment on change in relation to photography, specifically, because the pace of technological advancement is currently a fast and furious one. I believe it will most certainly speed up long before it stabilizes or slows down.

This speed of advancement can create a sense of anxiety for individuals who feel like it took a lot of time and effort to get this one field under their belt, thank you very much. And then everything becomes redefined. But there will always be the next great camera or that new unheard-of device that makes it easier than ever before to properly photograph highlights, midtones, and shadows. We will constantly see software updates that blow our minds.

What we haven't seen any advances in, however, is how photographers can better connect with their subjects, how they can read how another is feeling about a current experience, or about why they relate to another in the particular way they do. Being able to empathize with another's experience doesn't improve with pixel count. And what we've seen so far is that as we become increasingly connected through technology, we become increasingly disconnected from each other emotionally. Thus, the need to understand how to reconnect with those we want to authentically photograph becomes that much more important. Showing others what they mean to each other, live and in person, becomes one of the most compelling offerings we can ever give them.

At the root of the greatest portrait photography we've seen is the heart and soul of what we are drawn to the most—the hope, love, and aliveness we find in each other. Arrive at that, photograph it, and hand such a thing of beauty back to your subjects, and you have done more for them than you know—maybe more than they know now. But great portrait photography has a long shelf life that only improves with age. Although you cannot do anything to preserve the vitality of those you create portraits of, you can give them what my client commented on in her family's portrait, referring to their hope as a family: "At this moment, we know what it feels like to have it. And it [the family portrait] will serve as a reminder to all of us that it is possible."

I have written hundreds of pages about family photography here. The truth, of course, is that I've barely scratched the surface. I am grateful for that, though, because it means that along with all the changes, much will stay fresh and interesting throughout the evolution of photography for years to come. I have more to learn and share and try.

If you want to continue along with me, and I certainly hope you do, please check out my website at www.tamaralackey.com. There you will find consistently updated information about photography, business, products, and ongoing workshop options. You will also find fresh gallery images, contact information, and links to connect with me on social media. I am hopeful that you will reach out, because I'd love to hear what you have learned.

And I look forward to discovering what you will undoubtedly teach me.

Take care,

Tamara A. Lackey

Tamara A. Lackey

Index